W9-BAV-609

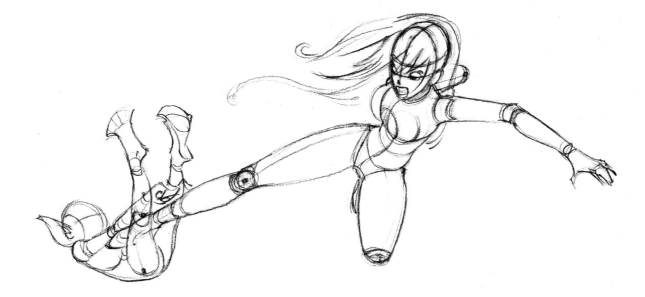

STAN LEE'S
HOW TO DRAW COMICS

STAN LEE'S
HOW TO DRAW COMICS

From the Legendary Co-Creator of Spider-Man,
The Incredible Hulk, Fantastic Four, X-Men, and Iron Man

Watson-Guptill Publications
New York

Contributing writer: David Campiti

Contributing artists: Neal Adams, Erica Awano, Dan Borgones, Nick Bradshaw, Ariel Burgess, Aaron Campbell, Chris Caniano, Eman Casallos, John Cassaday, Frank Cho, Vince Colletta, Bong Dazo, Mike Deodato, Jr., Steve Ditko, Tina Francisco, Ken Haeser, Tabitha Haeser, Bob Kane, Gil Kane, Michael Kelleher, Jack Kirby, Fabio Laguna, Jonathan Lau, Jae Lee, Jim Lee, Jun Lofamia, Gemma Magno, Jezreel Morales, Earl Norem, Ariel Padilla, Cliff Richards, Al Rio, John Romita, Alex Ross, Mel Rubi, Steve Sadowski, Gaspar Saladino, Edgar Salazar, Mel Joy San Juan, Alejandro Sicat, Joe Sinnott, Anthony Tan, Wilson Tortosa, Michael Turner

Paperback edition cover artists: John Romita; color by Dean White

Excelsior limited edition cover artist: Francesco Francavilla

Copyright © 2010 by Dynamite Entertainment

All rights reserved.
Published in the United States by Watson-Guptill Publications
an imprint of the Crown Publishing Group
a division of Random House, Inc., New York
www.crownpublishing.com
www.watsonguptill.com

WATSON-GUPTILL is a registered trademark and the WG and Horse designs are trademarks of Random House, Inc.

Produced in association with Dynamite Entertainment

www.dynamiteentertainment.com

Library of Congress Cataloging-in-Publication Data
Lee, Stan, 1922–
 Stan Lee's How to draw comics : from the legendary co-creator of Spider-Man, The Incredible Hulk, Fantastic Four, X-Men, and Iron Man / Stan Lee. — 1st ed.
 p. cm.
 Includes index.
 ISBN 978-0-8230-0083-8 (pbk.)
 1. Comic books, strips, etc.—Technique. 2. Drawing—Technique. I. Title. II. Title: How to draw comics.
 NC1764.L44 2010
 741.5'1--dc22
 2010005781

Paperback Edition: 978-0-8230-0083-8
Hardcover Excelsior Edition: 978-0-8230-0085-2

Special thanks to POW! Entertainment, Inc., Gil Champion, Michael Kelleher, Arthur Lieberman, Luke Lieberman, Mike Kelly, Roy Thomas, John Romita, Glass House Graphics, Heritage Auctions, Peter Sanderson, Michael Lovitz, Digikore, Carol Pinkus, Dave Althoff, Ryan Potter, Nick Barrucci, Juan Collado, Josh Johnson, and Josh Green.

Stan Lee, Excelsior, Stan Lee Presents™ and © 2010 Stan Lee and POW! Entertainment, Inc.
How to Draw Comics the Marvel Way © 1979 Stan Lee & John Buscema
Silver Surfer Graphic Novel © 2010 Stan Lee & Jack Kirby
Sherlock Holmes & Complete Alice in Wonderland ™ & © 2010 Savage Tales Entertainment, LLC
Bring the Thunder ™ & © 2010 Savage Tales Entertainment, LLC & State Street Films
Black Terror®, Death Defying Devil®, Green Lama ® & Project Superpowers ™ & © 2010 Super Power Heroes, LLC
Zorro ™ & © 2010 Zorro Productions, Inc.
Red Sonja ® & © 2010 Red Sonja, LLC
Jungle Girl ® & © 2010 Jungle Girl, LLC
Totally Tina ™ & © 2010 Tina Francisco
Buck Rogers ™ 2010 Dille Family Trust
Single image from Awakenings by Phil Miller © 2010 Len Mihalovich
Vampirella ® & © 2010 DFI
Re-Animator ® & © 2010 Re-Animator, LLC
Dynamite Entertainment ® 2010 DFI. All Rights Reserved.
Marvel, and all related character names and their distinctive likenesses: ™ & © 2010 Marvel Entertainment, LLC and its subsidiaries. All rights reserved.
Images and likenesses of DC Comics characters ™ and © 2010 DC Comics.
Design by Ellen Nygaard

Printed in China

First Edition

10 9 8 7 6 5 4 3

TO ALL
TRUE BELIEVERS,
KEEP ON
DREAMING!

PREFACE

How time flies! Was it really in 1947 that I first wrote and self-published a tantalizing little tome in which I revealed with unabashed pride much of what I knew about comic books and that I then followed up with an article in *Writer's Digest* entitled "There's Money in Comics"?

Was it really 1978 that I first penned pithy prose and Big John Buscema put his seemingly magic pencil to paper to bring *How to Draw Comics the Marvel Way* to a world of artists hungry for knowledge of "comicdom" in general and the Mighty Marvel Manner in particular?

The cosmic clock confirms, as does my calendar, so it must be true!

I seem to do this every three decades or thereabouts, and now the time is right. Just as the world of technology spins fast and furiously under us, so does the world of comic books. Since the era of John Buscema and our fateful and fruitful collaboration, we've gone from NASA performing moon landings with less computing power than my wristwatch has today to Americans in practically every household using amazing personal computers that can perform digital wonders that comic books only dreamed of at that time. Every bit and byte of that newfound technology has made its way into comic book creation—just as it has into video games and moviemaking.

For half a century, comic books were printed on cheap newspaper letterpresses and even cheaper pulp paper. Yet now, the paper is better, the printing is better, and the creative standards are better as the quality of the art and color has risen commensurate with the technology. It's all about staying vital, contemporary, and—dare I say it?—cutting edge.

Normally, in those days of yore, an artist and writer had a very simple method of producing a comic book epic. The writer would simply type the script and then hand it to the artist. On receiving the complete script, with panel descriptions and dialogue all spelled out, the artist merely followed the writer's written instructions and rendered the illustrations, much in the manner of a director structuring a stage play after receiving the author's manuscript. Yes, that was the way it used to be done—and sometimes still is, all depending on which writer, artist, and editor are involved.

But in my years—has it really been decades?—of collaborating on myriad fantasy, western, romance, humor, and superhero adventures, the artists and I evolved another system of working . . . one that proved far more satisfying to us.

Originally, since my colleagues always had the greatest creativity, the greatest imagination, and the greatest visual story sense that one could hope for, I realized there would be no need for me to labor over a fully developed script if they were to be the illustrators. All that was necessary was to discuss the basic plot with them, turn 'em loose, and occupy myself with other bits of mischief until they brought me the penciled drawings.

Then it was my task to write the dialogue and captions, giving the story the proper rhythmic mood and establishing the necessary characterization. After writing the copy, I'd give the pages to a letterer, who'd then letter all the captions and balloons in the areas I had indicated. Next, the pages would be taken by the inker, who would—you guessed it—go over the penciler's drawings with pen and brush, applying black India ink to all the indicated areas. At this point, the artwork would be returned to me for final editing, and once the colorist had applied the proper colors to Photostats of each and every page, the completed strip would be ready to go to the engraver . . . and what hapened then I never knew and would never dare ask.

Much has changed since then, so I realized it was time for a new book—a cornucopia of cutting-edge, techno-savvy instructions to lead you down the freshly laid yellow brick road of creativity. And this time around, I've enlisted the aid of Dynamite Entertainment and some of comicdom's finest artists, inkers, and colorists—along with dazzlin' David Campiti, writer, agent, and teacher of more comics-creation seminars worldwide than the both of us can count. With their help, we've put together a complete package that people of all ages can enjoy!

Everybody can draw, and this is your ticket to enlightenment—to how to do it better. So hop aboard. Join us on this new journey creating comic books for the twenty-first century and beyond.

Excelsior!

The original: **How to Draw Comics the Marvel Way** *with a cover by John Romita.*

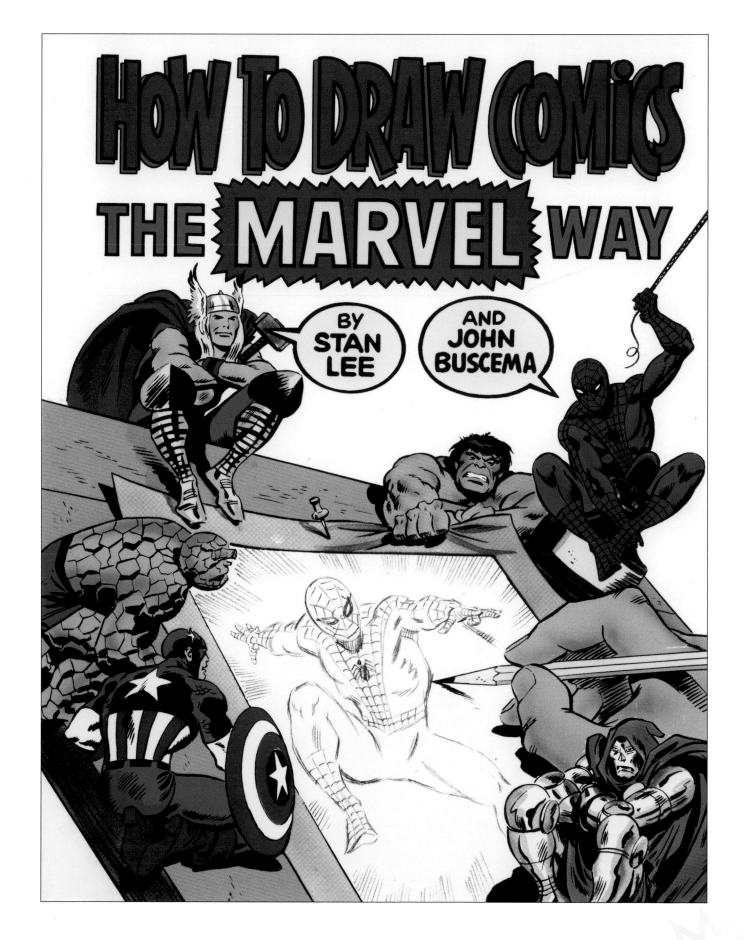

INTRODUCTION

This book is for every boy and girl, every man and woman, who ever wanted to illustrate his or her very own comic strip. Whether your goal is to do it only for your own enjoyment or to publish it yourself or to work for a real publisher, large or small, great things are in this book for you to enjoy and experience.

Drawing. Think about it. It has been with us as far back as the caveman era. In fact, those early cave paintings relating man's primitive adventures likely qualify as the world's first comic strips. The most beautiful thing is how they prove that *anyone can draw!* Yes, even if you think that you can't draw especially well, everyone has a sense of imagination. Some totally talented titans have created and published well-received comic strips and comic books from stick figures. Others have latched on to such computer programs as Poser and Sketchup to create characters and entire worlds without ever worrying about a ruler and a straight line.

There are no limits! Drawing comes from your imagination, and imagination is inspired by everything around you. Every sight, sound, smell, taste, touch, thought, and intuition becomes part of your imagination, and it is boundless. So stand tall! Through this book, inspiring that limitless imagination, you may reach the peak and pluck the proudest prize: knowledge.

Hang loose! As a no-fear, all-fun zone, this book opens up to you the joy, the thrill, the passion of putting pencil to paper, weaving wondrous worlds and calamitous characters. In other words, welcome to this universe of imagination that we love called *comic books.*

One of the reasons I love comic books so much is that they are

different from every other art form in existence. And yet, why do some people still have the misconception that comics are just for kids? Well, let's examine that a little bit, shall we?

Art isn't just for kids, is it? Look at all those museums over our beautiful ball of a world, proudly displaying all those masterpieces of paintings and sketches and drawings—from your city's own museum to the artist down the street who wins third place in the local art show. This isn't for children alone, is it? How about those multimillion-dollar masterpieces in the Metropolitan Museum of Art or the Louvre? Hardly kids' stuff, wouldn't you say? Those stunning statues in the Vatican, those panoramic paintings on cathedral ceilings can't be merely for bouncing babies in diapers, can they?

And then there are stories. Are stories only for youngsters? *Hamlet* and *Othello*? *The Godfather*? *Schindler's List*? Tales for tots? Hardly. How about the works of Stephen King or John Updike or Elmore Leonard? Not exactly "Disney-fied" fairy tales for tykes, right? So why is it, in some folks' minds, the moment you put art and stories together, it becomes a medium that's just for kids?

I don't quite get it, either. For a long time, I wrote comic books with college-age adults in mind, and of course, it worked. Marvel attracted a lot of readers who might've thought comics—some called 'em "funnybooks" then—were kids' stuff before they tried it our way. Perhaps it's because a lot of comics were,

indeed, focused on the youth market, and after a certain age, readers in the USA went on to other things.

It's not that way in other countries. In Asia, comics known as manga and manhwa are read by guys and gals from ages eight to eighty (or younger and older!) because of the wide range of stories and subjects for everyone. Europe boasts a phenomenal, sophisticated grown-up market for graphic novels. When I travel abroad and see the smartly dressed businesswoman or the blue-collar man alike reading comics wherever I go, I couldn't be more pleased. So I continue to spread the good word about comics—to the United States of America and to the world at large.

Also, keep in mind that comic books are *not* just about superheroes. I know, sacrilege coming from the cocreator of *Fantastic Four* and *The Avengers*, right? Not really. Comics are a medium, not a genre. Remember that. As such, comic books can offer *any* and *all* kinds of stories—adventure, anthropomorphic, educational, exotica, fantasy, historical, humor, horror, political, religious, romance, science fiction, urban, western, and, yes, superhero—and in combinations: superhero westerns! Urban science fiction! Historical horror! The mind reels.

All this, of course, is my typically long-winded way of saying comic books can stack up against the best of short stories, novels, films, TV shows, video games, or any other story mediums. But that's

not all. What distinguishes a comic book from other mediums? What makes our much-loved sequential stories stand out from all the rest? It's the specific kind of *control* the writer and artist have over the comic book story they set out to tell.

Think of it this way:

Short stories and novels give you page after page of location descriptions, but only a comic book can conjure up those locations in front of you and hold those images for you to gaze at, for as long as you desire.

Movies give you big-budget action and explosive excitement, but only a comic book can bring the same billion-dollar visual imagination to the printed page with only one or two people at the helm, their ideas undiluted by a thousand other contributors.

Television gives you serialized stories, but only a comic book can bring you the innermost thoughts of its characters without some cheesy voice-over.

Comic strips give you a semblance of sequential art in a confined space, but only a comic book can expand and breathe and explode the sequential experience into double-page, triple-page, and quadruple-page spreads—and beyond!

Video games give you a handheld, pulse-pounding, action-packed adventure experience, but only a comic book can do it without batteries, without electronics, and without screens. (Try rolling up your PS3 or PSP and stuffing it into your back pocket sometime, and you'll know what I mean.)

What's more, comic books bring with them a love, a feeling of camaraderie, and a collectibility missing from most other mediums. Few folks collect DVDs or novels or video games and organize them lovingly and passionately into long white boxes, reopening them to savor the amazing artwork, scintillating story lines, and chaotic

characters they feel are part of their lives. It's more than just a memory; it's the sight, the smell, the feel of holding it. You can reopen a comic book ten, twenty, thirty, forty, fifty years later, and a single glance at the cover and the splash page can bring back

memories anew of some of the greatest adventures with your favorite friends. It's a unique, amazing art form that you want to be a part of . . . these thrilling things called comic books.

We know how to read 'em. Now let's learn how to make 'em!

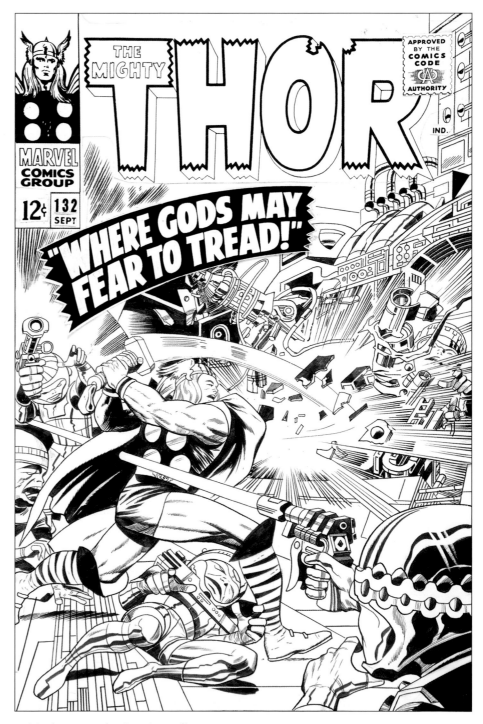

Original cover art showing Vince Colletta's inking over Jack Kirby's pencils for Thor #132 *(Thor vs. the Colonizers of Rigel).*

Fantastic Four #1 *introduced to the world some of the most enduring superheroes.*

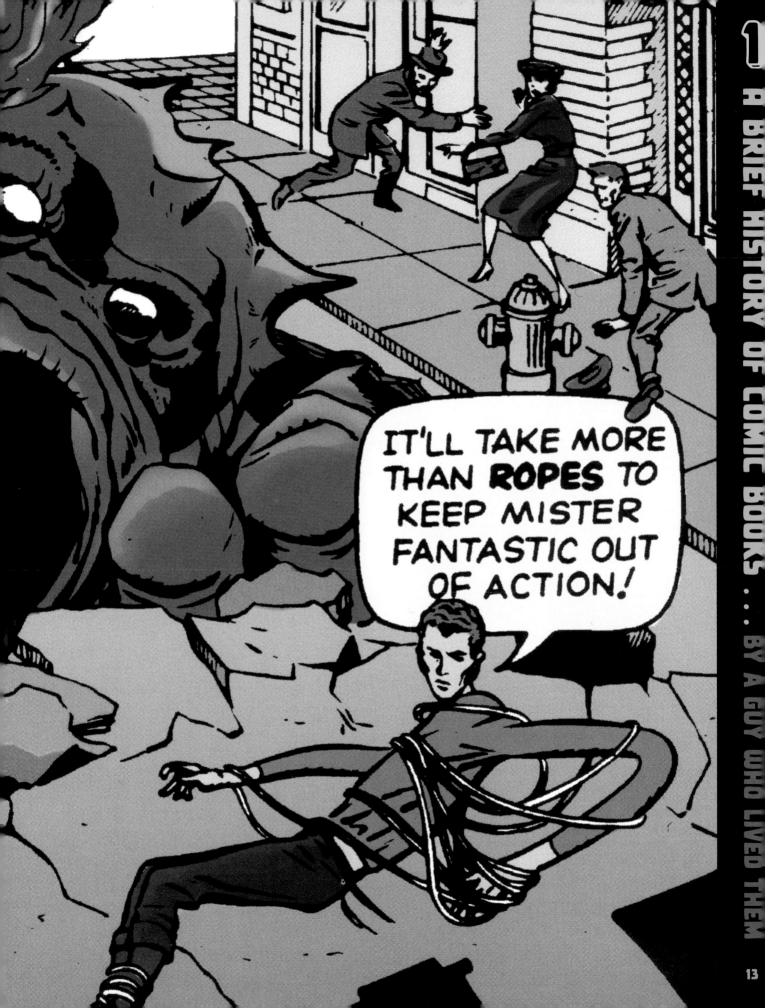

IN THE BEGINNING . . .

Late in the nineteenth century, comic strips began to appear in the Sunday supplements of newspapers. The first among these was *The Yellow Kid*, which originally appeared in 1896. In 1897, these strips were compiled into a package inserted inside a five-cent newspaper. From this beginning, an industry was born, though it would not have immediate success. In 1933, when I was a mere lad, the first true comic book was published. It was called *Funnies on Parade*, and it appeared in essentially the same approximately 8 x 11–inch format in which comic books are printed today, give or take an inch. Ten thousand copies were printed, all given away with coupons for Proctor & Gamble products. The comic book consisted of reprinted comic strips. Some of these stories did have somewhat ordinary heroes fighting crime, such as Dick Tracy, The Shadow, and The Phantom. *Funnies on Parade* paved the way for the release of *Famous Funnies*, in 1934, which was the first-ever newsstand comic book published with all-original material. It was published by M. C. Gaines and would be continuously published for the next thirty years.

In February 1935, Malcolm Wheeler-Nicholson published the tabloid-sized anthology title *New Fun Comics #1* through National Allied Publications, later named DC Comics. National Allied Publications was responsible for arguably the most important superhero of all time: Superman. Superman was born Kal-El on the planet Krypton before being rocketed to Earth as an infant by his scientist father moments before Krypton's

destruction. Discovered and adopted by a Kansas farmer and his wife, he was raised as Clark Kent and imbued with strong American values. Very early on, he started to display superhuman abilities, which upon reaching maturity he used for the benefit of humanity. Superman made his debut in *Action Comics #1*, published in June of 1938. He was created by Cleveland-born writer Jerry Siegel and artist Joe Shuster. Sales of Action Comics generally surpassed half a million copies per issue, which was a record high at that time in American history.

The other famous character published by National Allied Publications was Batman. Batman is Bruce Wayne, who as a child witnessed the murder of his parents and swore revenge on crime, an oath tempered with the greater ideal of justice. Bruce trained himself both physically and intellectually and dons a bat-themed costume to fight crime. He first appeared in *Detective Comics #27* and was created by Bob Kane and developed with a bit of help from Bill Finger and Jerry Robinson. (When National Allied Publications officially changed their company name to DC Comics in 1977, it was named after Detective Comics.)

A dramatic burst onto the scene in 1940, as Batman makes his debut in Detective Comics #27. *Due to the limits of printing in the early days of comic books, bright primary colors were used for almost every element of comic book art, but this changed as Bob Kane brought us Batman—a creature of the night who altered the way superheroes could be presented. Aside from his yellow belt, Batman's costume consisted of monotone colors to represent him as a creature of the night and to inflict fear in his adversaries.*

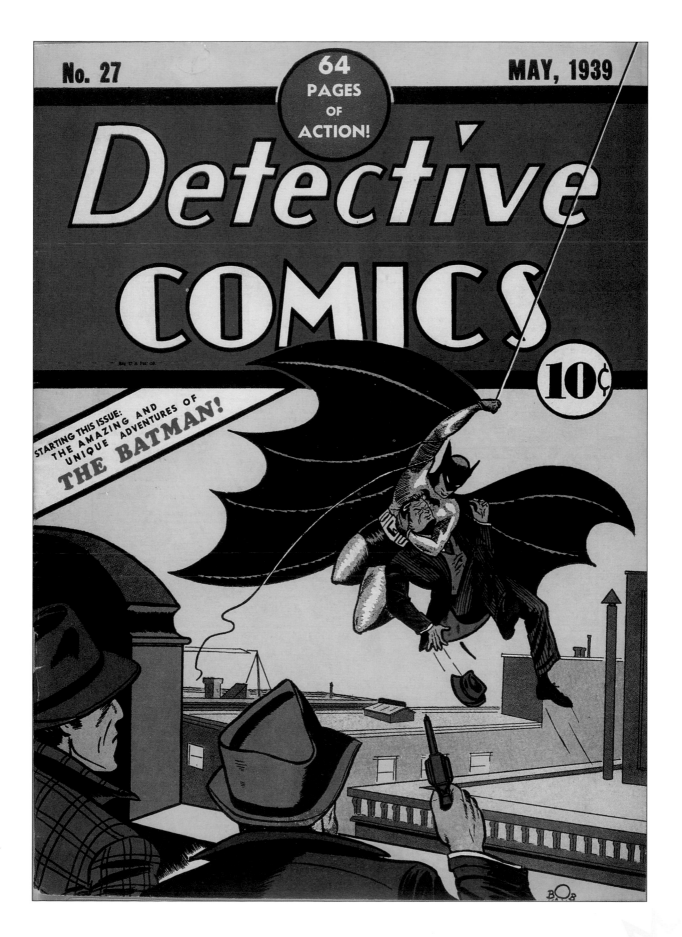

THE GOLDEN AGE OF COMICS

Bob Kane's cinematic angles and use of light and darkness created a unique world. The twisted, dark villains and Batman's quest for vengeance were unlike anything seen previously. Thus, with the likes of Superman and Batman and the slew of other heroes created by DC, the Golden Age of Comics was born.

Not to be outdone, other publishers dove into the field, bringing forth such characters as Fawcett's original Captain Marvel in the form of a child whose heroic wish-fulfillment transformation came at the utterance of the magic word *Shazam!* Marvel Comics (why does *that* name sound familiar?), which was first known as Timely and then Atlas (but which publisher Martin Goodman incorporated under scads of different aliases), would eventually supplant DC Comics as the number-one comic book publisher.

Timely's first comic book was *Motion Picture Funnies Weekly*, which was handed out at movie theaters along the East Coast. Its first comic with mass distribution was *Marvel Comics #1*, showcasing the first appearance of The Human Torch.

In 1941, a company called Archie Comics would publish a comic book that made history. The book starred Archie Andrews, a teenager who was caught in a love triangle with two girls. This comic book took America by surprise; every child, especially young girls, read and laughed at Archie and his gang.

By the end of 1941, more than fifty million people a month—the majority of them male—were reading comics. But by 1943, paper shortages caused by the war were limiting the expansion of comics, and fewer new titles were produced. In the 1940s, pulp comics (whose story genres consisted

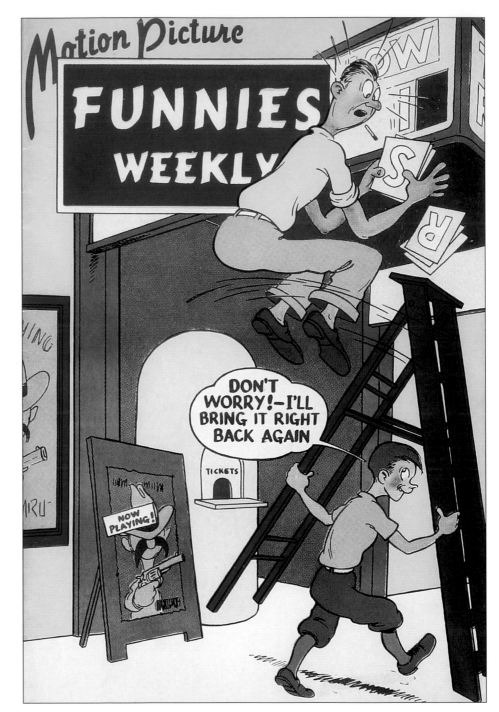

Timely's **Motion Picture Funnies Weekly.**

OPPOSITE: Timely's **Marvel Comics #1,** *featuring The Human Torch.*

of westerns, romance, crime, and mysteries) sold well on the market. As soon as word got out about the popularity of pulp comics, other publishers made more of them.

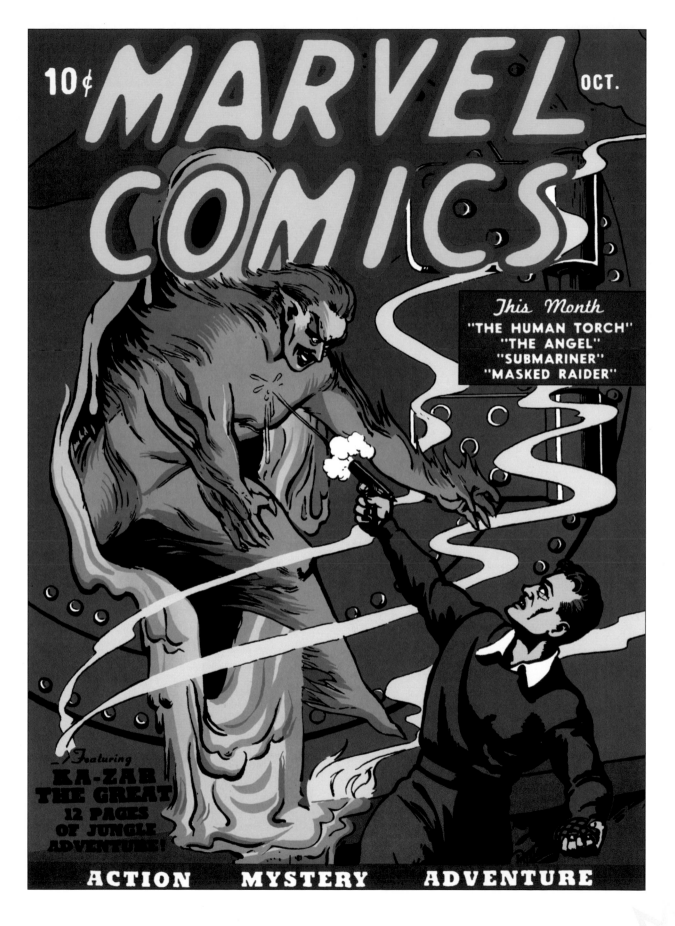

THE "CORRUPTING" INFLUENCE OF COMICS AND THE CCA

The 1950s saw the greatest witch hunt ever in comics. Bolstered by a new trend in horror comics from many publishers, including Timely/Atlas, psychiatrist Fredric Wertham wrote a book, *Seduction of the Innocent*, in which he accused comic books of causing youth corruption and juvenile delinquency. He blamed comics for enticing youth to violence, something that had already happened with rock 'n' roll. Some of the residents of Birmington, New York, held a massive comic book burning. The comic book companies got the message and created the Comic Magazine Association of America (CMAA), and then they created the Comics Code Authority (CCA) in 1954. The Comics Code was created to limit, and rule on, what could and could not appear in the pages of a comic book. But the code ended up not-so-inadvertently destroying all the comic titles from EC Comics (publisher of, arguably, the best horror comics of the time) except for one: *Mad*. It escaped the Comics Code by changing its name to *Mad Magazine*, which is still published by DC Comics today.

The comic book industry in the mid-'50s was in a slump. The only comics that still sold were DC's *Superman*, *Batman*, and *Wonder Woman*. The traditional comic book outlets and corner newsstands were riding into the sunset. At a dime a book, comics were not profitable enough to be attractive to the typical franchise store or shopping center. Also, television was competing for the attention of young readers in the 1950s. Senator Joe McCarthy started televised Senate subcommittee hearings during which a politician could scream about some sort of persuasive evil. Comic books were the target of these hearings because they were said to have turned kids into juvenile delinquents. Juvenile delinquents read comic books, so comic books must cause juvenile delinquency, went McCarthy's logic. I said, "Juvenile delinquents eat chocolate cake, so chocolate cake must cause juvenile delinquency," but nobody listened to me. I wasn't on TV.

THE SILVER AGE OF COMICS

In the latter half of the '50s, comics once again gained popularity. DC Comics was experimenting with its characters. The heroes' names were the same, but the characters (for example, The Flash and Green Lantern) were different people with redesigned costumes. The artwork was cleaner, clearer, and more modern in style than what was seen in the Golden Age of Comics. This brought about the Silver Age of American Comics. Other revivals quickly followed from DC and other publishing houses.

Marvel Comics began to flourish in 1961 under the stewardship of their editor and head writer, Stan Lee (where have I heard that name before?). Yup, this is where I come in. I was born as Stanley Martin Lieber in New York City on December 28, 1922. (Go on, do the math. I'll wait.)

In 1940, I was hired at Timely (Marvel's former company name) as a gofer. ("Go fer" this, "go fer" that.) My first-ever writing for a comic book, in fact, wasn't even a sequential comic book story; it was a two-page text story called "Captain America Foils the Traitors' Revenge!" in *Captain America Comics #3*. (Catchy, eh?) When the former editor of Timely—the great Joe Simon—left the company in 1941, I was promoted to "temporary" editor and art director. My temporary job (with the exception of a few years in the war

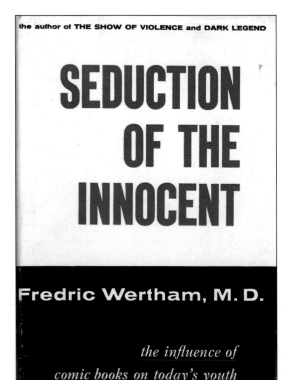

Fredric Wertham's Seduction of the Innocent.

when I mostly wrote and designed instructional comics and posters for the war effort) stretched into decades.

But in 1961, when a creatively frustrated yours truly was pondering quitting comic books altogether, at my wife's urging I tried something different, cocreating *Fantastic Four #1* with Jack Kirby. Soon after that fateful issue, the company officially changed its name to Marvel Comics. Then came Spider-Man, The Hulk, Iron Man, Daredevil, The Avengers, and X-Men.

Spider-Man, who debuted in *Amazing Fantasy #15*, began as an ordinary teenager who had to deal with the normal struggles of youth in addition to those of a costumed crime fighter. Spider-Man had superstrength and superstamina, the ability to cling to most surfaces, shoot spiderwebs using devices of his own invention that he called "web-shooters," and react to danger quickly with his "spider-sense," which enabled him to combat his foes.

The X-Men were a group of teen superheroes that were all brought together due to an extra gene that gave them their powers and in turn caused the public to fear and hate them. This comic book appealed to many Americans because it conveyed a message to the reader about how badly different races were treated during that time in America.

By late 1968, sales of superhero titles for all publishers except Marvel were beginning to fall. I don't mean to brag, but Marvel Comics was selling more than fifty million comics a year. American Comics Group had closed down in 1967. Archie Comics, Harvey Comics, and Dell Comics had canceled all their superhero titles once again. Sales were down everywhere. By 1970, the top-selling title was non-superhero Archie Comics, and that was selling over five hundred thousand copies per issue. The

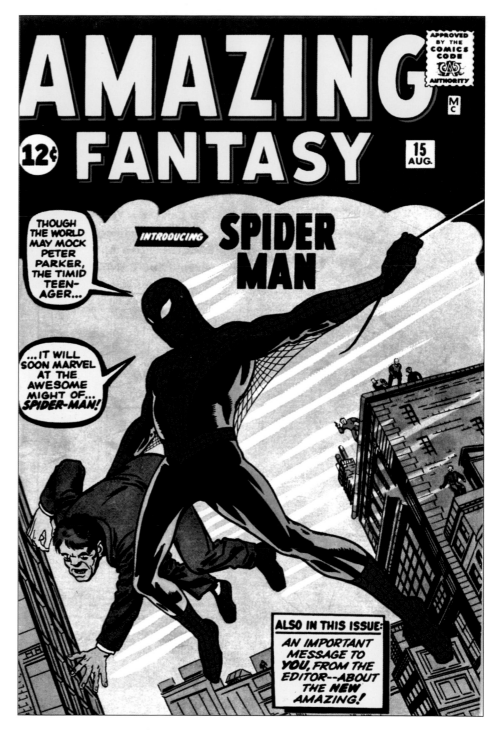

The debut of Spider-Man in Amazing Fantasy #15.

1970s were a troubled decade for American comic books. DC Comics had a rough time selling comics. An event known as the DC Implosion signaled the time when DC canceled nearly half of its titles overnight.

BREAKING THE RULES

During the '70s, Marvel broke the rules, producing a "don't do drugs" Spider-Man story that the CCA would not approve. But we published the story anyway. Nobody complained, and our government—who had asked me to do it—was happy. Only twenty-two years earlier, people were burning comics because of the evil effect they were supposed to have. The story in the comic book was about the harmful effects of drug use. The CCA thought the drug issue should be ignored completely, but the public was on Marvel's side in this case. After we published the story on drug usage, the CCA relaxed some of its rules a bit, allowing some horror comic books to pop up again. These horror characters were also superheroes and were used in mainstream superhero comics because they added a different twist to the stories. Therefore, since horror comics were again available to comic book readers, grim and gloomy comics began to gain popularity.

As an aside, this is where I stepped away from being Marvel's head writer and editor and became publisher, president, chairman, and then chairman emeritus of Marvel, most likely in that order. I still devote a full day each week to the House of Ideas, writing the Spider-Man newspaper strip, doing interviews, talking up Marvel to Hollywood and to the world at large, and even sneaking in a cameo appearance here and there in the films based on characters I cocreated.

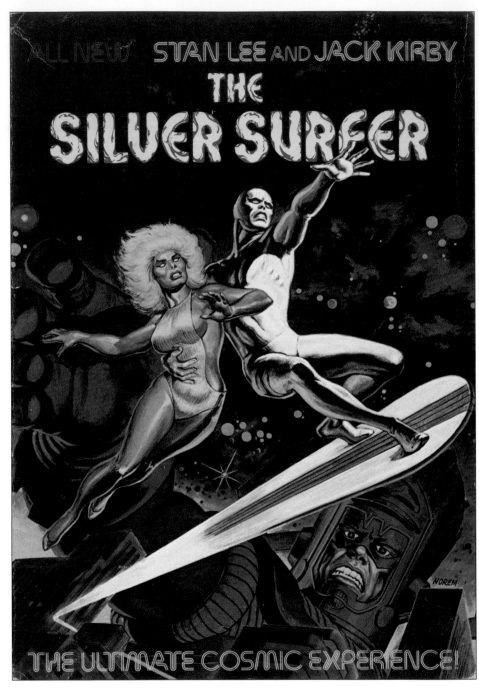

The Silver Surfer, *the first graphic novel.*

In 1976, Marvel and DC would create the first comic book company crossover between Superman and Spider-Man. Because of the success of this book, many other company crossovers have been created since then. Jack Kirby and I introduced one of the first graphic novels in America—*The Silver Surfer*, naturally—and before long, graphic novels became a hot commodity in bookstores, a pattern that continues today.

ADVANCEMENTS

The 1980s brought us better printing and the beginnings of new technologies in the comics industry. Offset printing and a paper stock called Baxter Text were all the rage, and it took a couple of years for our colorists and artists to get used to the blazing hues and better printing. In fact, new methods of coloring changed the face of comics, as methods called *graylines* (coloring grayed-out stats of art) and *bluelines* (coloring treated watercolor paper)—both with separate blackline overlays on clear acetate—replaced the traditional hand-separation methods. Here, the beginnings of computer color began to crop up, as well.

This same time period also opened up a new sales venue for comics. Traditional mom-and-pop stores were becoming a thing of the past, and standard newsstand distribution had become sadly inefficient (comic book publishers had to print five copies for every one that sold!). A new method called *direct sales* sprouted up, thanks to an enterprising fan named Phil Seuling. Comics were sold directly to comics shops at a slightly better discount but were non-returnable, a total turnaround from fifty years of magazine distribution. This helped both store owners and the publishers. Soon, tons of comics per month were being sold exclusively into the direct sales market. Although many of those comics were of the superhero variety, dozens of new publishers came (and often went) bringing genres that had been missing from the racks for a decade or two: book/movie/TV adaptations and tie-ins, humor comics, and straight-out fantasy. Some of them even won awards.

In the 1990s, superstar artists flourished. While the business had always had its superstars—Jack "King" Kirby, Sturdy Steve Ditko, Jazzy Johnny Romita, and John "Blood 'n' Guts" Buscema among them—big sales meant big royalties, and a new crop of top talent became multimillionaires. A hefty handful went on to create Image Comics, which blew open the comics market even wider and made bigger, brasher, bolder artwork and coloring the name of the game for a number of years.

THE TWENTY-FIRST CENTURY

The twenty-first century has brought with it even greater advances: for example, slick paper and state-of-the-art computer color techniques. Inkers are often replaced with "digital inking" and print-from-pencils techniques unheard of only a few years earlier. Computer lettering rivals—even surpasses—the best hand lettering. Artists scan art themselves and send digital files to their editors via e-mail and ftp sites. Even entire books are drawn on digital tablets, leaving no art paper behind. And through it all, the styles and techniques are getting better and better.

Now that you've boned up on your comic book history—there may be a test later!—let's get on to the good stuff.

From black and white to computer coloring, all methods and options are at the disposal of the artist.

MATERIALS

Just as a plumber needs pipes and wrenches or a surgeon needs a scalpel and forceps, so does the comic book artist need tools to create! The combination of technology and traditional mediums has pushed comic book art to new heights.

COMPUTER

Thought the pencil would be number one on our list? Not for the twenty-first century, newly enlightened one. Today, a computer is as important to the process as any pencil or pen or brush—and it's critical for scanning and fine-tuning your art and sending it to your editor.

You'll also need an Internet connection and the right software, too, which we'll get into starting on page 30.

SCANNER

Without a scanner, how else will you scan your artwork to send to your editor? Pencilers as well as inkers and colorists will need this. A large-format (11 x 17–inch or A3 size) scanner is infinitely preferable to a regular (8½ x 11–inch or A4 size) scanner, but the smaller one will do in a pinch.

PRINTER

Even if you're not a colorist proofing your work, you'll need a printer. Looking at your artwork at print size helps you see whether or not your art reduces properly.

In the twenty-first century, a computer and printer are two pieces of must-have equipment for comic book artists.

PENCILS

Regular, wood-clinched drawing pencils come in roughly seventeen grades of softness or hardness, lightness and darkness, and better consistency than that #2 pencil with an eraser that you used in school. (You'll need a pencil sharpener for these, too.) Mechanical pencils hold different thicknesses of leads and never need sharpening. Lead holders are similar to mechanical pencils but don't push the lead out. There are also non-reproducible blue pencils, which some artists like to use in their initial layout stages. The benefit to these pencils is that artists' initial linework done in non-repro blue doesn't reproduce, and they don't have to worry about erasing it. Every type of pencil brings its own benefits. Experiment to find which pencils feel the best for you.

PENS

So many from which to choose, so little time: cartridge pens that hold ink; dip pens, such as Speedball; markers; even Japanese markers (with tips on both ends and flexibility that resembles brushes). Experiment, experiment, experiment!

BRUSHES

Inkers often recommend the Winsor & Newton series 7 sable brushes, in sizes 0–7, depending on the job. Again, experiment with different brands and types. Some inkers take sharp scissors to their brushes and sculpt the ideal brush head for their purposes. I've even seen inkers use three-for-a-dollar kids' watercolor brushes in a pinch!

Pencil types, from left to right: four graphite pencils, a standard no. 2 pencil, and two mechanical pencils.

Various brush and pen types: crow quill, sable brushes, flat brush, a Micron Pigma pen, and a Micron Sakura brush pen.

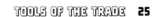

INK

Black India ink, of course! It ensures the best reproduction. Some inks are thicker, some more watery. Find the brand that works for you.

ERASERS

Think you'll never make a mistake? You'll be the first! Whether you use rubber erasers (the kind that leave crumbs) or kneaded erasers (which behave like hard Silly Putty), make sure your favorite problem remover doesn't damage the surface of your art paper.

PERSPECTIVE GRIDS

You'll need 'em to simplify your life when you're on deadline—and who isn't? (See page 53 for an explanation of the grid.)

ART BOARD

Comic book artists use two-ply bristol board (either smooth or rough finish), cut to 11 x 17 inches. Several suppliers now offer professional-quality two-ply illustration paper with the correct dimensions preprinted in non-repro blue. (Manga artists, drawing smaller, cut a sheet in half.)

DRAWING BOARD

This can be a flat board you hold at an angle on your lap or a full drawing table (opposite). Don't try to draw flat on a table; your drawing will be distorted.

DRAFTING TABLE

This is the way to go! It's a professional drawing table with a partial glass-top surface and a light beneath it. This *light box* helps you see layouts and perspective grids under your art board. It's a lot easier than holding your art boards up to a sunny window.

DRAWING TABLET

This is a surface for drawing directly into a digital file, accompanied by a pressure-sensitive pen with swappable points to mimic pencils, pens, and brushes. Good for drawing, for coloring, even for corrections and digital cleanup of scanned art.

REFERENCES

You should spend time every day adding to your reference file—sometimes known as a "morgue." Eventually you'll need to draw it all: faces, hairstyles, fashions, cars, buildings, exotic locales. More and more artists keep reference files on their computers, though everybody has printed references they hang on to.

Eraser types, from left to right: Pink Pearl eraser, plastic eraser, kneaded eraser, and ink eraser.

Commonly used India inks and correcting fluids.

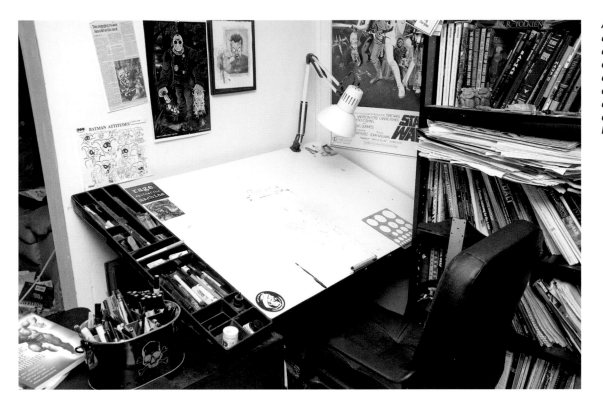

A basic setup includes a drafting table with an adjustable surface that can be set at any angle, an attachable table caddy for easy access to tools, and a swing-arm lamp. Reference materials should also be nearby for easy access.

T SQUARE

When not subbing as reference for your hero's sword, the T square is invaluable for keeping lines parallel and for drawing borders.

RULER

Choose a raised-edge ruler to keep your ink from flowing under it and smearing your art. A clear plastic one helps to see under it.

DRAFTING TOOLS

Common useful tools include templates for ellipses and French curves, an ink compass, a clean rag, a water jar or two for your brushes, white "opaquing" paint, "opaquing" markers, a triangle, pushpins, and water cups to clean your brushes. Some artists also use everything from electric erasers to toothbrushes (to splatter paint for "starfield" effects).

The T square, triangle, and ruler are also necessary tools for rendering correct perspective in your drawings. A circle stencil is also handy.

USEFUL TERMS

A list of terms is often relegated to a glossary at the back of a book, but it's actually helpful to become familiar with the lingo of the comic book medium *before* you really get into the drawing process. Some of the terms will already be familiar from the previous section, and others will provide further information.

ART BOARD
Illustration paper, usually two-ply bristol board sized to 11 x 17 inches.

BALLOON
The bubble surrounding comic book lettering, as in the terms *word balloon* or *thought balloon*. (See page 170.)

BREAKDOWNS
Half-finished penciled artwork drawn on art board but lacking final pencil rendering.

BURST
A lettered balloon rendered with sharp points, to denote a yell or a scream.

CAPTION
A lettered text box containing information not told through a character's dialogue or thoughts. It can set the time and location, establish mood, and more. A character's thoughts can also be included here, making that character the storyteller and stepping the narration away from the immediacy of the scene being depicted.

CLIFFHANGER
A suspenseful ending to a story, meant to entice readers to read the next installment.

COLORIST
The person who adds color to black-and-white images.

COMIC BOOK
A publication made up of narrative artwork.

COMIC BOOK LOGO
A title in a specific, recognizable design and type style that describes the subject of the comic book.

COMIC STRIP
A short sequence of artwork that tells a story.

COVER
A compelling image meant to entice the reader into buying the comic book and also serving as a preview for that issue's contents. The best cover distills the concept of the issue into a single, powerful image that tells a story.

CREDITS
The names of the contributors to a comic book and what creative work they performed.

DIALOGUE BALLOON
Contains a character's spoken dialogue.

EDITOR
The person who coordinates and oversees the content of the story as well as the creative collaborators.

ELECTRONIC BALLOON
A jagged balloon (and tail) meant to signify sound coming from a broadcast/sound source, such as a TV, radio, iPod, or bullhorn.

FTP
An acronym for *file transfer protocol,* a secure online folder into which *you* upload files to your editor (or from which you download files from your editor).

GENRE
A general category of story type, such as adventure, horror, fantasy, romance, western, science fiction, or superhero.

GRAPHIC NOVEL FORMAT
Periodical stories bound in a larger-page format (i.e., larger than a comic book), usually with a square spine (i.e., *perfect* binding).

GUTTER
The space within panel borders.

INKER
An artist who finishes a penciler's artwork, usually in India ink, for reproduction.

LAYOUT
Storyboard artwork for a page, usually created small on separate paper but complete with all the action, perspective, and character performances.

LEAVE-BEHIND
A concise sampling of your work, stapled or otherwise collected with your complete contact information, to leave behind for an editor to review later. This can also be submitted through the mail, of course.

MANGA

Comics from Japan, or comics drawn in the Japanese comics style.

MONTHLY PERIODICAL

Most comic books are published on a monthly schedule, typically at twenty-two pages in length.

NON-REPRO BLUE

A shade of blue that doesn't reproduce when printing, under certain circumstances. This often refers to a type of artist's pencil or specific printer's shade (such as found on art board).

ORIGINAL GRAPHIC NOVEL

An original story created especially for the graphic-novel market.

PANEL

An illustration laid out within borders, usually part of a sequence on a page.

PENCILER

An artist who works from an outline, plot, or script, creating the storytelling and visuals for a panel-to-panel comic book story.

PERSPECTIVE GRIDS

Preprinted sheets on clear plastic, precisely ruled in one-, two-, and three-point perspective to simplify perspective drawing for draftsmen, architects, and illustrators.

PLOT

General story outline.

POINTER

Connects balloons to each other and to the character speaking.

SOUND EFFECTS

Written words created in display lettering, often in onomatopoeia, to signify sound on the printed page.

SPLASH PAGE

A full-page illustration that assists in emphasizing a key story moment. Often a splash page will open a story and include the logo, story title, and credits.

STORY TITLE

The name of each comic book issue's story.

TEASER ADVERTISEMENT

A glimpse of future comic books presented as advertisements to excite reader interest.

THOUGHT BALLOON

The bubble-shaped balloon used as a narrative device to represent internal dialogue.

WHISPER BALLOON

A word balloon designed to show a character speaking quietly, achieved with a broken bubble.

WORD BALLOON

A graphic convention used to indicate the speech of a character.

COMPUTERS AND SOFTWARE

Computers and assorted drawing-related peripherals have become such critical weapons in the comic book artist's arsenal today. Certainly, I'll discuss other specifics in subsequent chapters, but let's wend our way through the necessary bits, bytes, and buzzwords, shall we?

As a pencil-and-pen-on-paper type of illustrator, you may be thinking, *What need do I have of a computer? I just draw!* Oh, so true. But then what? Let's examine the process. You're drawing layouts for your book. Now what? Editors no longer wait for snail mail to deliver a package with your layouts for their approval. Nor is it particularly convenient

for you to fax 'em over and make the editor wait by the fax machine. These days, artists scan and e-mail their layouts for approval. Then they send JPEGs of their pencils for approval. The same goes for inks and letters and colors, with final files being sent over in high resolution.

Right away, this means you need a computer (and a monitor,

keyboard, and mouse), a scanner, an Internet connection, an e-mail account, and certain software. If you color your artwork, you need Photoshop. If you tone it, you need Deleter or Manga Studio. And that's only the beginning. Let's go into more detail for the uninitiated. I just hope I don't get into trouble for giving away all these secrets!

A computer is a must for today's working or aspiring comic book creator!

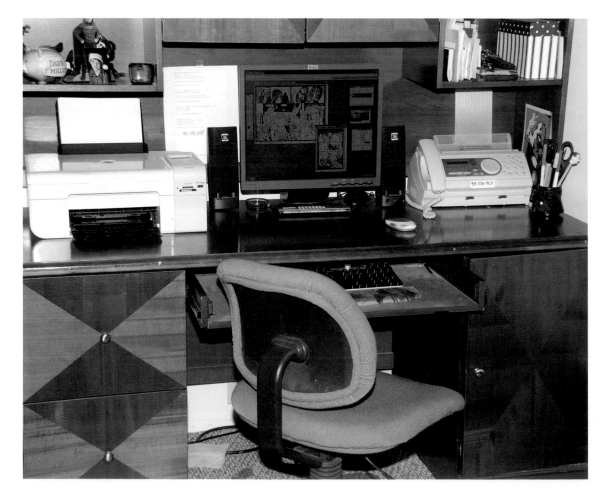

COMPUTERS

Many artists tend to use a Mac (an Apple computer product). They're quite intuitive, graphics-oriented computers, making them especially easy to learn. (The all-in-one iMac is especially inventive and easy to use.)

Of course, artists also use PCs, which are Windows-based computers made by a whole range of companies including Sony, Dell, and HP. (Yes, I know a Mac is also a PC, albeit with specialized hardware and operating system. Humor me.) And to make things even more confusing, you can also run Windows on a Mac, but you cannot run a Mac's operating system on a non-Mac PC. For our overall discussions in this book, we'll refer to a Mac, but practically everything is valid on a Windows computer, as well.

Sure, when you're just starting out you may be using someone's hand-me-down computer that's a few years old. As long as it can connect to the Internet, has the necessary software, and has a reasonable amount of memory, you're fine. The newer computers simply run faster and can utilize the newest software for the greatest speed. (Cuz when you're a pro artist on deadline, every few minutes count!)

THE INTERNET

Start by getting yourself an Internet connection (preferably not just a dial-up connection, because that may be too slow for business) and an e-mail account. Gmail.com (courtesy of the ubiquitous Google at google.com) is an especially good, basic e-mail provider to set up an account, though there are many others depending on where you live. America Online (AOL) is a huge international service that sells Internet access in addition to providing free e-mail accounts. Comcast is a cable TV and phone service

provider that offers both, as well. It's a fair bet that your local telephone yellow pages offers some access and e-mail account services in your area.

Next, sign yourself up for an instant messaging (IM) account that you'll probably end up using every day for chatting with editors and fellow talents. Yahoo! Messenger is a good one that anyone can access (http://messenger.yahoo.com/). So is AOL Instant Messenger (www.aol.com). Mac users can even use iChat. These are great for chatting about notes with an editor or collaborator in real time—and you can save every conversation for later reference! What's more, if you want free phone calls and video conferencing anywhere in the world, use the aforementioned iChat (if you're on a Mac) or sign up free for Skype (for PC or Mac, at www.skype.com). See how easy that is?

Finally, I suggest that you build a portfolio of your work online. Many options are possible. A popular one is DeviantArt, in which thousands of artists worldwide post their masterpieces and interact with one another (www.deviantart.com). Other artists build their own Web sites using free Web site templates or simply post their images at sites such as Photobucket (www.photobucket.com). Browse 'em all, and pick an option that fits you best.

A word to the wise: The more logical your e-mail name, the easier you are for an editor to reach. I suggest that you do not get overly clever with your e-mail address. TonyStark@aol.com only works as your professional e-mail address if your name really is Tony Stark. MooMooWingyDingy@comcast.net may certainly be memorable, but it isn't your wisest choice. Your name (and possibly your studio) is usually best. So, if your name is

Alain Resnais, for example, Alain-Resnais@gmail.com is a perfectly reasonable professional e-mail address. Be sensible, not silly.

SCANNERS

Scanners can run as low as fifty bucks or can cost twenty times that. Any good scanner from a reputable manufacturer will be fine. Don't simply buy the cheapest; research the best for your money. A really basic scanner might do the job, but you may spend more time cleaning and fixing your scan before it's usable. Many scanners are A4 size; they scan 8½ x 11 inches or slightly larger (international size). That means that unless you're scanning small originals, such as those drawn for manga, you will have to scan your 11 x 17–inch original art in two halves and "marry" them together in Photoshop. It's a bit of extra work.

A canny alternative is a large-format A3-sized scanner. They cost more but are worth it in the time saved (no second scan and no wasted worry and minutes in Photoshop putting two halves together). I've come across many an artist who has complained that no good, inexpensive A3 scanners exist. I beg to differ. I don't usually make product recommendations, but in this case, I will: Look for a Mustek A3 USB flatbed scanner. They're as much as one thousand dollars (less than the next-best-priced A3 scanner), and plenty of knowledgeable professional artists, inkers, and colorists in the biz use them.

PRINTERS

Everybody needs a printer, not only for occasional letters but to print out references, enlarged layouts, and much more. Colorists need an especially good one to color-match their colors

to their screens for print. It also helps for pencilers and inkers to print their work at printed size to make sure all their lines will publish as beautifully as they think they will. You may even want to select a large-format (11 x 17–inch or even 13 x 19–inch) printer so that when you blow up a layout to original art size or print a clean scan of your art for your portfolio at full size, you can do it as one piece!

DIGITAL TABLETS

If you've ever tried to do detail work on your computer using a mouse, you know how frustrating it can be. Quite a few artists, inkers, and all computer colorists use a digital tablet. They come in many sizes, with the medium-sized tablet being the most popular. Many types and quality levels are available, from the very basic Genius Mousepen and VisTablet to the Wacom Bamboo and then on up the professional scale. The Intuous4, with 48½ square inches of work area, is the current standard for comic book professionals, though the Cintiq 21UX 21-inch interactive-pen display tablet seems to be the high-end tablet the top professionals are buying.

The best of these tablets offer pressure-sensitive "pens" with interchangeable nibs that simulate working with pencils, pens, brushes, and markers. Not only are comic books routinely colored using these, but some artists are drawing and inking their work entirely on such tablets. The good news is that it saves scanning and cleanup time. The bad news is that there's no original art to sell to collectors afterward!

LETTERING FONTS

Planning on lettering, or at least dropping such details as signage into, your artwork? How about sound effects or logos? Yes, you can still do them by hand, but they're also available as some of the greatest balloon, title, and display comic book fonts in the world! Here are a few to get you started:

- The shining stars of comic book fonts are from ComiCraft. You can find hundreds of top-notch choices at www.comicbookfonts.com. What could be easier?
- Another source for terrific lettering fonts is www.blambot.com.
- A very basic, popular comic book font is Whizbang. You can find it at www.studiodae.com/whizbang.html.

TRUE STORY

An artist contacted an editor using "evergreenfajita" as his e-mail address and showing samples from a Web site that bore that name. He later phoned that editor looking for work, identifying himself as Mulongo. Still later, he shipped a package of samples that he signed as Roman Sargento. Finally, he topped it off with a link to the portfolio on DeviantArt under yet another name.

The editor was surprised to discover, after months of correspondence and calls, that this was one guy. And yet the artist was shocked—shocked, mind you!—to discover that the editor thought he was dealing with four different guys. Had the artist been clear and efficient about his identity, all the samples and follow-ups would have made sense, and he would have gotten assignments from that editor months sooner. (The names have been changed to protect the guilty.)

SOFTWARE

It's not merely a matter of loading software onto your computer and starting to work. You'll need to learn how to use the software programs that are part of your beautiful, burgeoning career. Consider it to be just like learning to use other tools of your trade—even though their learning curves are a bit more involved than mastering a new pen or brush! The most valuable software programs for the comic book artist, inker, letterer, or colorist follow.

ADOBE PHOTOSHOP

The current version is CS4, but the earlier versions will do just fine, as well. For scanning, tweaking, art cleanup, coloring, and many other uses, this is the gold standard. Some pencilers and inkers can get by with the stripped-down, occasionally free Photoshop Elements software. If you're a colorist or simply want the powerhouse, you need Photoshop.

ADOBE ILLUSTRATOR/ ADOBE INDESIGN

A lot of illustrators and letterers need one or another of these software programs for creating logos, working with word balloon shapes, and a whole lot more.

COMICWORKS (AKA DELETER)

This is manga drawing software, designed for professional manga artists. Ordering information and tutorials can be found at www.deleter.jp/eng/cw_english/.

MANGA STUDIO

Known in Japan as Comic Studio, this is advanced cutting-edge drawing, coloring, and toning software designed for manga. It includes 3-D objects, word balloons, vector tool kits, and all sorts of other helpful features (http://my.smithmicro.com/win/mangaex/index.html).

GOOGLE SKETCHUP

Consider this my gift to you: This is *free* software! Just go to google.com and type in "Sketchup" or go straight to http://sketchup.google.com/ and click Download! There are versions for Windows and Mac, and they work equally well.

With Google Sketchup, you can locate, download, and build 3-D models of just about any kind of background, from a library interior to a cathedral exterior, or from a bicycle to a Humvee, and customize it however you need. You can move things around to the exact angle and perspective you need, hit Print, and have a perfect background that you can "light box" for your scenes. But don't tell anybody that we discussed this, okay? Sketchup is one of the biggest behind-the-scenes secrets of today's comic book pencilers. In fact, in a later chapter I'll take you through a tutorial for Google Sketchup; that's how important I think this is.

Perspective is an important tool for storytelling as seen in this page layout.

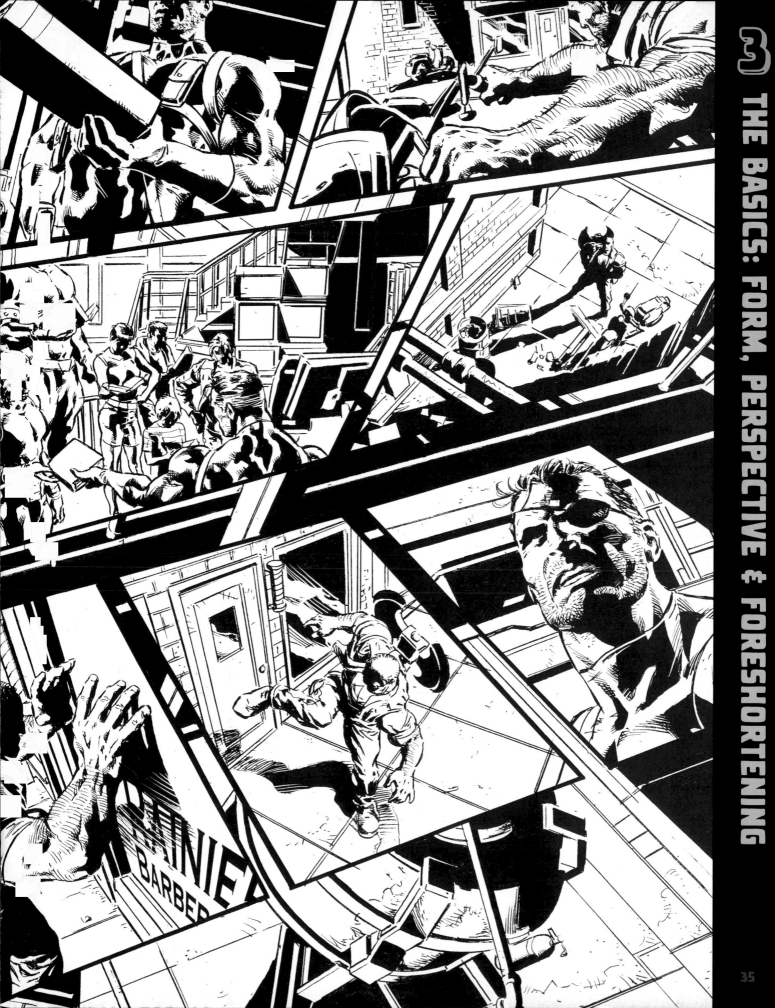

THE FOUNDATIONS OF FORM

Now that we've got the basics out of the way, let's move on to some art, since this is a book for artists! Here I go, giving away more secrets!

From the time we're infants, we learn about shapes and sizes. We're given all sorts of toys that help us to understand spatial relationships. People learn—well, at least some of us do—to put square pegs into square holes, round pegs into round holes, and so on. As we become toddlers, we recognize shapes and shadows in ways we can describe to others. By the time we're old enough to be in school, we learn about measurements and such things as *length* ("How long is that?"), *width* ("How wide is that?"), and *depth* ("How thick is that?").

As a result, all of us can draw a square. Or a circle. Or an oval. Or a rectangle. You get the idea. It's like the foundation of a house—the load-bearing part that has to be sturdy and strong. The homebuilder gets that part right, then moves on to the next step of constructing the house.

The next step for an artist, of course, is making those simple forms into something that has *dimension*. Today's theaters are chock-full of 3-D movies, so we're more aware of three-dimensional form (depth) than

probably any other viewers in history. Let's use some of that thinking to examine giving objects proper form.

Do you prefer your pillow to be flat or fluffy? How about clouds? What's better for the tires on your car, motorcycle, or bicycle? Flat or filled? And while a flat-screen TV or computer monitor today may be infinitely preferable to those fat, heavy, cathode-ray-tube TVs of the last century, they're not truly flat. They have length ("Hey! I want that 52-incher for my den!") and width ("Will it fit into my TV cabinet?") and depth ("It's only 1½ inches thick!"). Remember those three things, and you are remembering *form*.

When drawing anything, think about those three dimensions. Don't go for flat. Think about an object from all sides so that you understand how it comes together. You'll be surprised to find that most of the things around you (which, of course, means all the stuff the comic book artist has to draw) are actually pretty basic shapes. So if you're just learning all this—walking before you can run, running before you can fly—each step builds on the last

so that you can become the kind of comic book artist you already admire!

Realize that a circle can easily become an orange or a basketball or an apple. A couple of circles, a rectangle or two, and the shape of a blackboard eraser form the secret shapes of an automobile or a building. A basic box and three rectangles become a chair. A simple cylinder becomes a drinking glass or a table lamp or a pipe. Circles and a rectangle transform into a jeepney. A regular rectangle transforms into a computer or a television.

Pretty easy, don'tcha think? Toldja anybody can do this! This all goes to show ya that most things around you are based on three essential geometric shapes: the circle (or sphere), the square (or cube), and the cylinder. Even a human being! Yup, it's true. And I'll even show you (because after all we've been through, you still doubt me). With the help of cartoonist and animator Tina Francisco, let's look at some practical examples.

An oval is just a circle stretched out and best fits the shape of the human head. This is the primary shape to use when drawing a person's head and provides an ideal starting ground for all varieties of people.

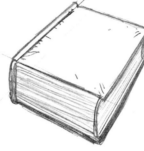

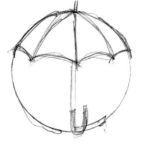

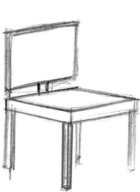

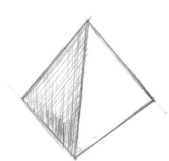

The basic shape of the triangle head-on is flat with only three sides, but when shown in perspective, depth is created and a pyramid that has four sides to it is formed.

This may look like a simple circle, and it is; but notice how it becomes the basic building block for other objects, such as a basketball, an umbrella, or even an apple. Start to observe certain objects around you and you'll notice a basic shape that fits best to what you're observing.

It may look like a simple square, but once used in variations, it becomes any object imaginable. Adjusting measurements and adding complex shapes can turn a square into a cube, old book, chair, or even a car.

What looks like two circles (or more accurately here, two ovals) joined by two straight lines is what makes the shape of a cylinder. Again, when you add more shapes and lines to basic objects, they take on a whole new life of their own. A lamp, mug, and space gun have little in common, but the underlying structure for these objects shares the cylinder shape.

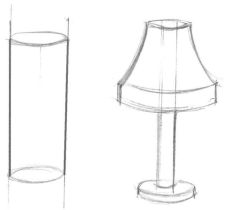

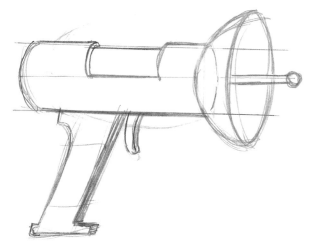

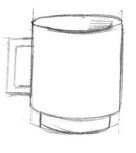

Here's a clever creature based on a walrus, but he's also based on a series of circles and cylinders. So in real life, human beings are about 60 percent water, and we're essentially made up of oxygen, carbon, hydrogen, nitrogen, calcium, unstable molecules—oops, skip that last part. Meanwhile, in illustration, human beings are made up of circles, cubes, and cylinders! (See? I promised I'd show you!)

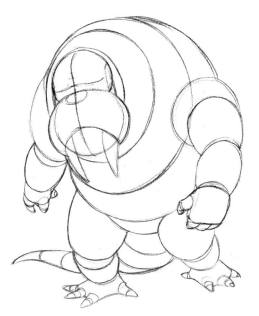

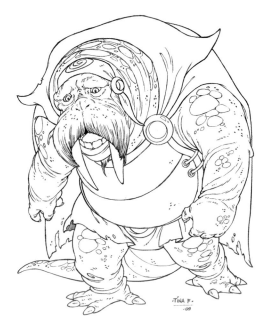

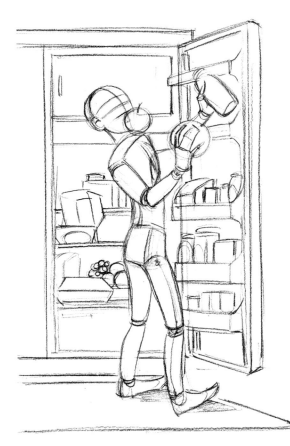

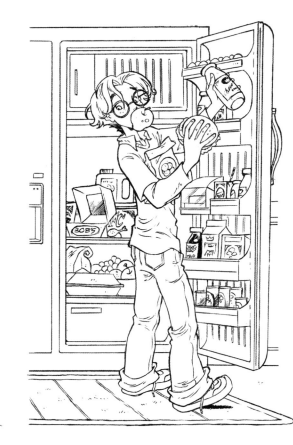

Here's a hungry young boy raiding the refrigerator. As you can tell, the boy is a sphere, a couple of box shapes, and a series of cylinders. Likewise, the tasty foods in the refrigerator door are essentially cubes, with a sphere and circle thrown in for variety's sake.

Here's a scoundrel with a suitably unpleasant weapon made of cylinders and a sphere or two.

This guy's a rocket scientist in "regular Dad" mode. Beneath his fatherlike figure are two box shapes and a collection of cylinders. Even his head is primarily a cylinder with the sides sanded down. Now you know what the well-constructed cylinder man wears on his day off!

Also notice that making an object seem real, or at least dimensional, involves adding shadows to give shape and contour to each object. Grab a lamp off somebody's desk and play with light sources on objects around your drawing area. You'll be surprised at how different, how solid, how dimensional everyday objects look with a dramatic light source!

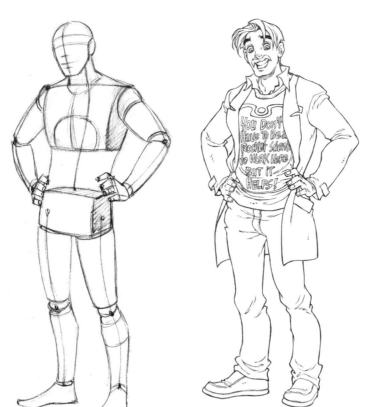

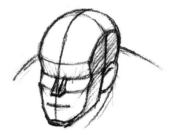

Tina's own creation, a tantalizing teen temptress known for her mixed-up magic and wide-eyed witchery. Several cylinders, a few swift spheres, and . . . voilà! She's boarding her broomstick in no time!

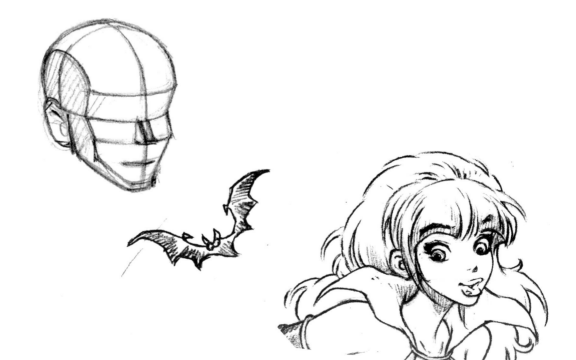

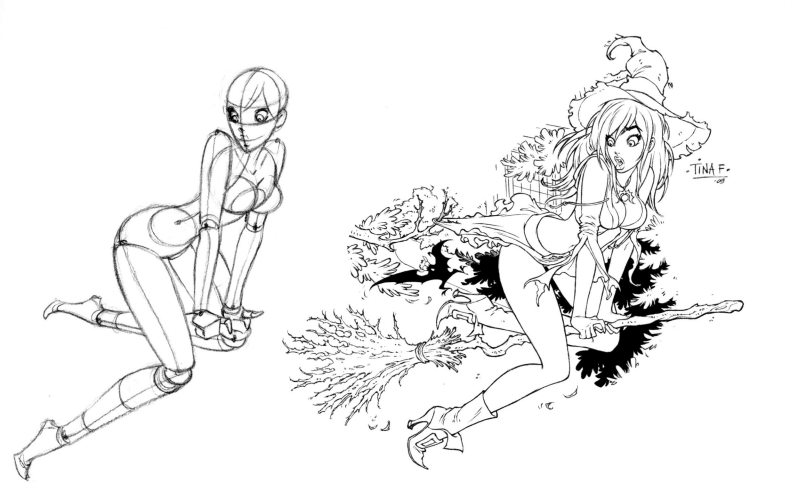

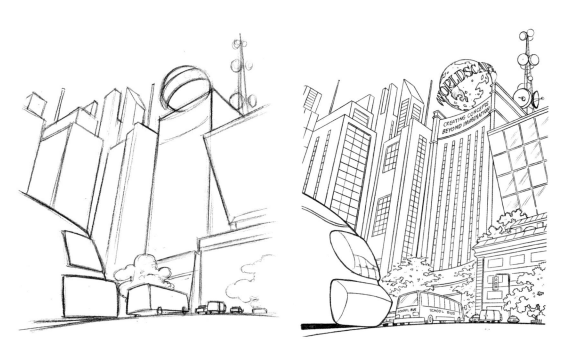

Note how this fish-eye-lens view of a street and building complex is achieved through basic cubes—in this case, rectangles for buildings.

THE POWER OF PERSPECTIVE

Don't worry, the fun part of drawing comics is just over the horizon. But first, you have to learn what a *horizon line* is! If you're looking out at a scene, any scene, from your bedroom window, looking straight out at your eye level, that's the horizon line. The same goes for staring out your car window or gazing out over some dewy meadow or peering down a subway track.

And see the way those tracks disappear into the distance? The point at which they seem to converge is what's called a *vanishing point*. That's perspective.

If something's at your *eye level*, the elements in a scene are right at the same level as your eyes. But, where *are* your eyes? Other than in your head, I mean. An artist can choose to make the eye level down where characters' knees are. Or their

heads. Or their waists. There are other angles to consider, as well. A bird's-eye view is a high angle, looking down. A worm's-eye view, as you might suspect, is a low angle, looking up. Are you with me so far?

A lot of aspiring artists seem to stumble over the different points of perspective. But you needn't worry. There are three types worth talking about: one-point perspective, two-point perspective, and three-point

perspective. Master these, and you can draw practically any scene.

In one-point perspective, all parallel lines converge on the horizon. In two-point perspective, lines carry out to two separate points outside the picture plane. With three-point perspective, an added third vanishing point gives the optical illusion of looking up or down at an object.

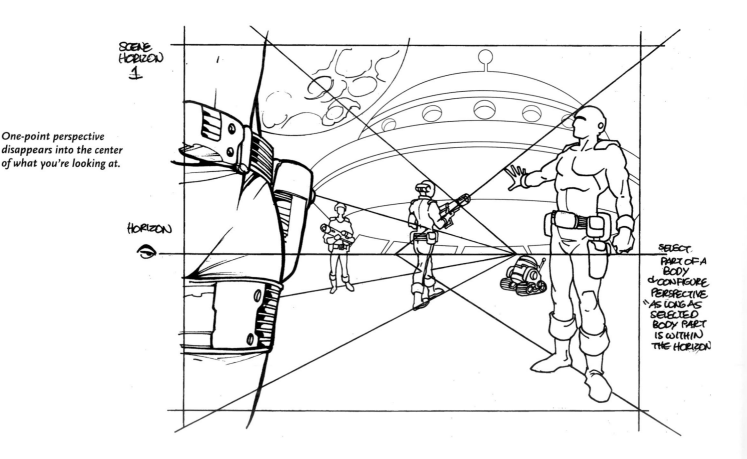

One-point perspective disappears into the center of what you're looking at.

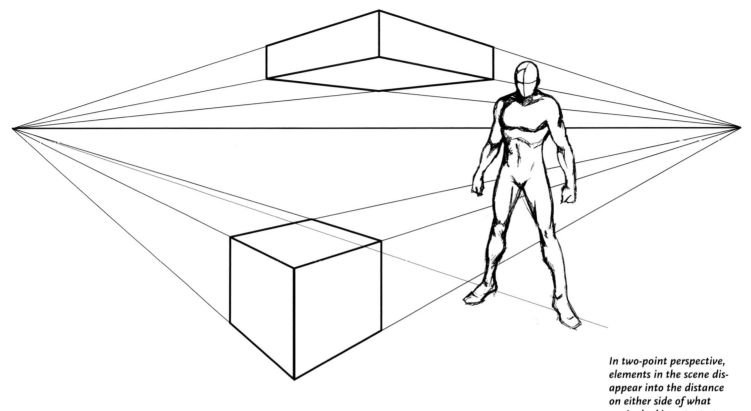

In two-point perspective, elements in the scene disappear into the distance on either side of what you're looking at—to two separate vanishing points.

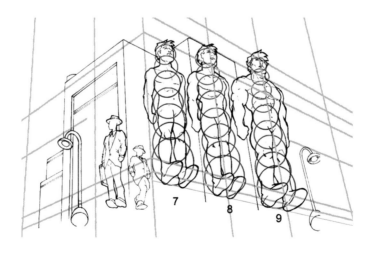

7

8

9

In three-point perspective, elements in the scene disappear on either side and into some point toward the center. (This particular drawing is also a worm's-eye view.)

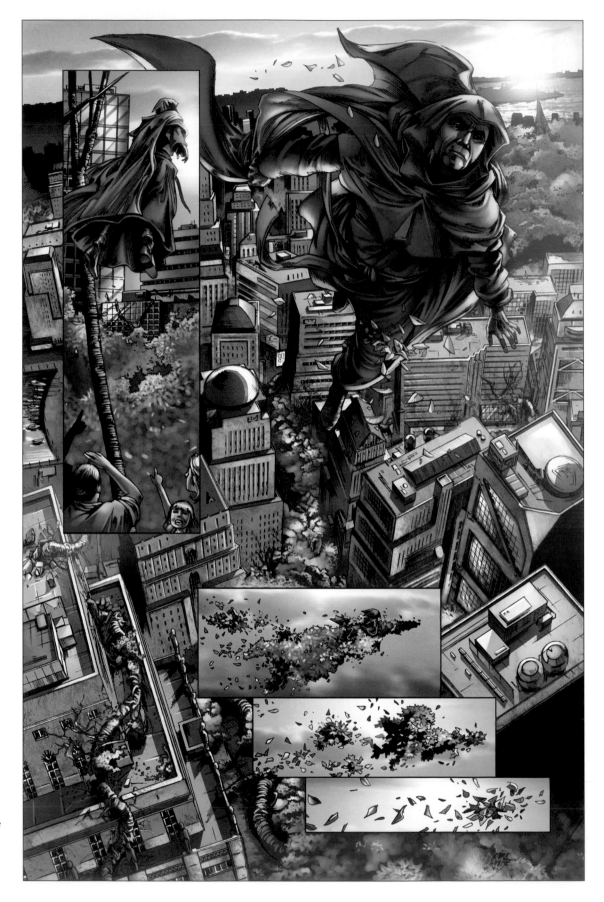

This powerful use of perspective by Jonathan Lau is emphasized by the character's position and the leaves around him in relationship to the surrounding buildings. Notice, too, the deliberate fish-eye perspective working its way upward from the bottom. Majorly dramatic and action packed!

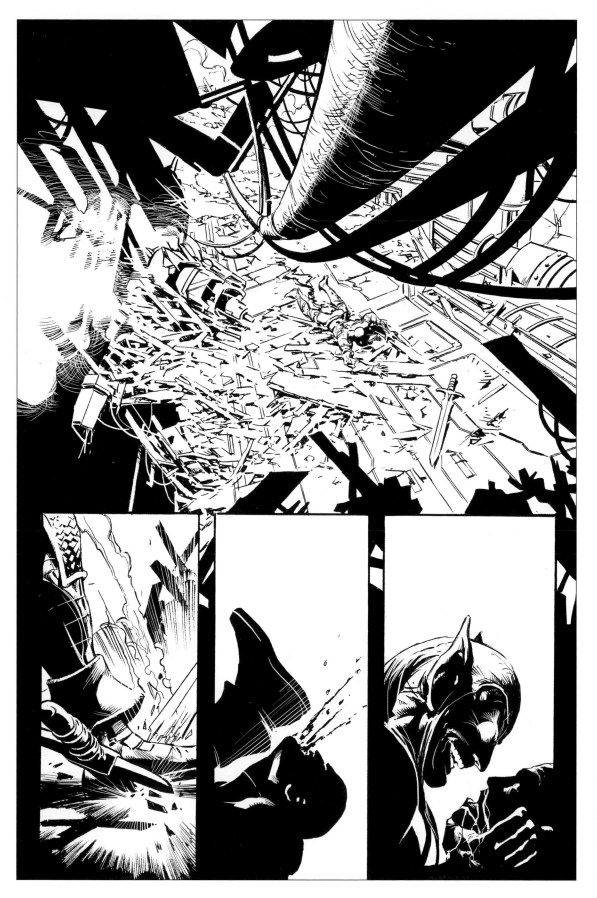

Even straightforward one-point perspective doesn't have to look exactly straightforward—if you plan it well. Just take a look at this senses-shattering shot down a long, wrecked corridor moments after some mighty mayhem!

This is an easy one to learn. If something is a straight-on shot like this, pick your eye level—in this case, the characters' necks. No matter how far you go back into the distance, every neck will fall on that same horizon line.

If you pick the waist of every character as the horizon line and some characters are sitting down, the horizon line will touch their chins. Easy stuff!

As elaborate as this double-page spread from artist Al Rio is, it nonetheless shows simple one-point perspective. Look closely at the characters' knees. Notice how, whether they're in the foreground (the woman in the dress), the middle ground (the man and woman), or the background (the man closest to the wall), all their knees fall in the same area. This is because the knees in this shot are at the reader's eye level. If there were no walls behind that guy at the far end of the room, no matter how far back you'd look into the horizon, the knees of every character standing would fall at the same level. If they were sitting, the horizon line (the eye level) would fall slightly below chest level.

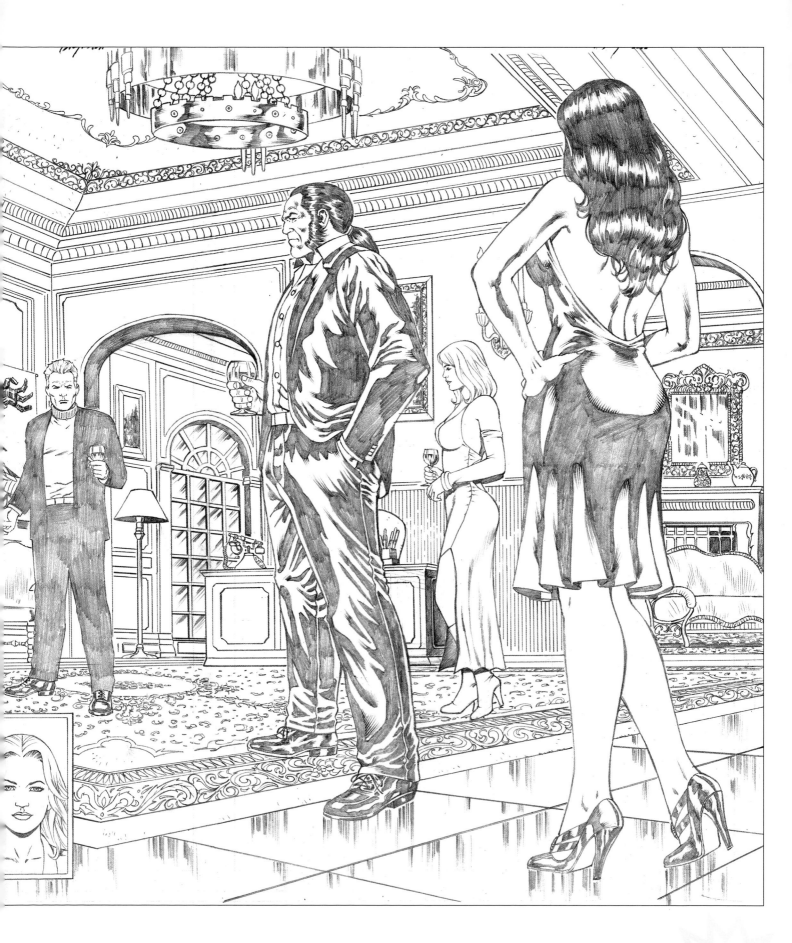

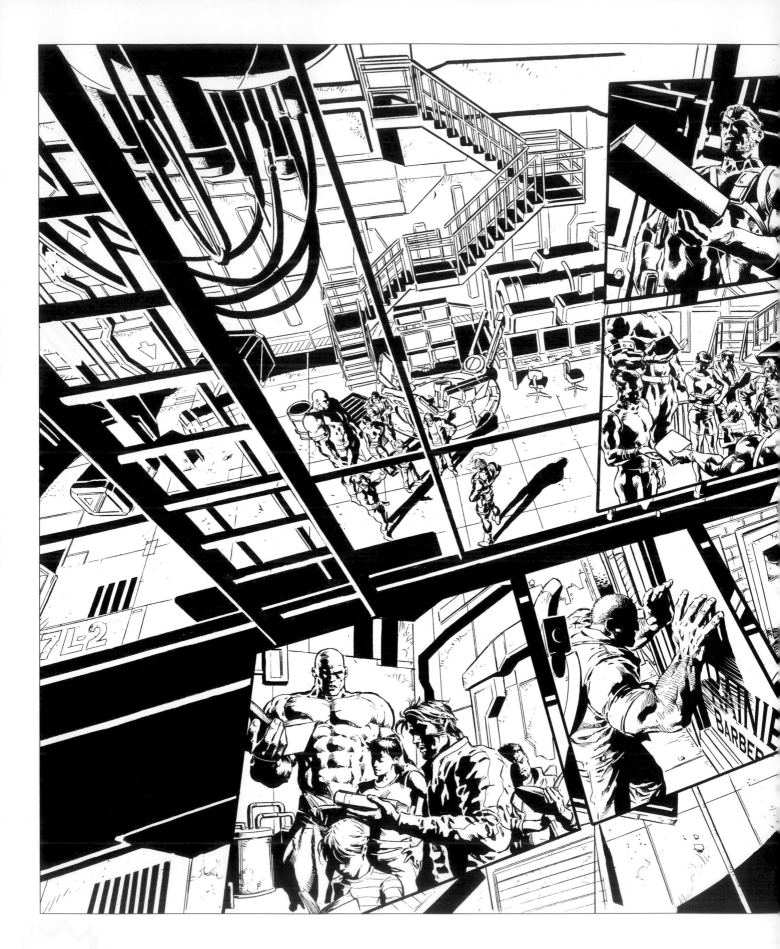

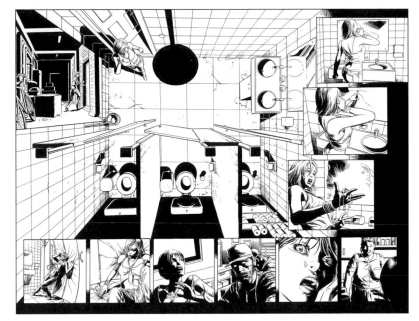

Who'd have thought anyone could draw a down shot of a public restroom with such detail, drama, and panache? Despite the powerful, extreme angle, the big panel makes use of simple one-point perspective. (For that matter, so does the small panel 1 in the upper left corner.) Think that kind of shot is simply a happy accident? Think again!

Learn the power of perspective and you can conjure up breathtaking shots like this: sensational stairways, hanging wires, ladders, computer stations, people, shadows, lighting fixtures, multiple levels—all of it in perspective!

WHEN PERSPECTIVE GOES WRONG

Things can go very wrong if you mix up your perspective in a panel or don't bother to draw proper perspective in the first place. Compare these two examples—one wrong, one right—that artist Aaron Campbell provided as a teaching exercise.

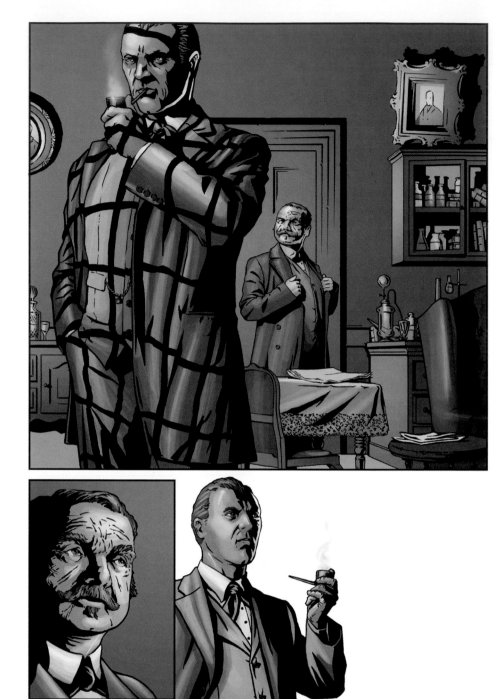

Take a look at panel 1. At first, all seems well: a big establishing shot of Sherlock Holmes with Dr. Watson in Holmes's flat at 221B Baker Street. But look closely. Is Holmes over seven feet tall? Or is Watson a midget? The problem is improper perspective. The reader's eye level is at Holmes's chest (at the point of his raised elbow), meaning the chest of every character behind him should be at that same level.

What's more, the background shows three different perspectives! In the middle ground, the flat surfaces of the end table, chair, and reading table all tilt toward us. In the background, the sideboard with decanter and the door frame are flat, in proper perspective. And yet, the tops of the desk at right with Watson's apothecary items and the cabinet above it both tilt away from us.

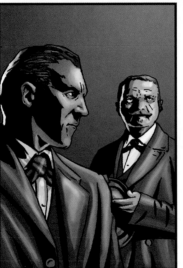

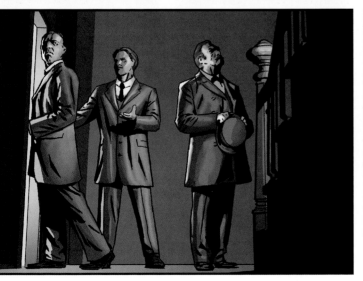

Just so you're not left with the wrong idea, check out panel 4 here. In this shot of Holmes and Watson, the reader's eye level is at Holmes's nose. Watson's nose falls on the same level. Obviously, this is proper, straight-on perspective.

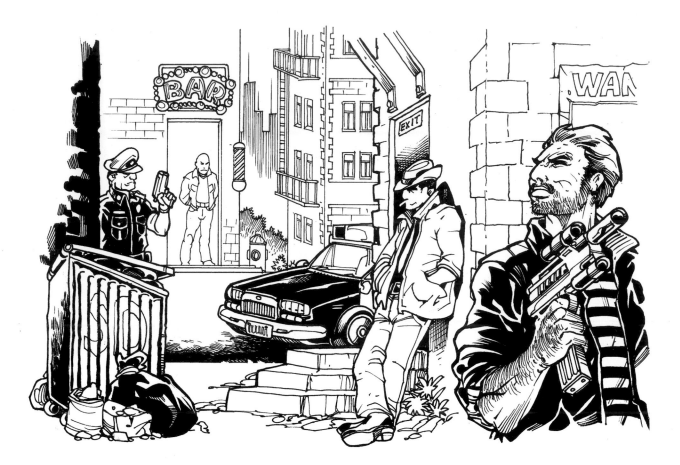

This shot is a perfect example of imperfection: Here, the foreground character is clearly in one straight-on perspective, while the garbage bin is in another, the exit door in another, the car and building in another, and the bar entrance in yet another! Still not sure you see it? Keep looking.

Here's another perspective misstep. This artist is clearly exhausted by all this talk about perspective. See for yourself what errors occur in this panel.

PERSPECTIVE GRIDS

Once you master the power of perspective, I grant you permission to sneak a shortcut when you need it. Just as mathematicians can comfortably use a calculator once they've learned to do it by themselves, so too can you use perspective grids!

Perspective grids look much like these pictured here—just printed on clear plastic. They're available at specialty stores that cater to architects. Canny comic book artists slide them under drawings they're working on, while using a light box, and have perfect perspective guides immediately. As these grids show, drawing proper perspective is mostly a matter of looking to see where things disappear into the horizon. Whether you find it easy or hard is just a matter of . . . perspective!

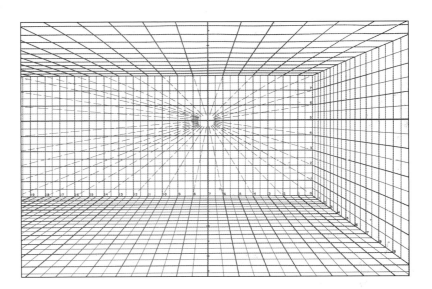

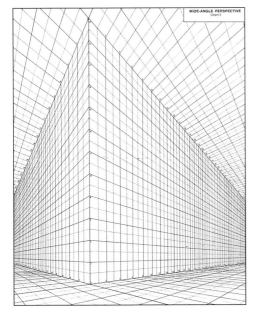

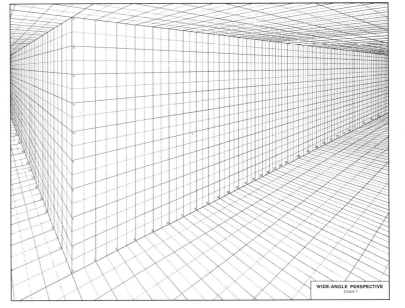

FANTASTIC FORESHORTENING

What can I say about the fantastic subject of foreshortening that I haven't already covered in the previous section on perspective? After all, isn't foreshortening merely the knack of drawing your figures in perspective? Turns out, I can say quite a lot, actually, but the most important part for the comic book artist is this: It makes your drawings more exciting. Thank you, and good night.

Okay, okay, you're not through with me that easily. So let me show you what I mean. Take the illustrations below of an angry chap throwing a punch in our general direction. In the first version at left, his right arm and fist look pretty much like they would in real life if you posed yourself in a mirror or had a friend in front of you. Powerful enough, and

it would hurt plenty in real life if it connected, but it's hardly dramatic. In the second version, although *most* of the body looks the same as before, the differences in his *right arm and fist* are absolutely amazing. They're big. They're bold. And they almost make you wanna duck out of the way—just in case! That's what foreshortening does.

It isn't always that obvious, of course. But *rarely* do you see a drawing in which something isn't exaggerated, just a little, to get that extra effect. (Remember how we talked about drawing the human body as cylinders and cubes? Try thinking of it this way: At nearly every point, those cylinders and squares are either angled facing *toward* or *away* from you.)

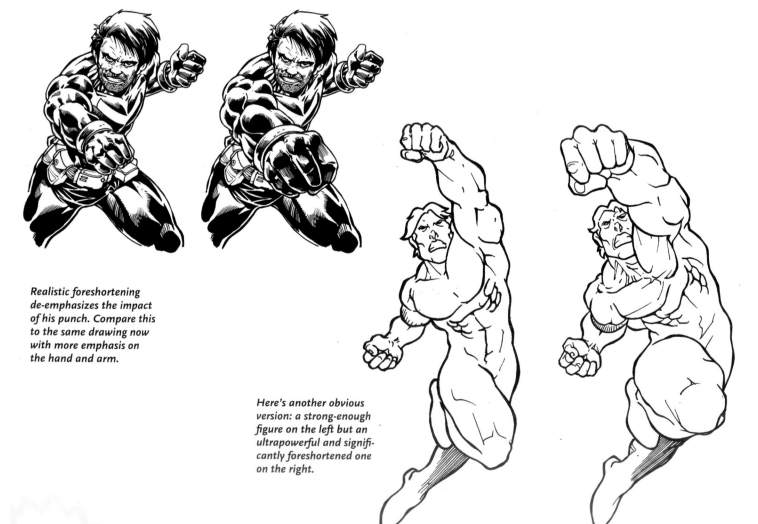

Realistic foreshortening de-emphasizes the impact of his punch. Compare this to the same drawing now with more emphasis on the hand and arm.

Here's another obvious version: a strong-enough figure on the left but an ultrapowerful and significantly foreshortened one on the right.

Take a look at this guy. He's out to grab someone—with major foreshortening in evidence—and ruin his day!

FORESHORTENING IN SCENES

Some good stuff . . . yet worked into the overall design of a brilliant comic book page, foreshortening can deliver even more visual oomph!

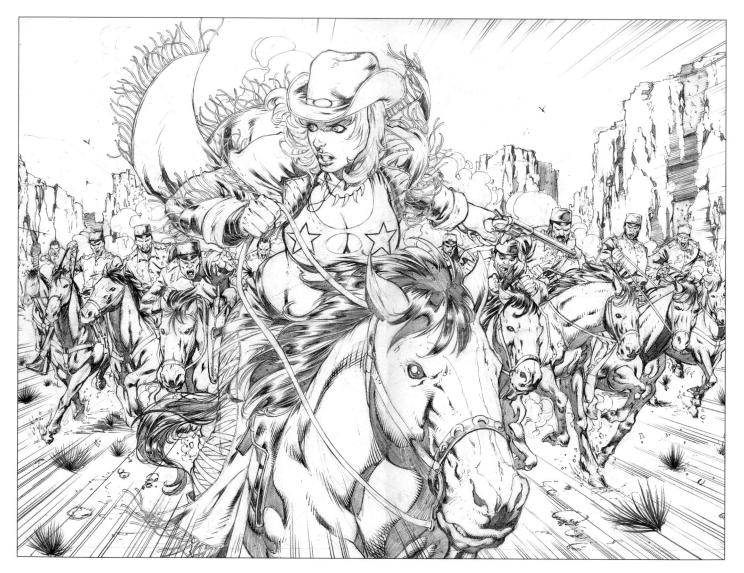

The exciting visuals in this image evoke a real sense of speed through the foreshortening of the lead horse's face. It's as if the main character and her horse are leaping off the page.

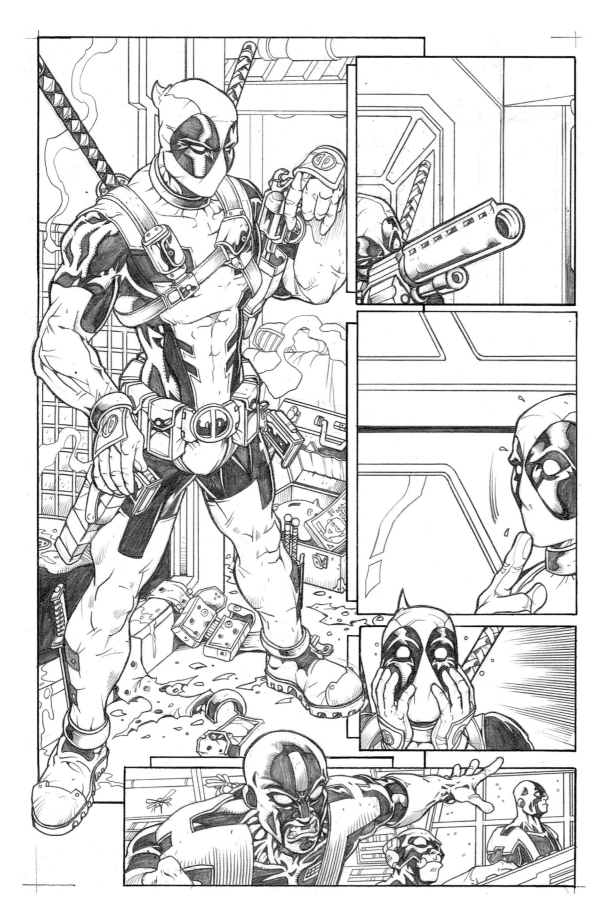

Not every bit of fore-shortening has to be in-your-face dramatic, because if everything is over-the-top, then nothing is—since the baseline is too high. This first panel from an issue of Deadpool is slightly, perfectly foreshortened from head to toe.

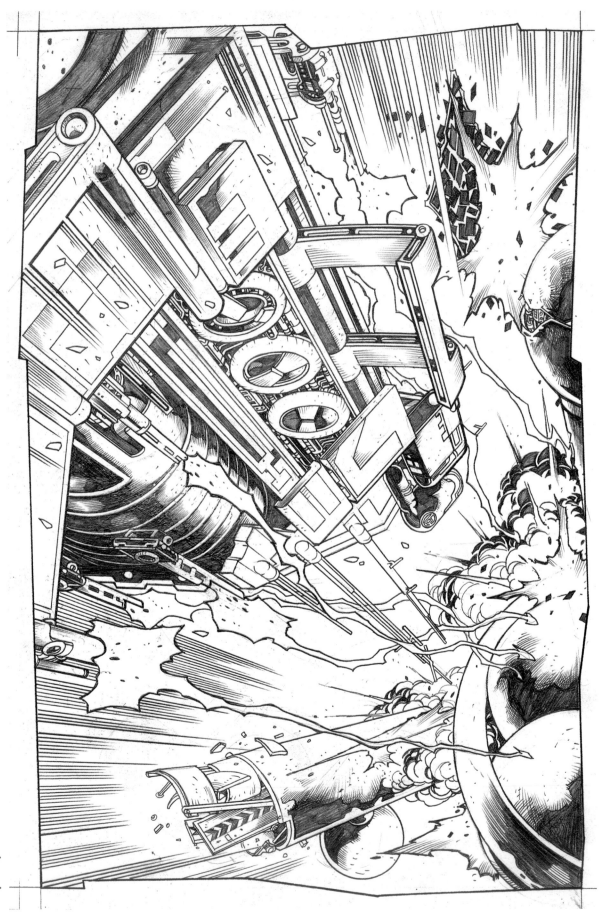

Whoa! That's definitely some fine foreshortening at work—a battle cruiser with guns blazing! How ever can we top that? . . .

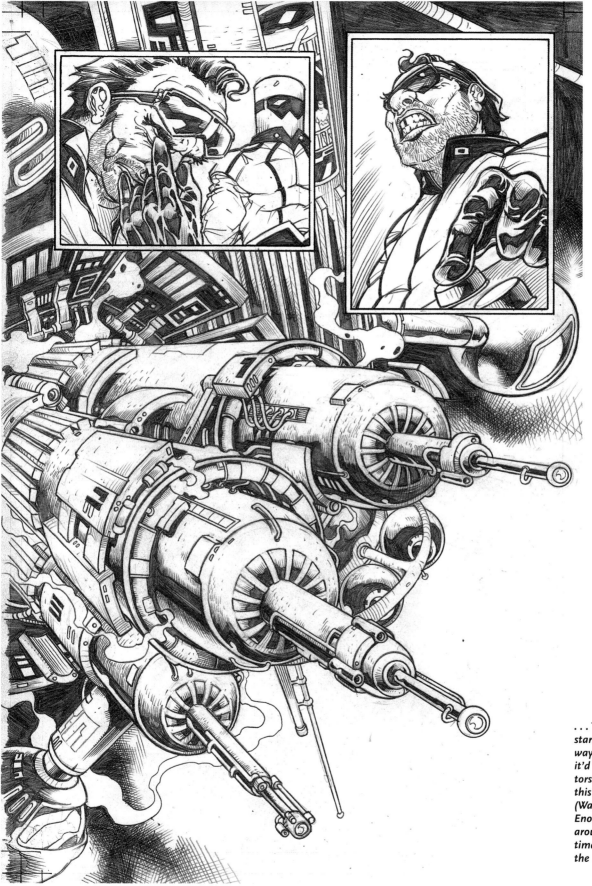

. . . That's *how! Massive starship spires thrust our way in such thrilling 3-D it'd make Hollywood directors jealous! Somebody get this Bong Dazo guy a book! (Wait, he already has one!) Enough to wrap your head around? Then, of course, it's time for us to learn to draw the human head!*

Expressions are more powerful than words themselves in getting the point across to the reader.

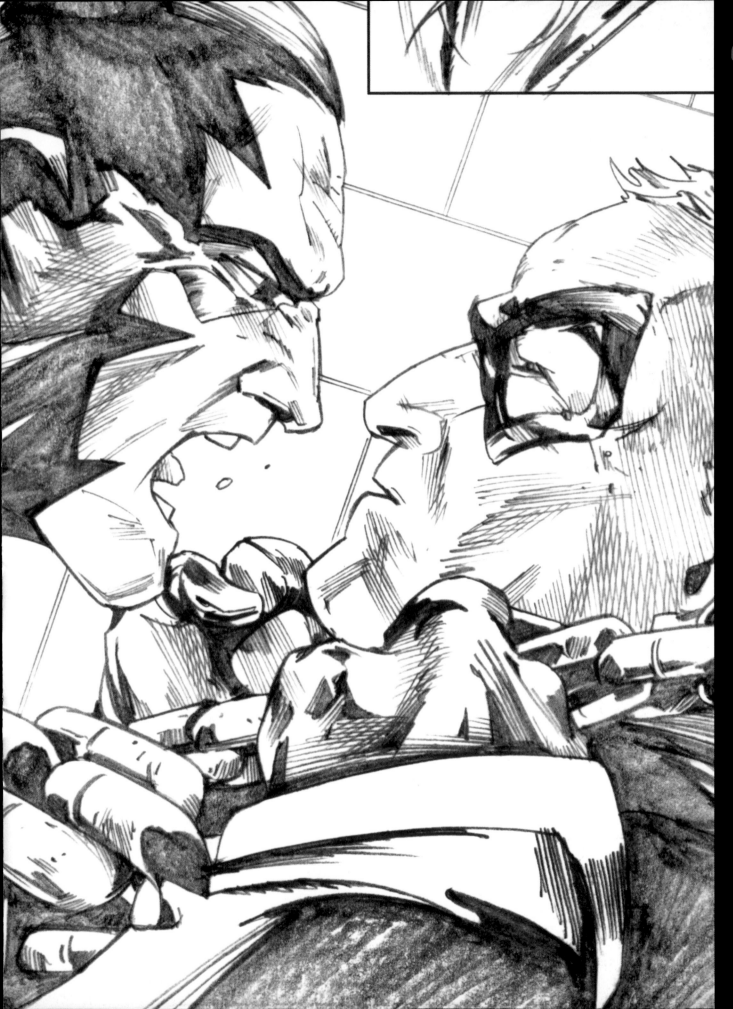

THE BASICS

Practically everybody can draw heads and faces: Make a circle with a couple of dots and a line, and anyone who sees it will acknowledge that it's a basic face. Give a pen and paper to a four-year-old child, and she'll amaze you with the wealth of detail she'll put into drawing her family—not just eyes and noses and mouths, but hair and eyebrows and eyelashes and glasses with nose pads and earrings and other details. These details may not all be accurate, but they're wonderful because they are filtered through memory and imagination. Children are sponges of information. And they never stop learning.

DRAWING THE FEMALE HEAD-FRONT

Faces, in some ways, are the easiest thing to draw and also the hardest. They're the easiest in that references are all around you—some six *billion* of them. That's a lot of eyes, ears, noses, mouths, chins, dimples, and hairstyles to spark your imagination! They can also be the hardest thing to draw if you don't understand the basics.

For example, if you draw an oval to start a quick face, where do you put the eyes? The uninitiated might put them about one-third of the way down the oval. But did you know the eyes go in the *middle* of the head? Yup, that's right, the middle! Measure it for yourself with your own hand, chin to the middle of your eye;

Starting out! Kids show an amazing attention to detail in their artwork.

now move your hand up, middle of your eye to the top of your head. It's the same distance! While you're still reeling from that tidbit, let's try some front-view sketches. Little kids always draw front views first, so why should we let them have all the fun?

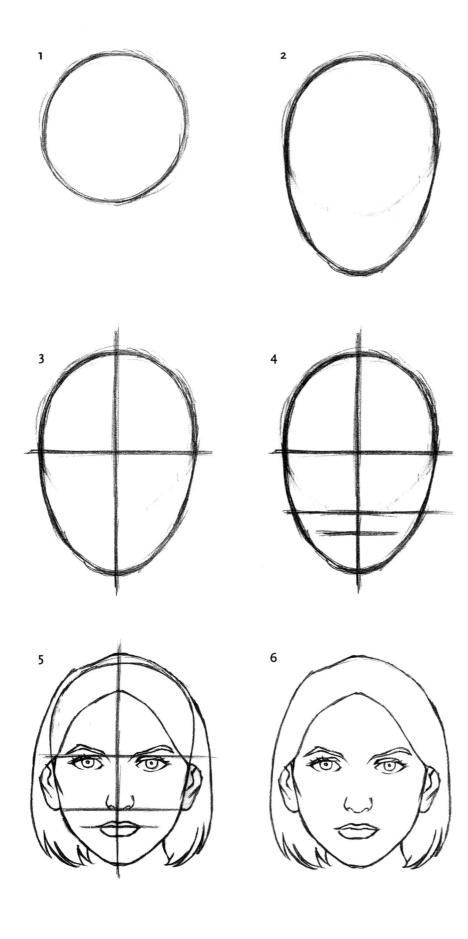

1. *Start with a circle.*

2. *Add on to the bottom of the circle until it becomes a soft oval.*

3. *Now bisect the oval both horizontally and vertically, essentially into quarters.*

4. *Add a line dividing the bottom half into two and then do it yet again. You've just spaced out the proper proportions for a face!*

5. *From these humble beginnings, add the eyes at the top horizontal line. Your head should be about five eyes wide, with one eye space between the two eyes. Set the nose atop the second horizontal line, and center the lips on the third. Add eyebrows and lashes. Add ears that begin even with the eyebrows. And add hair.*

6. *Congratulations! You have a lovely, basic female face.*

DRAWING THE FEMALE HEAD-PROFILE

Now try it from the side. You can fit the side view essentially into a boxy shape.

When drawing a lovely lady, make sure to keep the features less pronounced than those of a male character.

Start with a circle, and hang a "drunken U" shape off it for the jaw area.

EXTRA TIPS

Think of these pointers as you draw males:

- Chins: The chin makes the man! Heroic figures usually have strong chins—but not exaggerated to the point of humor.
- Hair: Give hair sufficient thickness and body. It shouldn't just lie there like a soaking-wet cat.
- Variety: There are many kinds of men. Don't limit yourself to one head type for heroes or villains or "regular people."

Think of these pointers as you draw females:

- Eyes: Draw eyelashes as a mass, not as individual lashes. Give eyebrows a twist, but don't draw them as merely a curve.
- Noses: Try a cute, upturned look with small nostrils.
- Mouths: Try a pouty, pleasing shape on your heroines, but avoid bow-shaped lips or lips that appear too angular.
- Hair: Lavish some attention on it! Long, short, wild, demure . . . hair can take on a life of its own. Keep it fresh and modern, just like women's clothing styles!

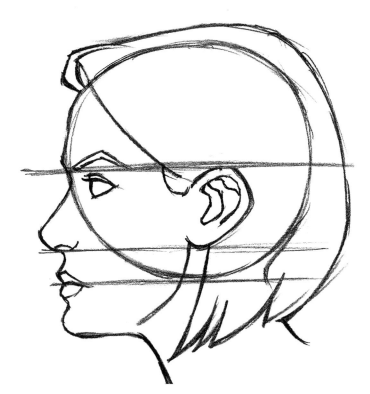

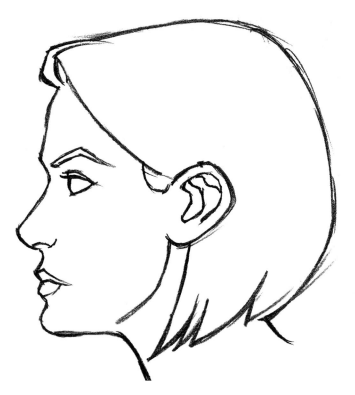

Bisect the circle horizontally. Center the ear within the circle, and start adding other details.

When you're done adding details, erase the guidelines.

FEMALE HAIR

One clever trick is always to keep long hair moving, as if a wind is blowing or a fan is on. This can give life to an otherwise static shot, such as this drawing of a not-so-nice lady.

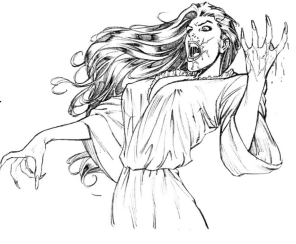

She's ranting and raving but otherwise standing still; yet her hair, caught in the wind, makes a big difference!

DRAWING THE MALE
HEAD–FRONT

Got it? Now let's try drawing a man's face. They say men are less complicated than women . . . shall we see? Circle . . . turn into oval . . . bisect . . . bisect horizontally twice . . . add details.

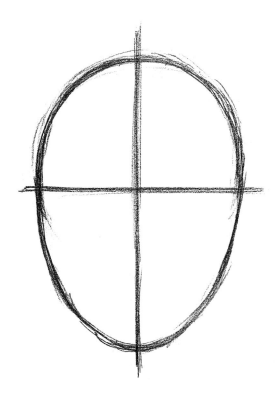

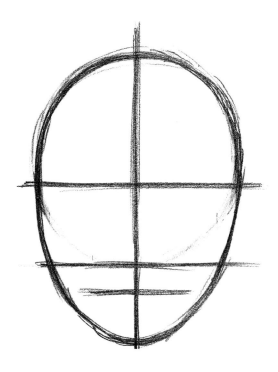

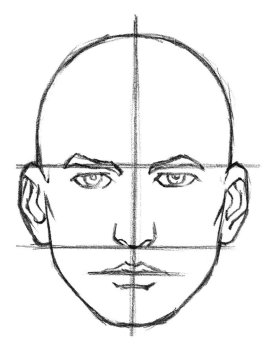

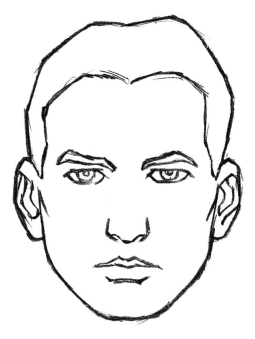

DRAWING THE MALE
HEAD—PROFILE

As you can see, the same basics hold
for the side view of the male head,
too. All the guidelines about spacing
the features are roughly the same
on a man's head as they are on a
woman's head.

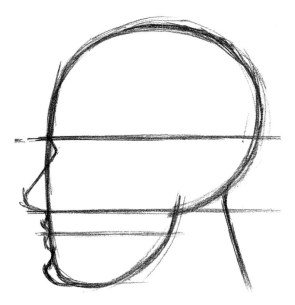

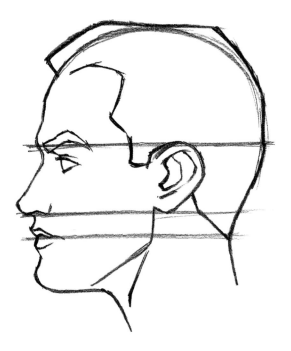

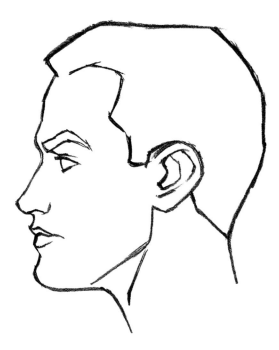

HEAD TYPES

When creating heads, pay attention to volume, making sure that your heads appear three-dimensional and that you understand how to draw them from each and every angle. What's more, although our earlier exercise began with an oval shape for both female and male heads, faces can be essentially any shape: rectangle, pear, pill-shaped, squarish, even shaped like a gourd! Pay attention to the world around you to learn what's possible. Also keep in mind that the more exaggerated you get with these shapes, the more cartoony—or grotesque—your characters become!

Here we have some studies of different types of heads. It's a magnificent—and useful— montage of faces young and old, male and female, beautiful and otherwise!

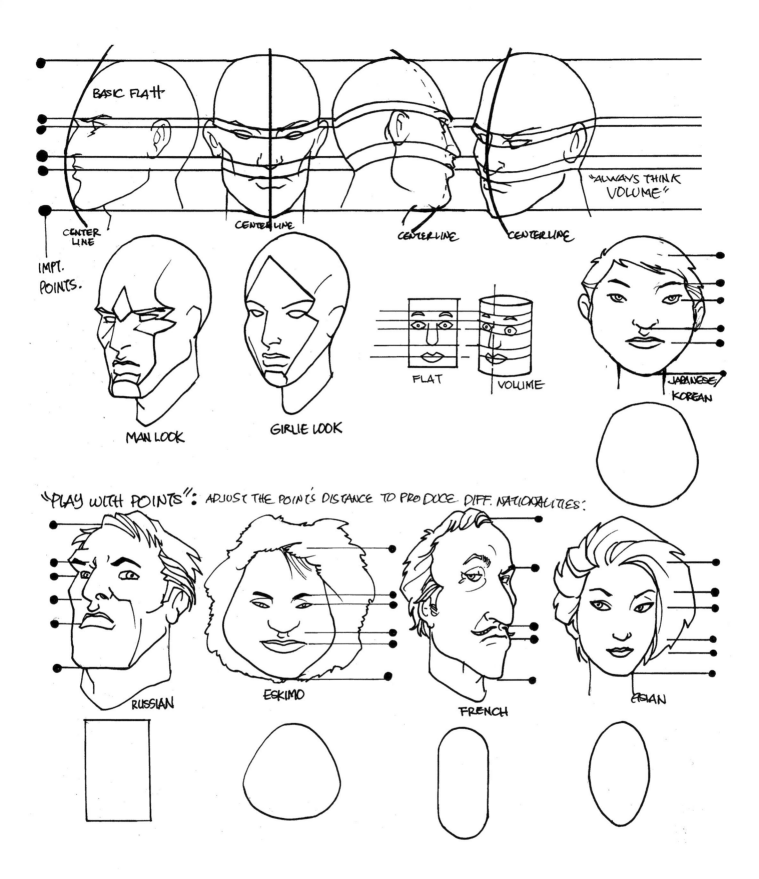

BASIC FLATT

CENTER LINE

CENTERLINE

CENTERLINE

CENTERLINE

"ALWAYS THINK VOLUME"

IMPT. POINTS.

MAN LOOK

GIRLIE LOOK

FLAT

VOLUME

JAPANESE/KOREAN

"PLAY WITH POINTS": ADJUST THE POINT'S DISTANCE TO PRODUCE DIFF. NATIONALITIES:

RUSSIAN

ESKIMO

FRENCH

ASIAN

TILTING THE HEAD

Notice how the shape of the head stays the same no matter what angle you see it from? It's only when you add in guidelines that you can change the angle of the head. Depending on how you curve the lines for the eyes, nose, and mouth, you can show the tilt or direction of the head.

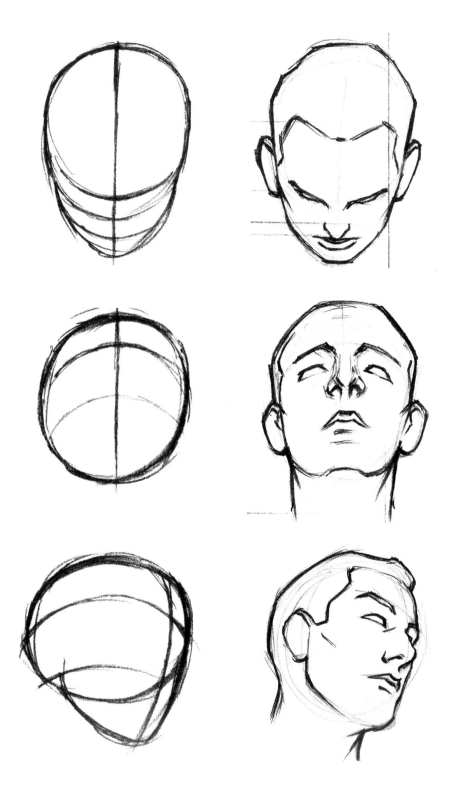

OF MOUTHS AND NOSES

Once you understand the basic principles of drawing the head, you can move on to the details that really make a face into an individual person. Hair type and style, eyes, noses, mouths, chins, age lines, weight—all these things will affect the gender, age, and ethnicity of your characters.

In addition, as you create a face, think about what that face would look like younger or older. Imagine the time you may be called on to draw the character in flashback . . . or in the future. The better you understand the faces you draw, the better you'll be at drawing them at any age, at any angle, and in any necessary, believable expression!

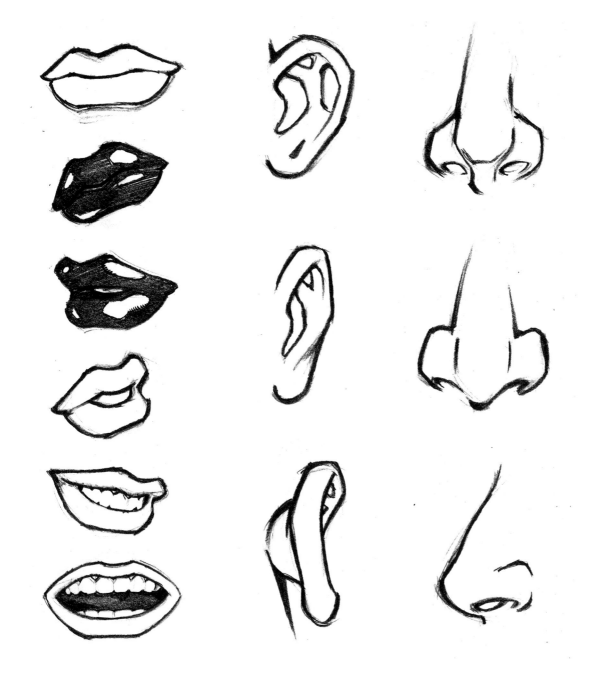

USING REAL LIFE FOR REFERENCE

With so much real-world reference surrounding each and every one of us in our homes, schools, subways, workplaces, coffee shops—and everywhere else!—only a beginner would think that professional artists make up characters' faces entirely out of their own heads. I have to look no further than my own longtime collaborators for proof!

John "Ring-a-Ding" Romita created the looks of many magnificent characters during our long, illustrious run on *The Amazing Spider-Man*. Two of his best-known characters from that classic era are Captain Stacy (the late, lamented Gwen Stacy's late, lamented father) and Mary Jane Watson, who remains Peter Parker's gal after all these years. Take a look.

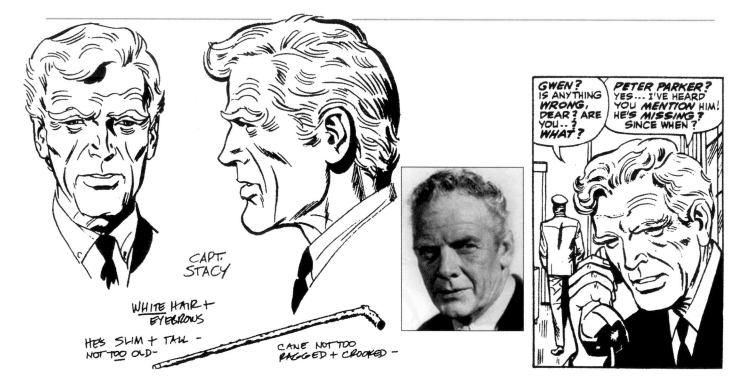

CAPT. STACY

WHITE HAIR + EYEBROWS

HE'S SLIM + TALL — NOT TOO OLD—

CANE NOT TOO RAGGED + CROOKED —

GWEN? IS ANYTHING WRONG, DEAR? ARE YOU..? WHAT?

PETER PARKER? YES... I'VE HEARD YOU MENTION HIM! HE'S MISSING? SINCE WHEN?

Above are Jazzy Johnny's first ever drawings of Captain Stacy and a photograph of actor Charles Bickford. See some similarity? This is because savvy artists like to use real people—friends, enemies, neighbors, family members, actors, actresses— as a starting point for their characters. Not only can they get a true feeling for their expressions from all angles, but they can even pick up body language and nuances of movement—dimples, head tilts when thinking, and so on.

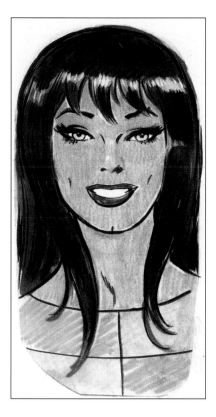

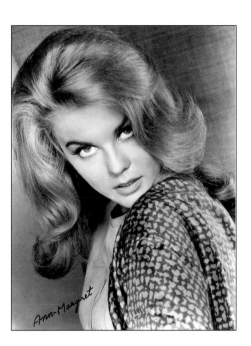

The drawing at far left is John's first color sketch of Mary Jane. Quite a head-turner and decidedly delicious competition for gorgeous Gwen Stacy. MJ's spirit was influenced and embodied by actress Ann-Margret, a sassy, sexy, fiery, young redhead with hullabaloo dance moves and just enough sweetness. John took every single scintilla of that exuberant personality right off the screen. American boys who fell in love with the girl in such movies as Bye Bye Birdie and Viva Las Vegas, in a sense, fell in love with her all over again as the inspiration for the girl under John Romita's pencil and brush. And no, with her triple-flip bangs and rounded chin, MJ didn't end up looking all that much like the actress who inspired her design, but that was never the point. John captured her essence, her vivacity, and her loveliness—and that's what counts!

And as you can also see in the bottom image, Johnny's first-ever depiction of Mary Jane Watson stayed terrifically on-target in her very first introductory panel. "You mean, that's Mary Jane?!!" Was it ever!

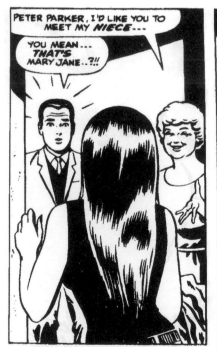

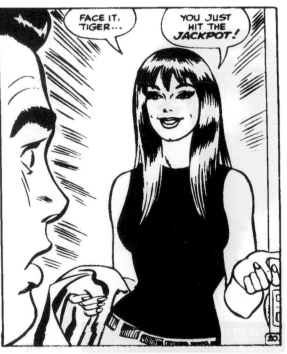

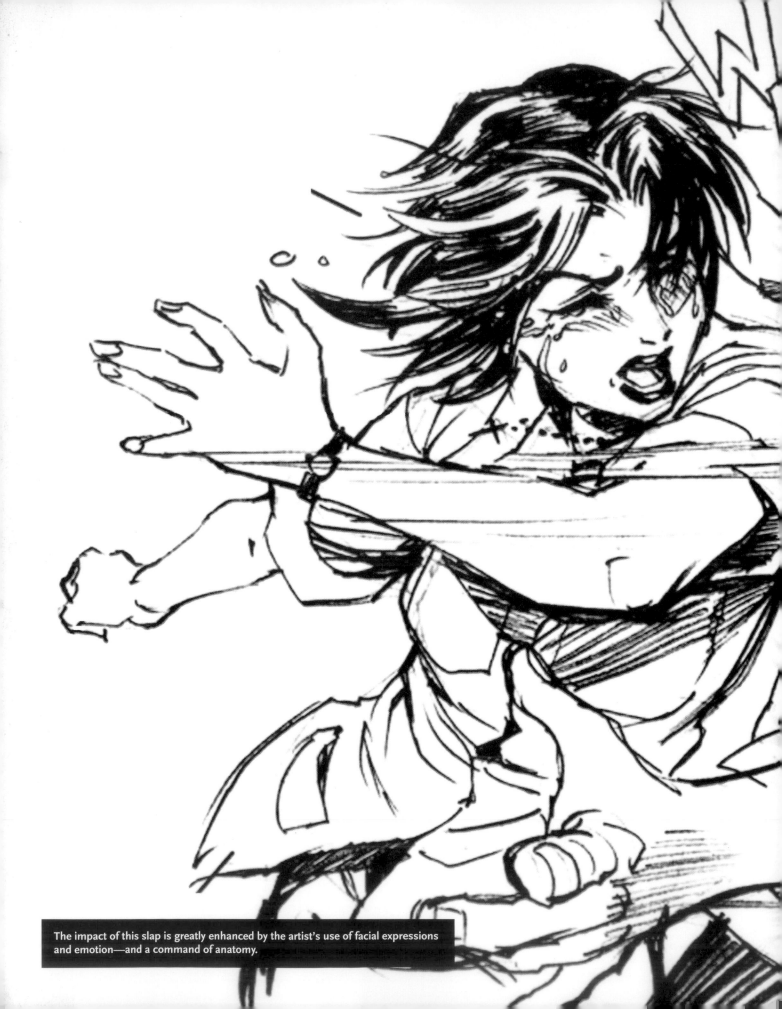

The impact of this slap is greatly enhanced by the artist's use of facial expressions and emotion—and a command of anatomy.

HEADS UP!

Hey, you . . . you're just too darn short! No, no, I didn't get up on the wrong side of the bed and feel like spouting insults. I'm trying to emphasize yet another secret of the comic book: If you draw normal people with normal-people proportions, they will look too short on the comic book page.

The average person is 6½ to 7½ heads high in real life. "Heads?" you ask. Yup, heads. They're the artist's standard of measurement for the human body. Fewer heads tall gives a figure childlike proportions; more heads reaches heroic—or even alien!—proportions. So, let's say a typical 6-footer might be 7 heads high. A really big guy might even reach 8 heads high if you turn to professional sports or if people

cheat and stand on their tip-toes. But in a comic book, filled with heroically built guys and gals, the proportions of what looks "right" are a little bit different. So the comic book artist knows to *adapt* reality.

This is another time when, even if you're using photos for references, you should use your captivating creativity to exaggerate, just as we did in the chapter on foreshortening. A person 6 heads high in real life

would come off looking almost like a Hobbit on a page, so you exaggerate the figure to perhaps 6½ heads high. A person already 6½ or 7 heads high might become 7½ to 7¾ high on a comic book page. And most superheroes, of course, are, fully, 9 heads high—whether they're male or female! (Plus, if you're putting that fabulous femme in sky-high heels to emphasize the length and curves of her lovely legs, she may appear even taller!)

From left to right, this chart shows normal, ideal, and heroic proportions.

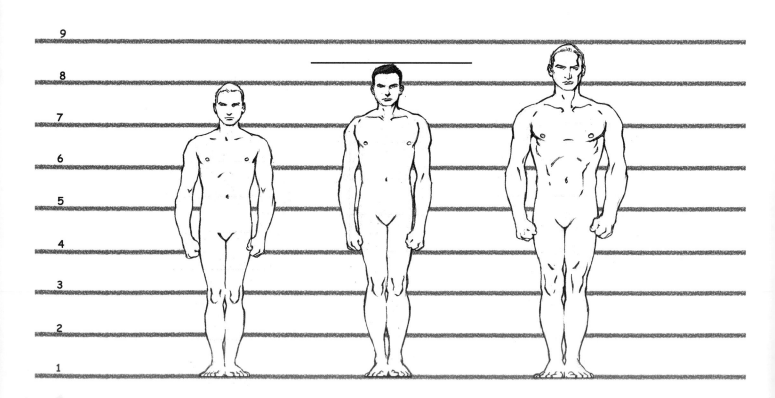

Yes, it's true: Even superheroes have gotten taller in the digital era! During the halcyon days of adventure newspaper strips, *Flash Gordon* was one of the best, remembered for its stellar art by Alex Raymond. He (Flash, not Alex) reached a towering 8½ heads high. Some thirty years ago, superheroes routinely topped out at 8¾ heads high. Just as, in many cases in real life, the next generation of children grow taller than their parents, so does the superhero hit new heights of heroic proportions in twenty-first-century comic books.

The wonderful thing about drawing the human form is that so many variations are still *correct*. Different heights, weights, ages, and general body types are all in evidence on the people we see around us, and those body types should be represented in the anatomy of your characters. An active teen with good structure stands and runs tall, while a very mature person might be, say, stooped over from osteoporosis—two very different anatomies, indeed.

John Romita created this 9-heads-high grid as a figure base for artists to invent their own superhero costumes. It also serves here as a terrific anatomy tutorial. Here you have a powerful, heroic shape, in proper proportion, just waiting for you to hang costume details, musculature, and facial features all over it. Take it, scan it, print it out, blow it up, draw and draw and draw some more! I guarantee you'll make John and me very happy.

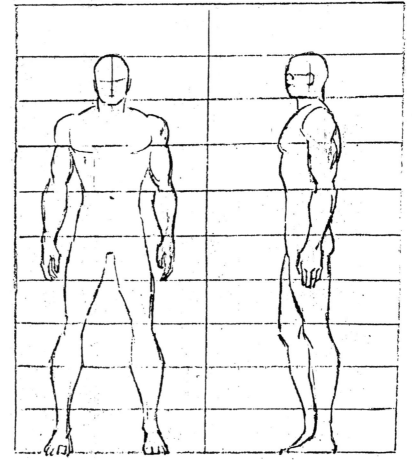

DESIGN COSTUMES FOR CHARACTERS! YOUR OWN HEROES AND VILLAINS, TOO!

MAKIN' IT EASY

Some time ago, when Jazzy Johnny Romita (Senior, not Junior, I might add) was the always-affable art director of mighty Marvel Comics, he created a wonderful example for artistic superstars-in-training—and I think this would be a wonderful place to show it to you.

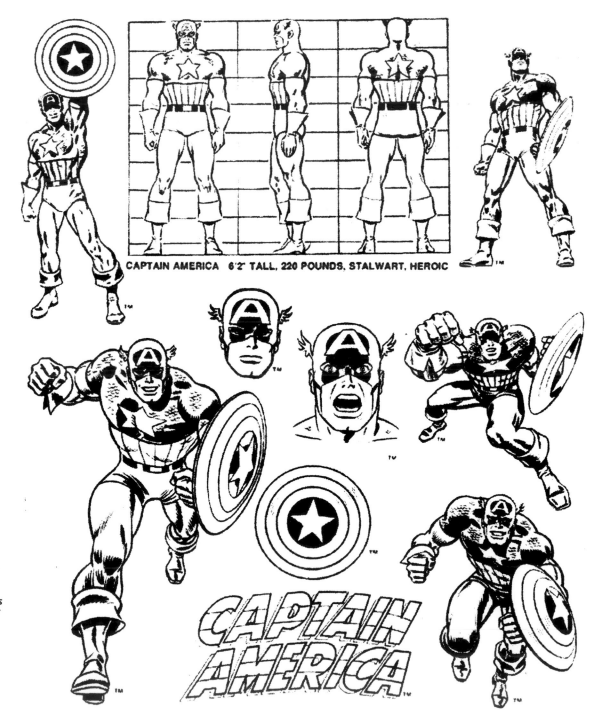

CAPTAIN AMERICA 6'2" TALL, 220 POUNDS, STALWART, HEROIC

This is Johnny's own artistic interpretation of none other than Joe Simon and Jack Kirby's immortal creation Captain America (with some Jack Kirby figures thrown in that Johnny inked). As you can see, Cap is well over 8 heads high here and is about as great an embodiment of the superhero—and the American—ideal as you can possibly get. It's a pretty darn good example of how to do it.

ANATOMICAL ADVICE

With six billion people around, we'll never be short on anatomical reference, right? But even so, perhaps you don't feel secure enough to draw a proper person. That's okay. Let's draw an *improper* one! Create a new character for this moment; we'll call him Doodle Dude. All you need for him is a stick figure. Anyone can draw that! Flesh him out just a little bit with some circles and cylinders, as we did in chapter 3.

Standing! Jumping! Leaping! Sleeping! Loafing! Punching! Snoring! For Doodle Dude, it's all in a day's work. Whether it takes minutes or months, the more you do it—while looking at real people and even artists you admire for your inspiration—the better you'll get at it. Then as you draw more and more, you'll get the hang of it. Your cylinders and spheres can be smoothed out to become recognizable body parts. And before you know it, you have characters moving on the page, much improved upon, but much inspired by, Doodle Dude.

Eventually, Doodle Dude will becomes a memory as you draw more and more from the people who pass your eyes every day, and as he does, keep this in mind: *Each artist has his or her own individualized adaptations of reality when drawing a comic book.* Still, some good things to remember are:

- Don't emphasize muscles on a female! Toned and taut, to be sure, but keep the curves and the sensuality—and vive la difference!
- As in real life, a woman's head is slightly smaller than that of a man, so even at 9 heads high, a female character should still appear proportionately smaller than a male one.
- It looks best if the elbows hit at, or slightly below, the waist and the hands reach mid-thigh.
- Careful when drawing children! They're not really short adults. They're not manga characters, unless your entire book is manga. If you find yourself drawing a manga or mutant child because you don't know how to draw a real one, stop what you're doing and go out and look at some kids.
- All these same rules apply to supervillains, too!
- Well, stand on my head and call me shorty! Just be sure to plan for exceptions to every rule. Some heroes, some villains, some aliens, and some monsters will vary significantly from these standards. Your creativity and imagination are what make your characters amazing, powerful, dramatic. . . and believable!
- Figure drawing doesn't merely mean people and monsters. The real and the comic book worlds alike are populated by animals—horses and chickens and cattle and rats and gerbils and cats and dogs of all breeds. And at some point, you'll be asked to draw 'em! (Just like that artist who said he'd never have to worry about animals because he's just gotten a Superman job . . . and then his very first issue was set on the Kent farm in Kansas. . . .)

ACTION AND ACTING!

As your drawings grow and mature to resemble genuine people on paper, you won't want your people simply standing around page after page as if waiting for their high school prom photos. You'll want them to do something sensational. And for that, the name of the game is *action!*

Comic books are all about visual storytelling. Nobody wants to see headshot after headshot of characters talking. Even the most dynamic dialogue can't completely make up for characters simply sitting around. Certainly, if a writer pens passionate prose that can propel a character through piles of personal problems, the artist can create a clever *performance* to bring that character to life on the page. A performance is *acting*. And since *action* and *acting* come from the same root word—*act*, meaning *do*—your characters should always be *doing* something.

Is a group of characters talking in a kitchen? Have them make pancakes! Set the table! Butter some bread! Pour orange juice! These things are called *theatrical action*. The term comes from actors on stage performing long conversations in plays. In these situations, actors (there's that word *act* again) and their directors make sure their characters *do* something.

Let gravity take part! Swing for the fences! Let the hair fly. Let the hero roar. Let the bad guy feel the burn! See the difference the little details make?

Look at this first drawing by artist Wilson Tortosa (left). The girl slaps the guy, the usual maneuver you see in movies and on TV. It looks pretty genuine. Her body leans forward, her fist is clenched, his face reacts in pain, his body leans away from the slap, and even his hands are sort of pleading. But it's so boring, there oughtta be a law!

Now let's try it the comic book way. Now we're talking! Her facial expression is more dramatic, as tears are flowing. This guy's really gonna get it! (Oh, too late. He already did.) Note her raised shoulders for more power. Her clenched fist is thrust dramatically farther from her body. The lifted hem of her blouse helps emphasize movement and speed. This guy's really on the receiving end of a doozy of a slap! It'll definitely leave a mark. His hair is affected (as is hers), his hands are flailing (and more interestingly foreshortened), he's totally off balance, and there are even bits of blood or spittle coming from his mouth! That's acting. That's action.

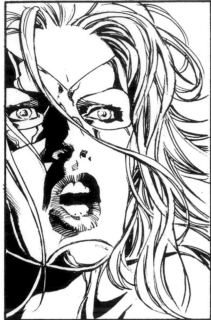 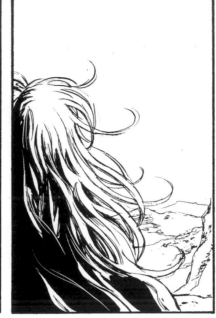

Is a female character just standing and talking? Have the wind blow her hair!

We'll cover this more when we get to the chapter on backgrounds, but for now, keep in mind that your characters will also perform best if the setting they're in—their environment—works in their favor. Two characters talking as they walk down a street is boring. Talking and gesturing as they walk down an interesting street that exudes character brings that panel to life.

In some ways, a comic book character's performance isn't merely about acting. Much like my movie cameos, it's about overacting so that the performance will be indelible in the viewer's mind. So keep this in mind: If it's natural and normal, it will probably appear stiff and dull on the page. If you exaggerate it, it will seem normal.

Try this little experiment: Grab a friend or family member and pretend to argue. (Okay, maybe it's not so hard to pretend, but let's try this anyway.) Notice how you're both positioned. How close are you to the other person? How are your hands positioned? How about the rest of your body? Now try it the comic book way! Invade the other person's personal space. Move your face within inches from theirs. Grab the front of their shirt in your hand and yank 'em even closer. Now both of you yell! See the difference? That's comic book exaggeration, and it will look right on the page.

This concept applies whether the character is in a full scene or not. In the rudimentary superhero drawing at right, Thor wields his hammer while standing on a rock. It's an idea drawn a thousand times by as many artists. Because it's essentially a single-character pinup, not really telling a story, Thor doesn't have anyone with whom he can interact. And this is essentially a drawing as it might be submitted by an artist in the same position as you, learning all about comic books. Some good ideas have been applied: Thor has an angry expression, his cape is blowing, he holds his hammer high, his fist is balled up in anger, and even the rocks are interesting. And yet the overall effect is static, lacking in the level of drama and performance suited to an Asgardian son of Odin.

So how do you make it interesting? Through Thor's acting, of course—his performance, even as a single character alone. Let's study the same setup as drawn by marvelous Mike Deodato, Jr. (opposite). Now that's more like it! Everything that makes comic books great is summed up in this drawing: Thor's upshot angle and the riveting rock lighting define his breathtaking nature as an Asgardian god. His legs are posed far apart for maximum impact. His hammer is raised dramatically above his head to define the height of his wrath. His cape doesn't just blow in the wind; it whips around with wonder and majesty. His expression isn't merely angry; it's furious—a god at war! His muscles are taut, tight, and ready to attack. The foreshortening of the torso, legs, sword-wielding arm, and thrust-back right arm alike show he's primed, powerful, and prepared to explode with all-out action! And that's what comic books do best.

TIPS FOR MAKING THE MOST OF YOUR IMAGINATION

Get the *most* out of every scene, every panel. Make it thrilling for your readers—and for yourself!

Blowin' up something? Use everything you know about explosive drama, smoke, shock waves, and action!

Having a big shootout with a battalion of bad guys? Throw in everything but the kitchen sink—and make it an amazing design, while you're at it!

SEQUENTIAL ACTION AND ACTING

Gettin' the hang of it now? Then let's try a little action in *sequence*! Since nobody did action better than Jack Kirby, check out how much Jolly Jack could squeeze into nine panels. And, of course, emotion (acting) is as critical to comic books as action. If you can't relate to the characters as people, you don't have anyone to empathize with, to cheer for, or to sneer and jeer at.

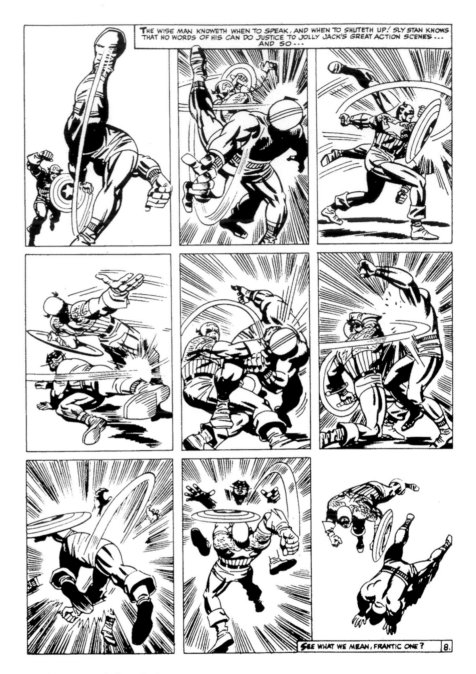

Got it now, true believer? Then let's graduate to sequential acting! Jack Kirby was a master of keeping action readable and flowing. The viewpoint swings in every direction yet always shows clearly what's happening in this battle.

This example is a page drawn by Al Rio. The woman is a sad, foreign wife who cannot get her clueless, patronizing husband to understand that her very soul is being stolen away, bit by bit, by the ever-present cameras that seem to capture our images wherever we go. There's a lovely subtlety of expression and emotion here that makes the character's fears, pain, and sorrow seem all the more real.

Shown in both layout and inked stages, this sequence of panels applies all the concepts we've learned in this section. In this scene, Peter Parker has just returned from being Spider-Man and has removed his mask. In their apartment, Mary Jane has just told Peter some devastating news; now he's so overwhelmed with rage that for a moment he goes berserk, smashing up the room.

Notice how everything's here, even in the rough layout stage: Action. Foreshortening. Perspective. MJ's reaction. Room for dialogue. Peter's anger, his hurt, his torment. Now that's acting!

The god of thunder's golden-blond locks, regal costume, and hammer make him instantly recognizable.

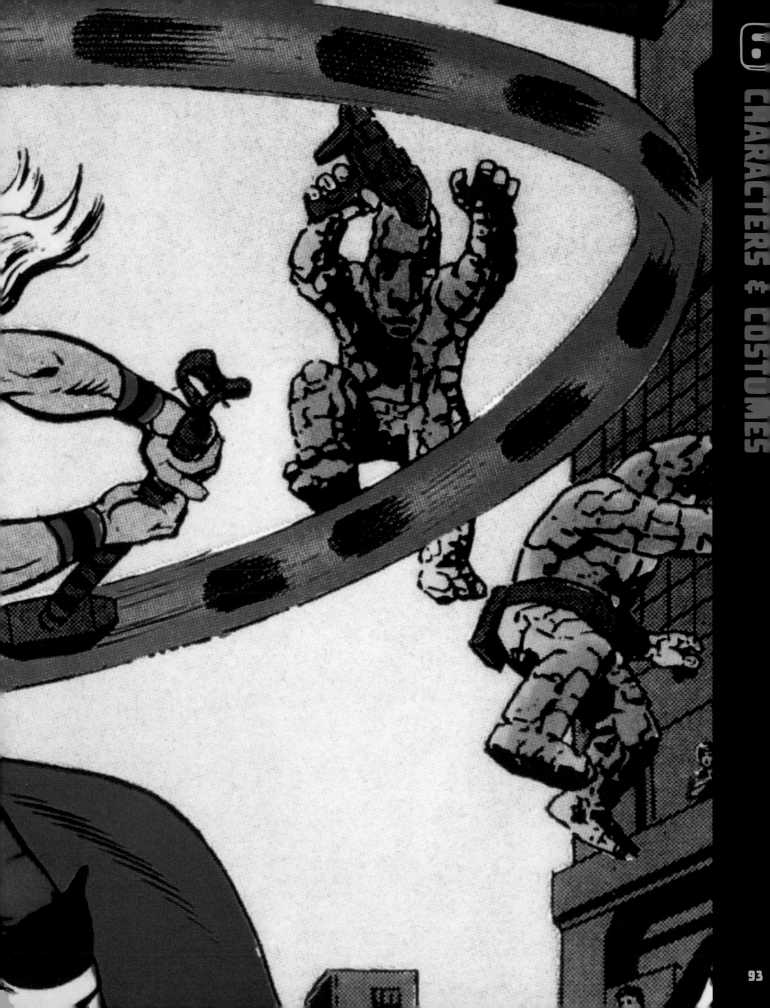

NAMES AND COSTUMES

What's in a name? And how important is a costume design to the success of a character? What's the thought process behind a character's creation? If you call a character Cable, is it because he shoots a cable (like Spider-Man shoots webs)? Does his costume visually tie in to the name? If a character is named Bishop, was he first a priest or deacon? Did he work his way up? By nature of his costume design, can you pick either character out of a lineup based on learning his name? Should he have a sidekick named Altar Boy? Should I be hitting up Cable for free HBO? Worry not, frantic one. I jest.

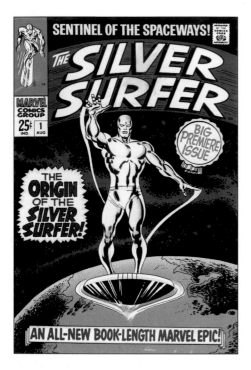

In any incarnation, whether comic book cover or postage stamp, the Silver Surfer is immediately recognizable.

Certainly, exciting and enduring characters like these have been created without using my approach. Yet I've always believed that a character should be instantly identifiable from his or her name and costume. Spider-Man looked like a spider (and obviously wasn't a woman). With the Fantastic Four (which you identified immediately because of the really big "4" on the costumes), you knew which characters were which. The Invisible Girl turned invisible. The Human Torch burst into flame. Only one of the four looked like he could possibly be The Thing. Which meant ole Stretcho, by default, was Mr. Fantastic, fearless leader of the FF.

The Hulk looked like a hulk of a man. Iron Man wore a suit of metals, first of basic iron, later as gleaming alloys with a colorful race car finish. Daredevil had the red costume with the horns. The shiny guy on the silvery surfboard was—get this!—the Silver Surfer. (Now that's writing!)

I recall when an editor, trying to invent a name, brought me Jazzy Johnny Romita's design of an angry man with a pair of big guns and a stylized skull on his chest.

"What's he do?" I asked. "What's his power and his motivation?"

"He punishes the bad guys," came the editor's earnest reply.

"Well, then, he's The Punisher!" I decreed.

The name stuck.

Not exactly rocket science, but did it work? You bet! Not only is every one of those characters I named still published as many as five decades later, but every single one of them has starred in a major motion picture or two. Their names are memorable, easy to comprehend, and simple to match up to their costumes. Even their secret-identity monikers are easy to grasp: Peter Parker, Reed Richards, Bruce Banner, and so forth. That combination of elements—that basic appeal—helped to capture the hearts of millions (Sam Millions, the dentist around the corner).

CANNY CONCEPTS

The concepts for the characters come from basic truths about humanity, for the human condition is really the subject of stories from time immemorial. In a story I've told so often it may even be true, I spotted a fly on the wall, which made me think of bugs in general, then arachnids, and eventually I settled on spiders. While I'm told the name Spider-Man might've come from a logo Jolly Jack Kirby may've had of a never-used character dubbed Spiderman (no hyphen), the character I dreamed up equated the repulsion some people have of spiders with a brainy loner teen's ostracism from his classmates . . . and soon, Peter Parker and the amazing Spider-Man were both born, brilliantly brought to life by shy Steve Ditko.

Likewise, the fabulous Fantastic Four came from wanting to do a group of superheroes that weren't obvious superheroes but rather adventurers—and a family. It seemed to be such a basic, logical, elemental idea; Jack Kirby and I based each character on one of the four legendary elements: earth (the very grounded Thing), air (the adaptable Invisible Girl), fire (the hotheaded Human Torch), and Water (the flowing, stretchable Mr. Fantastic).

The Hulk's genesis came from the rage and fury each and every one of us has at the world around us at some point or another, over things we cannot control. Jack and I started him out as sort of a combination of *Dr. Jekyll and Mr. Hyde* and Frankenstein's monster. Early on, he even transformed under a full moon, like a werewolf! (The Hulk, not Jack.) Our green-skinned behemoth has grown through many an iteration since then, just as we, as individuals, learn and grow and adapt in our own lives. All of these are basic concepts that exemplify something about the human condition and the world around us.

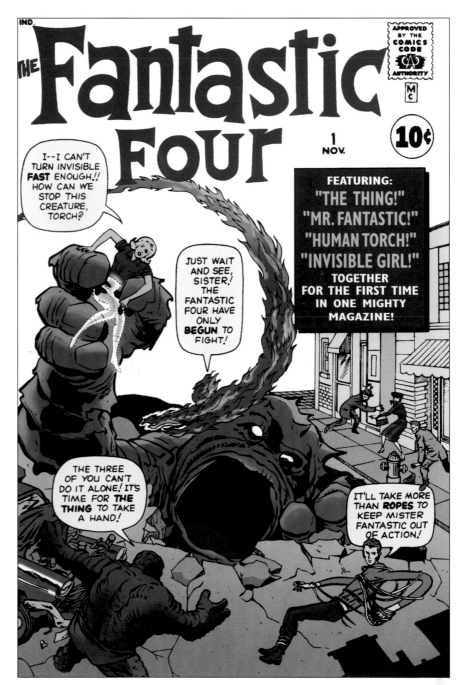

When Jack Kirby and I came up with the Fantastic Four, nobody had ever done an actual "family" of heroes before . . . not like this!

CLEVER COSTUMES

But what about those costumes? As I mentioned, the costumes all matched the characters—and their names. Each offered a unique-but-sensible design. Who else but Spider-Man would wear the webbed costume that wasn't meant to be pretty? In the first story, a sixteen-year-old boy designed it and sewed it himself! Completely covering his face also meant that nearly *every* reader could imagine himself beneath that mask—age and background and ethnicity didn't matter.

Fantastic Four weren't superheroes. They were adventurers! Their rough-and-tumble work jumpsuits didn't start out as skintight super-hero uniforms for that very reason. And they left their faces uncovered because they weren't trying to have a secret identity. By comparison, Iron Man not only had to hide his identity completely, but he became, almost literally, the knight in shining armor, a "bodyguard" for Tony Stark and protector for the world.

Only a blind man like Daredevil would start out with an ugly yellow-and-black costume before deciding on a red one . . . whose DD symbol was *also* red. And as we know from the Silver Surfer, sometimes the best costume is no costume at all!

Hulk's torn an tattered clothes show how monstrous he is (right), while Spider-Man needs to be slick-looking, with bright colors (opposite).

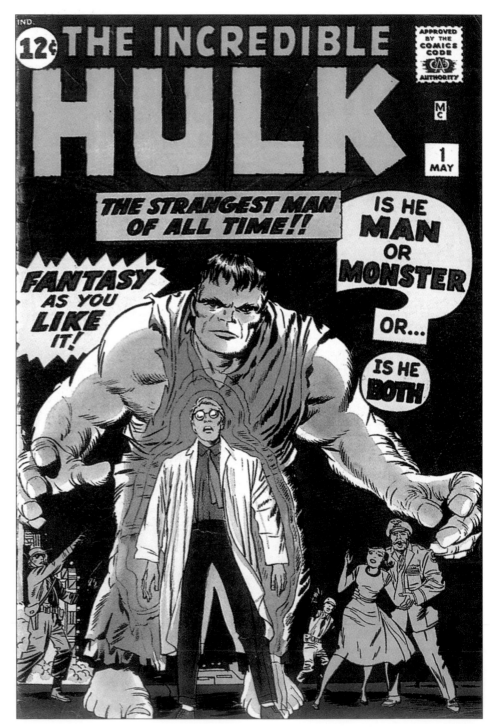

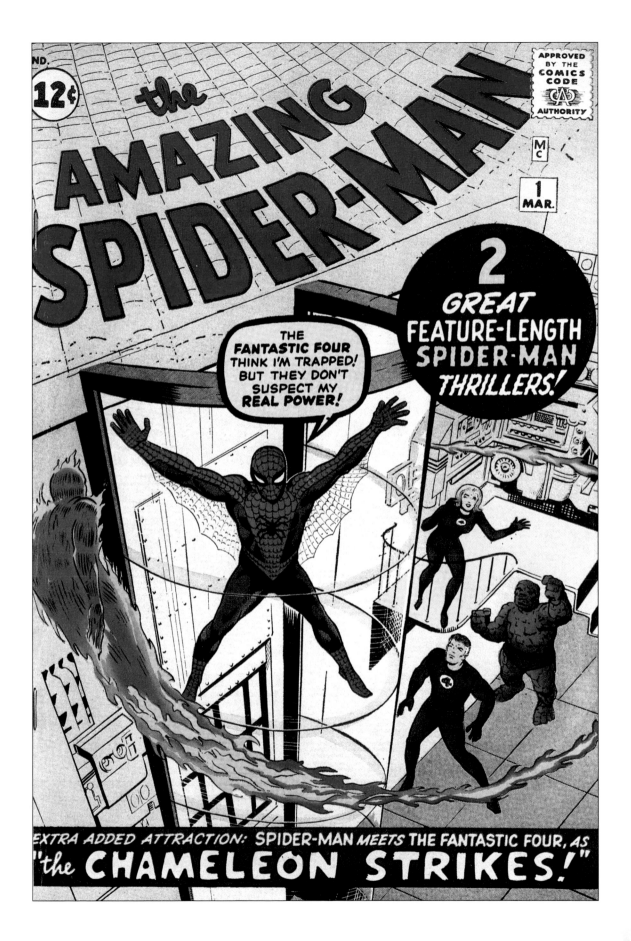

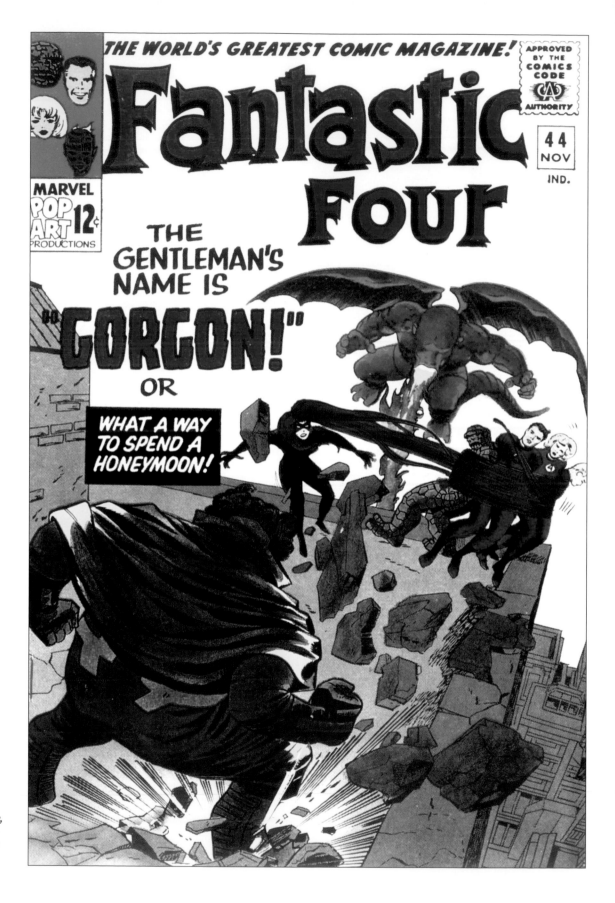

We had, with Jack Kirby, an epic run on the Fantastic Four, lasting over one hundred issues!

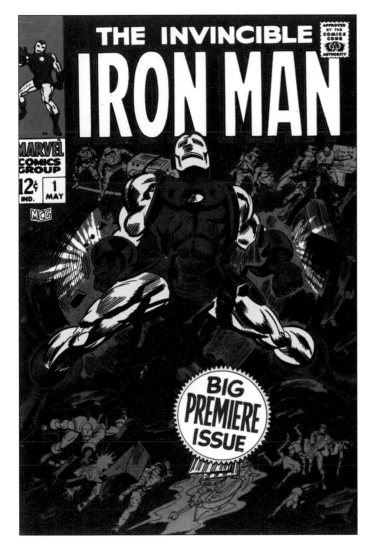

Iron Man's futuristic look was perfect as an introduction to his solo series!

The contrast of costumes between Daredevil and his foe, Gladiator, easily tells the viewer who is good and who is bad on this cover.

Spider-Man swinging through the city with its dynamic skyscrapers makes readers feel as if they are part of the action.

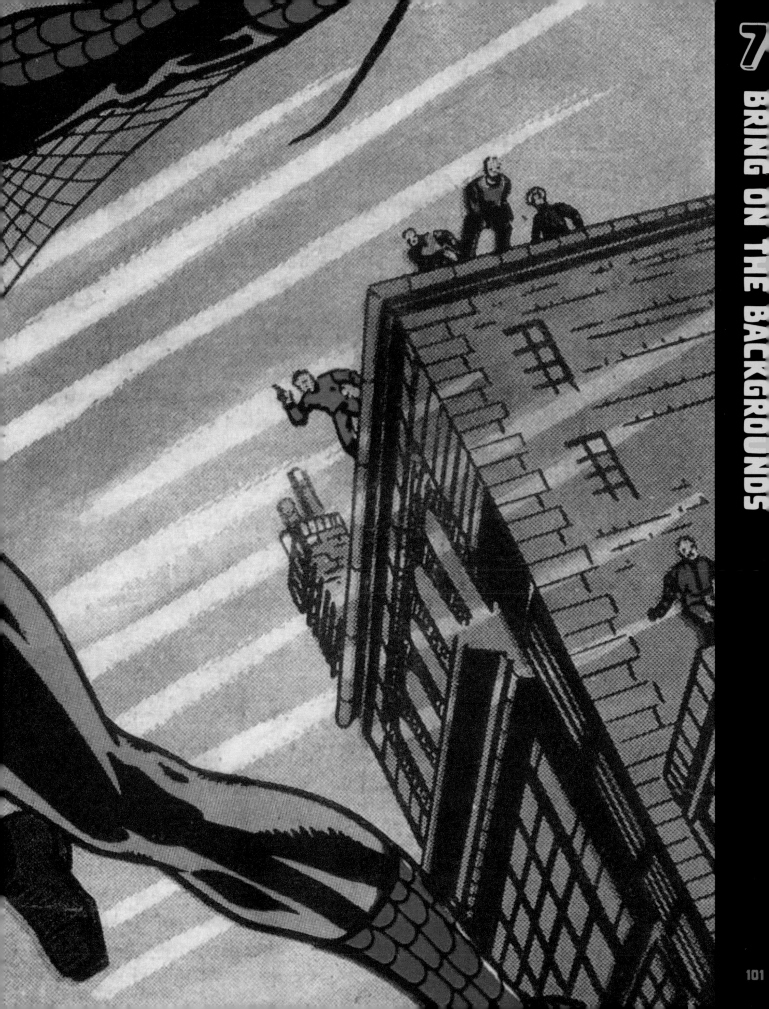

LOCATION, LOCATION, LOCATION!

Where would we be without backgrounds? Standing and running and jumping in a world of white space? No, not even that—because we'd have no gravity, no air, no environment with which to interact. Without environment, there is no *us*.

It's the same with comic book characters. Without environment, all you have are pinups, which is not storytelling. Without storytelling, you don't have comics!

Great backgrounds come from *paying attention* to everything around you. Let's say I dragged a pro comic book artist away from his spot in Artists Alley at Comic-Con and told him to draw the doorway I'd led him to. Would he simply sit and draw? Of course not! Every few seconds, he would look up from his paper and

pencil, studying the doorway, learning the relationships of space and form of that particular area. He'd see the shape and thickness of the door frame, how many hinges it had, the size and shape of the doorknob, the way that light and shadow emphasized the layers of door frame, and so on.

A beginner artist might, by comparison, only look up once or twice and then just draw what pops into his or her head—a half-formed interpretation of what he or she thinks a door frame would look like. If you find

yourself doing that, you're doing your backgrounds—and the characters who inhabit them—a disservice!

Understand that "convincing" does not necessarily have to mean "real." Backgrounds in books as widely different as *Archie*, *Banzai Girls*, *Scooby-Doo*, *Spider-Man Adventures*, and *Uncle Scrooge* appear in many different styles. As long as enough elements throughout seem genuine, and consistent with the rest of the book's style, they remain believable as backgrounds.

Let's look at an example from my good friend, master artist Neal Adams—himself a premier star of the Silver Age of Comics: This, true believer, is a background! It's not just a collection of unfinished rectangles with windows pretending to be a street scene. It really feels like a big-city street. Even as our intrepid main characters talk and walk down the street while on assignment, the city "lives and breathes" as a place where beings actually live out their lives. A woman walks by and is admired from behind, a child wants a toy fish on display, a grocer is ready to sell fruits and veggies, friends are chatting and living their lives. But it doesn't end there. Cars, trash, smoke, flying birds, antennae, dirt, and grit—here's every possible detail for making this city seem real, with a personality of its own. Understand what I mean?

Now let's try an example from Mike Deodato, Jr., today a star of the modern age of comics. This page is two panels of entirely background, as the opening of a story from a few years back involving a church in New York City. The first panel is a panoramic shot of a nighttime skyline; the second is an establishing shot of the church and the city street it's on.

In that first panel, it's pretty clear that's an authentic skyline. As a New Yorker, I can tell you it feels real. In the second panel, every detail of that church seems genuine. What's more, the street has life to it. A person walks by, smoking; another near the stairs carries her shopping bag. Papers blow high in the breeze. Trash needs collecting on the side of the street. Cars are parked. Smoke rises from a chimney vent atop a building. Laundry hangs on a clothesline high outside a nearby tenement.

Here's a down shot from later in the same story. You still see the trash and the cars and the steps and other details from the establishing shot, so you know exactly where you are. This amazing angle gives you a spectacular vantage point from which to witness this fatal shoot-out, and it's loaded with action and convincing detail. Even just this one panel is a masterpiece in the making!

Also keep in mind that not every story is told in the big city! Backgrounds can be anything anywhere, as shown here by Marvel star Bong Dazo. On one page, you can draw your curvy character entering a shower stall. On the next, she could be racing through dense forestation to avoid the gigantic jaws of a tyrannosaur, as she does here. And on the next, she could stumble through her city—in ruins! It's all in a week's work in the life of a comic book artist.

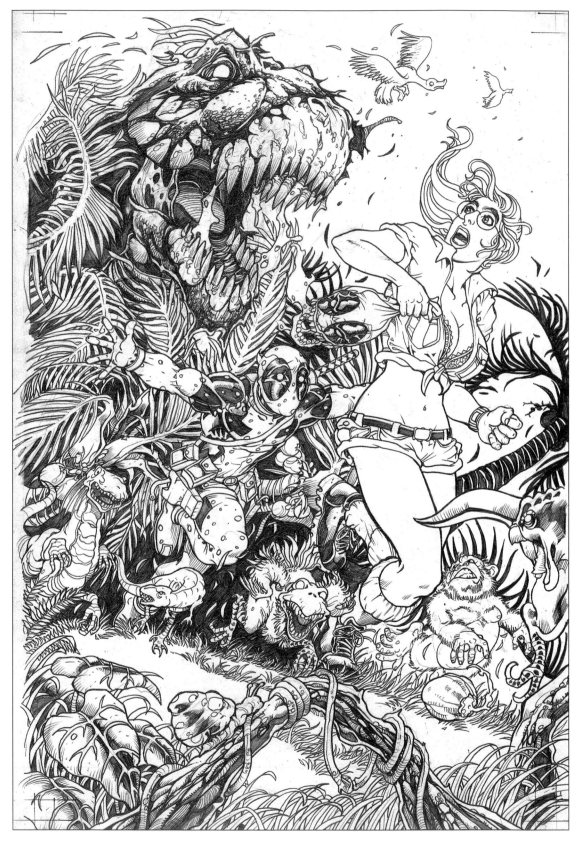

GOOGLE SKETCHUP
STEP-BY-STEP

Certainly, observing and learning and drawing, drawing, drawing what you see are the best ways to rise from decent to good to great. Using photo reference from books, the Internet, or images you've shot yourself can serve as further inspiration. But as I promised at the beginning of this book, there's a truly wonderful *free* software out there—Google Sketchup. The amazing artists at mighty Marvel Comics are often encouraged to use Google Sketchup, as well. So here's a tiny telltale tutorial to tantalize you and guide you through your never-ending battle for better backgrounds! Near your computer? Fire up ole Betsy and sign on. Go to http://sketchup.google.com.

For our tutorial we'll look at the Baxter Building. You're probably familiar with the near-legendary Baxter Building, home and headquarters of the fabled Fantastic Four. How do all of today's artists manage to draw the exact same building correctly from all angles? (The building doesn't really exist. Sorry to break it to you, but Jack and I just made it up!) Today, artists use a model created in—you knew this was coming—Google Sketchup. And through Google Sketchup, you can see our beloved Baxter Building in all its glory: front view, back view, side view, up shot, down shot—from any angle, no matter how extreme.

You'll begin with a male figure on a green background like you see here. And, fortunately, a dozen or more videos can show you the basics of creating everything from bridges and buildings to surfboards and zoos! (That way, we don't spend this entire book on one subject!) What's more, you'll learn about important incredible existing backgrounds—libraries, cathedral interiors, automobile exteriors and interiors, and much more—each and every one of which you can carefully customize into exactly the background you need! It's a seriously easy program to use—and just as with drawing, the more you practice at it, the better you become.

Whether you're using a Mac or a Windows-based PC, once you get to http://sketchup.google. com, click Download Google Sketchup. Take your time. I'll wait. Install it. Open it.

Once the element has been created, you'll have the ability to scale and use it from every conceivable perspective. An assortment of tools makes the process much easier. The primary tools needed for creating the Baxter Building were the Selection tool pencil, the Rectangle tool, and the Circle tool. The measuring of windows and all other architectural details for the building were done using the Tape Measure tool.

COMPLETED BUILDING

SIDE PROFILE

SIDE PROFILE

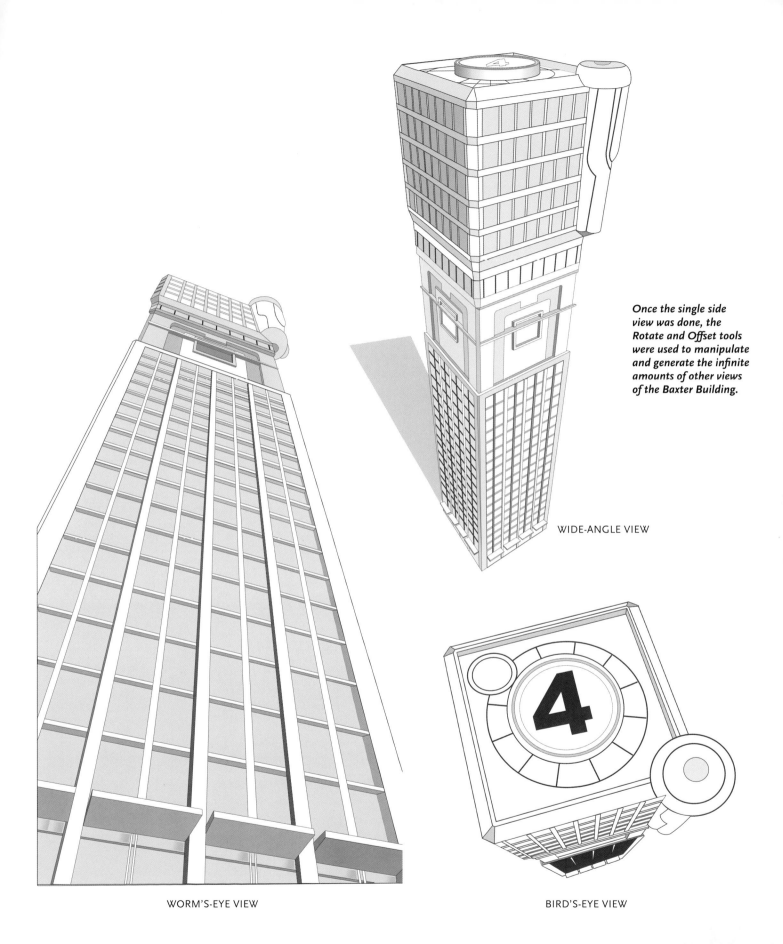

Once the single side view was done, the Rotate and Offset tools were used to manipulate and generate the infinite amounts of other views of the Baxter Building.

WIDE-ANGLE VIEW

WORM'S-EYE VIEW

BIRD'S-EYE VIEW

SKETCHUP AND A SAMPLE PAGE

So once you know how to make usable backgrounds, what do you do with them? You start creating a layout for a typical comic book page.

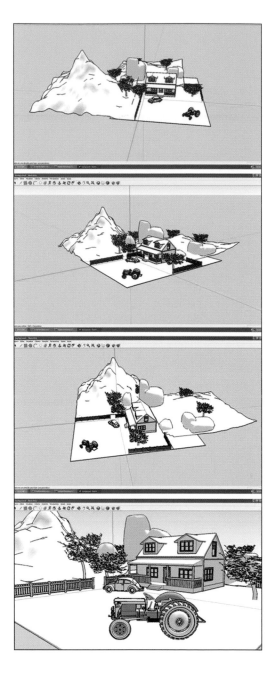

In this pre-Sketchup mock-up by the artist, our young hero is making his way down a suburban street, hoping to catch sight of the gal he has a crush on. He's always had a sensitivity to her problems and perils, and now something's wrong! He makes sure nobody's looking, and then he leaps into the sky, literally flying to her side. Little did he know that his own brother was watching, and he has just discovered his sibling's soaring secret!

Simple enough. Now we go into Sketchup and see if an environment (in this case, a house on a street) exists that we can use. If not, we can create one using basic forms and existing pieces we can download.

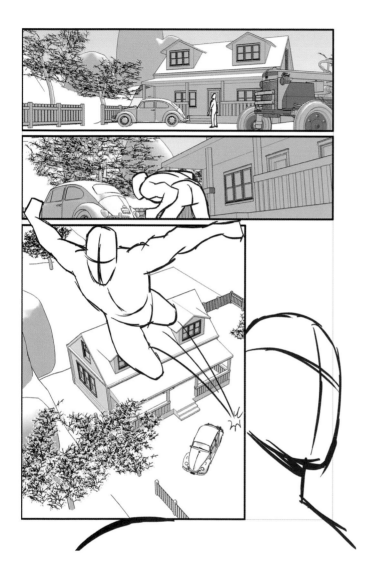

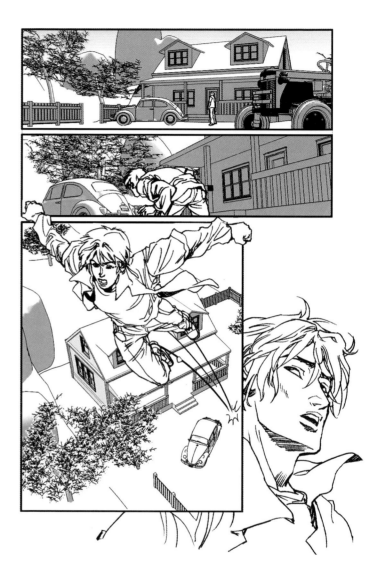

Once the elements are in place, you can move around your model in any direction and angle. Find the exact angles you want that fit your layout. Then you have a choice. You can either (1) size it the way you want, hit Print, then draw over the printout on your light box, adding the characters as you go along; or (2) export the images, each as a 2-D model in high resolution, and set them all up in Photoshop.

Let's say you chose the second option from the previous step. You import the 2-D images and place them in each panel. You can add your figure layouts to see how the characters will fit. If you've selected the right angles in the second step, the perspectives in each panel will match your figure work from your layout.

At this point, you can print the page at 11 x 17 inches (original art size) and work on it on art board over your light box. Here, you can see what it would look like with the figures more fully sketched in. At first glance, you might think, Wow, that's a bit of work just to get three panels! But if at any point you are drawing this issue or the next issue or the issue after that and the story comes back to this location, you have this setting permanently handy—and you don't have to create it again! You may even find, with some adjustments, that it can be reused as a different setting for another book. The opportunities, much like your imagination and the untold billions of backgrounds the world over, are without limits!

This Daredevil cover image needed careful planning and composing in order to elicit the feeling of suspense and action.

EYE FLOW

More important than style! More important than finish! Layouts are the single most important element of comic book art, because this is where *you tell the story!* Your job as a comic book artist is to tell the story as clearly, concisely, and *dramatically* as possible. As we've seen, in simplest terms, characters don't walk—they run. They don't argue—they lean in and scream. They don't jump—they leap with legs 5 feet apart. They don't whack the desk—they SLAM! the desk, with papers and telephone flying every which way.

Of course, today's comic book layouts require much more than that. They incorporate everything you've learned about form, backgrounds, anatomy, action, acting, perspective, foreshortening, and drawing people to create the perfect visual vehicle to tell your story! And the concept of eye flow is the first terrific tip that will help you do this successfully.

Eye flow refers to the composing of the panels and pages in a way that gently guides the readers through them, in the correct order, helping them to see what they should see, and when. Witness the crisp, intelligent flow of artist Jonathan Lau's pages.

On the first page here, notice how clearly you can follow the scenes from panel to panel. No confusion, nothing left to chance, despite dramatic displays of exteriors, interiors, and multiple cuts back and forth among locations. I've added arrows so that you can see the logical, easy-to-follow flow of movement the artist provides. He begins with a clean flow across the building in panel 1. Panel 2 pulls us back across the top of the panel, then to the right again, both following the architecture. Once we pass the lone figure, architecture gently directs us out of panel 2 and out toward panel 3, which cleverly points us across it and up into panel 4. Panel 4 nudges us downward from opposite directions, as does panel 5, which then drags us across the arm and chains in panel 6. The downward-sloping chains pull us in to panel 7, which forces us to the center from both sides, then out of the page completely.

On the second page, we see the sweep of visuals as Lau cuts from close-up to wide exterior shot to elegantly designed down shot and, finally, to another close-up, all with clear simplicity of movement. A body, a design element, architecture, dual circular designs, tall poles, and even a strategically placed costume design all guide the reader's eyes to follow the storytelling in proper sequence.

On this page from later in the same issue, the eye flow is a clear, elegant arc reminiscent of the figures in the legendary photo of the World War II flag-raising at Iwo Jima. (If you don't recognize the reference, go look it up. I'll be here when you get back.)

The same rules of eye flow apply no matter what your style (realistic, semirealistic, cartoony, and so on) and no matter which publisher the comic book is from. Look at the ease and grace with which artist Nick Bradshaw creates the action for Re-Animator. Panel 1 begins with the key character's placement. Placement helps direct the reader's eye to move easily across the page from panel to panel while preventing the reader's attention from getting lost. We read from left to right, and elements in the drawing help the viewer proceed in this direction. This solution should be on every page in a comic book to keep the flow smooth; it's an important element for story progression, which keeps the reader from putting the comic down.

The same rules about eye flow, of course, apply to covers, as well. The clear, dramatic arc of this design is breathtaking, following first the gun turret on the top of the page, then catching on to a hero's cape and arcing clockwise until it hits the bottom of the page, where weapons and debris are tumbling off the tank. There's no question what to look at first and where to look next. This is a master draftsman at work.

INCONGRUOUS ELEMENTS

This is related to eye flow—like a second cousin on your mother's side. You've seen this concept before when you've taken a photo with your friends and the background lined up wrong, so it looked like an arrow was sticking out of someone's head or you were a giant leaning against a mountain. Incongruous elements are things in your drawing that on a conscious—or even subconscious!— level, simply don't seem right.

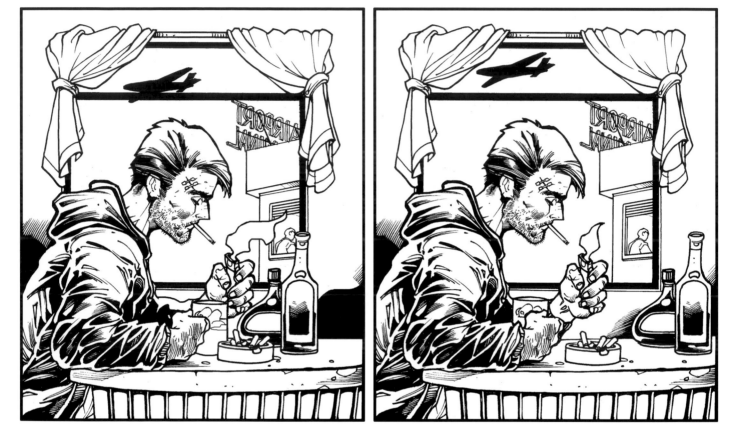

Let's take this man sitting near a window, indulging in bad habits in a rundown, little airport bar. As story points, we see he's cut and bruised and a little rough around the edges, but we also notice that some elements don't seem quite right in the composition of the left-hand panel. The airplane partly disappears into the window trim. The tall bottle lines up with the window frame. The flame from his lighter overlaps into the background, appearing almost to enter the window in the other building. His glass, ashtray, and left hand all overlap one another. As a result, some clarity is lost. (Even if you're drawing this directly from a photo, it's best to adapt the photo a little bit.)

Look now at the second version of the drawing on the right. The airplane is no longer blocked by the window design. The glass, ashtray, and left hand are all clear. The bottles are moved to the right so that they no longer line up with the window frame. "Why change it?" you ask. I'm glad you did! Comic book readers are pulled into the story, and for those moments, there's a suspension of disbelief. Anything that seems a little bit odd (a confusing layout, a double-page spread that makes the reader turn the page sideways, panel details that just seem a little bit wrong, incongruous) yanks the reader away from the story and back to the real world. What's more, clearly defined spaces help to establish depth.

CINEMATIC CONTINUITY

Major motion pictures have reached a level of special-effects magic that rivals comic books for sheer jaw-dropping visuals and excitement. They learned it from us; in fact, some of the most amazing movies of the twenty-first century are based on comic books. Yet you can learn something from them, as well. Don't just think about drawing characters. You can adapt some moviemaking techniques to your drawing, such as cinematic continuity.

Certainly one of the best storytellers in the whole history of comics was Jack "King" Kirby, so let's turn to the *Silver Surfer* graphic novel that he and I did together to show a few examples of cinematic-style continuity. Take care to use these techniques sparingly, however. I'm able to show you multiple examples from one book only because our book was a full one hundred pages of art!

The example shown here over panels 3, 4, and 5 illustrates the simplest type of cinematic continuity: basic, three-panel continuity. Keeping the "camera angle" exactly the same for all three panels, Jack establishes a glowing effect around the Silver Surfer; in the next panel, the effect solidifies; and in the last, it becomes a rock-hard shell. Basic, clear, and effective.

This time, the three-panel continuity that Jack uses for panels 3, 4, and 5 of this page transitions from present day to a flashback. We see a random brunette of the street become the Surfer's beloved Shalla Bal. Not only do her hairstyle, facial features, and clothing appear to transform to segue into an emotional flashback, but Jack wisely pans in closer and closer to make the transition even more dramatic. Yes, Jack could've played with the panel borders themselves, perhaps making the final panel's borders wavy to help emphasize the actual flashback scene beginning, but it would've taken away from the strict visual structure he set up for the continuity.

Never to be outdone by anyone except himself, here Jolly Jack shows the Surfer being rocked by dual power blasts from Galactus. So Jack shows us the Surfer's helpless, agonizing fall over not three, not four, but eight amazing panels!

Okay, now Jack is just showing off! The ole softie shows his romantic side as the Silver Surfer gets soulful with Ardina across nine panels viewed from the same camera angle.

Note the continuity across the panels in this sequence by Al Rio, even while he uses a variety of angles, close-ups, and longer shots.

CAMERA ANGLES

Unless you're using your handy-dandy digital camera to take photos for your references, you might think a lot of camera angles don't come into play when drawing a comic book . . . but you'd be mistaken.

Y'see, camera angles are all-important to your storytelling. This is something else that comics have adapted from filmmaking. (Considering how much they've adapted from us, turnabout's fair play!) Ever see a story drawn where all the characters seem to be about the same size in every panel? It kind of feels as though you're seeing a stage play from the middle row of the theater: As lively as the movement may be on that stage, a sense of immediacy, or urgency, is missing. That's where camera angles make all the difference.

Establishing shots, like those seen in this sequence, give readers the necessary overview of the scene, clearly showing the environment and where characters are positioned in relation to one another.

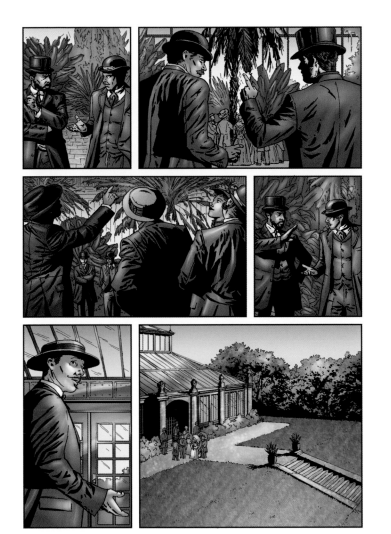

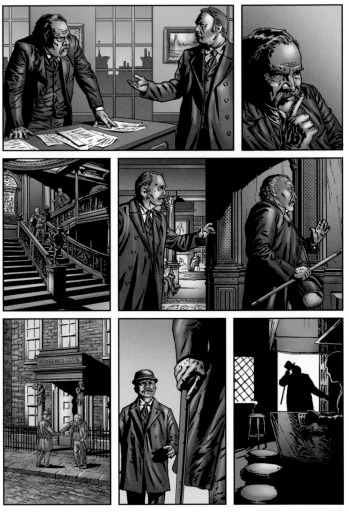

Up shots (in which readers look up at the scene) provide dramatic worm's-eye views that can make a character seem impressive and remarkable or can emphasize a great height.

Down shots (in which readers look down on a scene) can give readers a look at a situation they couldn't see otherwise or can make a character seem lowly and unimportant.

Long shots are usually full-body shots but may not show much of the setting as establishing shots. Panel 1 on the page shown here is an example.

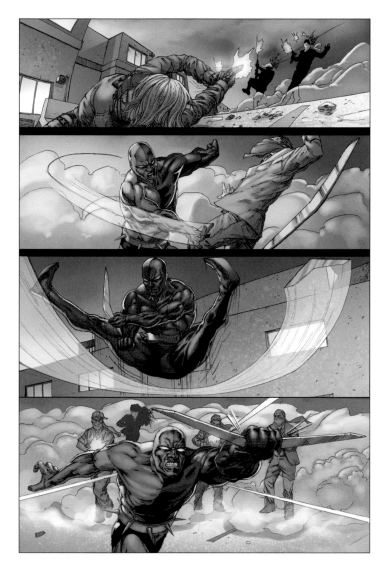

Medium shots give that middle-row-of-the-theater feeling. Not too close, not too far away. Panel 3 of the page above illustrates this.

Two-shots are close enough to get a real sense of emotion. They can be front shots (for example, two people sitting in a car) or over-the-shoulder shots of one character looking at another, which is what we see above in Panel 1, or other combinations.

Extreme close-ups capture part of a face, hand, or other object. There are a variety of close-ups in the page at right.

Close-ups are big and dramatic. Some can fill an entire page and don't have to be just of one face. The larger panel in the page opposite is an example of this.

THE MISTAKES

You know me. I'm an optimistic kind of guy, and I prefer to see and talk about the bright side of things. Every once in a while, though, some good can come from learning what *not* to do. So I turned to accomplished digital artist Jezreel Morales to create, in a slightly manga-influenced style, a deliberately cockeyed sequence we all can learn from, which incorporates a number of storytelling errors I've seen over the years.

We didn't wanna put any long-beloved characters through any embarrassment, so Jezreel and I created a pair of calculated characters just for this purpose. So let me introduce to you Hammersmith and his lovely-but-lethal foe Straightshooter! I leave it to you to decide who is the good "guy" and who is the bad "guy."

Here on the first page, Hammersmith is in the middle of a pulse-pounding action scene battling Straightshooter. He swings. She ducks, summersaults a safe distance away, and fires one of her arrows at him. At least, that's what's supposed to be happening. And panel 1 seems fine, at first glance, but who is the tiny female character being hit by the hammer? (Did the wistful, wonderful Wasp from The Avengers make a guest appearance?) She seems to go flying, end over end, till she lands safely in panel 2, and then fires her crossbow in panel 3.

The problem here is a confusing layout. The tiny female character is actually Straightshooter from panel 1, as the action from panel 2 overlaps. It's supposed to be her finishing the leaping action she began in panel 1! But it doesn't "read" that way. And in panel 3, although we see arrows in Straightshooter's quiver, we're not totally clear those are arrows she's firing—they seem to be some sort of power beams. (Though to be honest, this is one a writer can fix simply by giving them a name that sounds as if they could be dangerous and high-tech. So let's call them Nega-Arrows.)

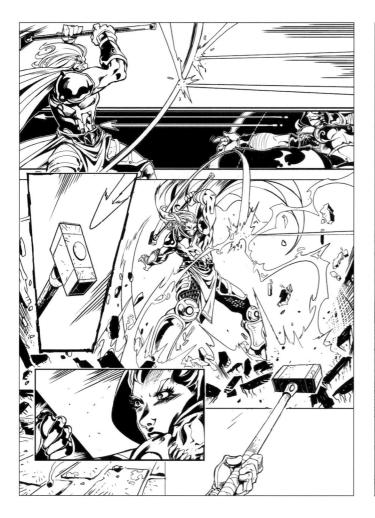

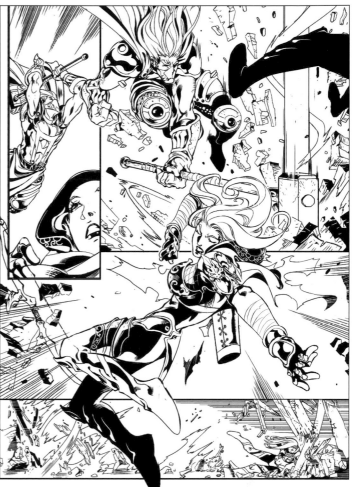

Now on the second page, Hammersmith is knocking arrows away with his hammer; each one Straightshooter fires gets knocked back. Then he raises his hammer once again, to strike. However, the actual layout is, once again, unclear. In panel 1, Hammersmith knocks back the arrows, and yet the visuals are a little confusing. Were those actually arrows? We never see precisely what he's knocking away. Panel 2 adds more confusion. Why is Straightshooter standing so close and still missing him? He's right there, barely an arrow's length away! The layout is too clever by half, attempting to have Hammersmith span panels 1 and 2 even though Straightshooter is obviously in two different locations.

More visual complications come from the use of too many lines. The extra lines in the top right of panel 1 serve no purpose, but that's only the beginning. We have speed lines from the arrows, we have the too-thin gutter lines separating panel 1 and panel 2, and we have the floating arrows in panel 2. The visual jumble is much too much. And yet we're still not finished! In panel 3, it seems as though she shot a Nega-charged arrow directly at the hammer. Why would she do this? Panel 4 has Hammersmith still knocking arrows around, none of which ever seem to strike back at Straightshooter.

Speaking of her, what exactly is she doing in panel 5? And then, who's holding the hammer in panel 6? That hammer is reaching up into panel 4 and causing a power blast of some sort that surges its way up to connect with the hammer's contact point in panel 4.

Here comes page 3! Hammersmith leaps toward Straightshooter, smashing down his mighty hammer and causing shock waves that send her crashing back across the ground, shattering her surroundings into debris. Yet that's not quite what the layouts tell us. In panel 1, he does leap, but why is he so disengaged from his target? Why won't he even look at Straightshooter? In panel 2, we see the hammer smashing down, shattering the ground, and just missing Straightshooter's head and flowing locks by mere inches as she's knocked into panel 3. (Maybe he missed because he wasn't looking at her in panel 1?) But wait . . . if he just missed her head, then who do the blacked-out legs belong to in the upper right of panel 2? They certainly can't belong to Straightshooter, because we clearly see her head being missed in that same panel. The artist's attempt to do a dynamic figure that breaks the borders of panel 3 and overlaps her back into panel 2 as well as into panel 4 has backfired. By the end of this page, the reader is left as exhausted and reeling as poor Straightshooter herself!

This is why clarity is as important as excitement in your layouts. Your job is to tell the story in the clearest, most dramatic way possible. If your tricks are going to confuse the reader in the slightest, don't use them. It's important never to pull readers out of the story to figure out what you're trying to show; they may never get immersed back into that story with the same intensity.

READY AND WAITING!

To give you a real experience of drawing from professional-quality layouts, here's a three-page action sequence courtesy of Wilson Tortosa. Give the main character any name you want! Here's the plot: She's a soldier in Pakistan fighting the good fight, but she has been partially blinded by an explosion of alien origin! Her troop has been ambushed—not by the expected hostiles but by aliens with powerful weapons. In the swift battle, one of the dead aliens' weapons imprints on her just when all seems lost . . . and she discovers a terrible truth though their the mind link—and realizes she may be fighting for the wrong side!

Now you have it: your premise and your plot (which you can change to your linking, of course) and your layouts. Take these layouts, and all that you learn from this book, and make magic happen. There's no limit to the possibilities or to your imagination. Feel free to scan 'em, blow 'em up to original art size, and pencil them as your own!

The artist was able to condense clear action in three pages.

WHAT'S IN A LAYOUT?

So how much work goes into a layout to bring out the most action? Some say the work involved is 100 percent thinking and 10 percent drawing. The right answer is: whatever works best for you! Here's what I can tell you: Most artists draw a layout quite small, usually no larger than a sheet of typing paper—and often as small as half that size. That's because if all your shapes, flow of movement, and fundamentals of storytelling aren't clear at that size, you're trying too hard. Some artists will try a layout several times before settling on one that works best. Others will cut and paste bits of various layouts until they come up with the perfect storytelling sequence. At that point, they either blow up the layout to original-art size on a photocopier or scan the layout and print it out to fit the 11 x 17–inch art board size and then work over it on a light box. Different artists put different amounts of effort into the layout stage.

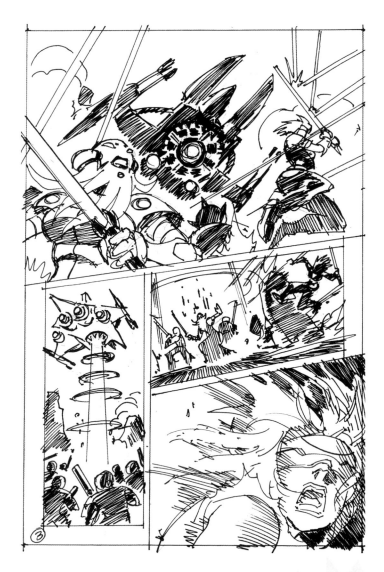

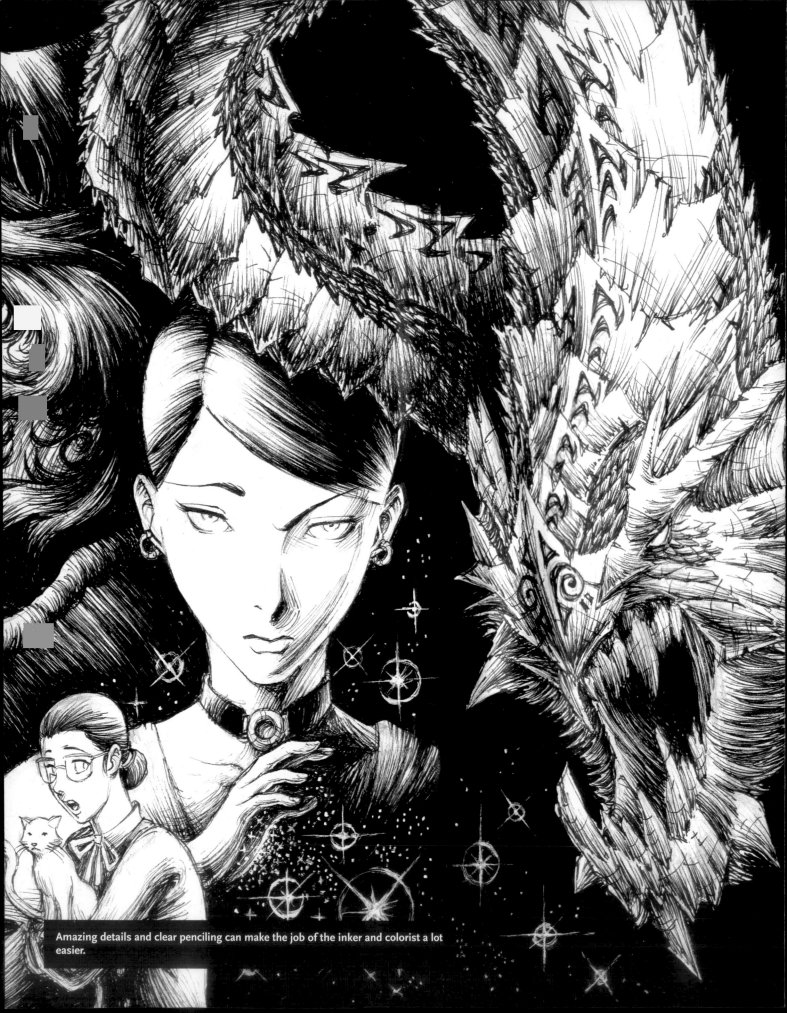

Amazing details and clear penciling can make the job of the inker and colorist a lot easier.

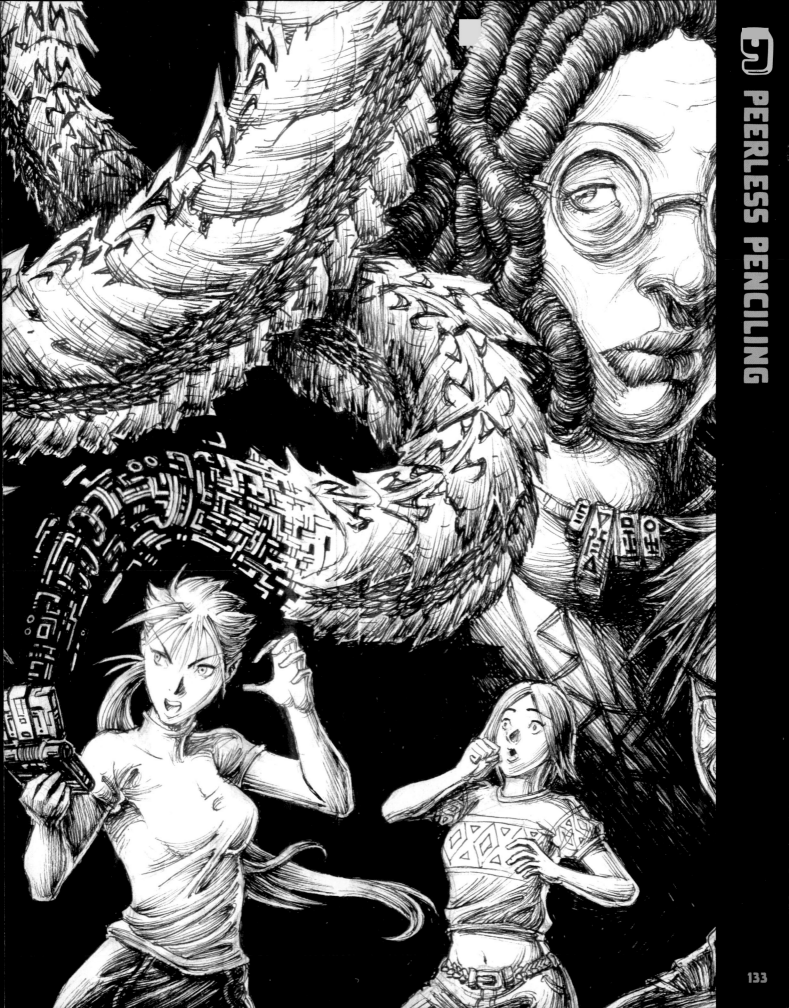

PENCILING STYLES

You can spell it with one *l* or two. You can call them pencilers or artists or innovators or illustrators. Whichever way you describe 'em, they all add up to the same thing: They are the guys and gals who create worlds of wonder on the comic book page, in a wide variety of stunning styles! At the risk of sounding a bit like Dr. Seuss, there are loose pencils and tight pencils, dark pencils and light pencils. All of 'em have a reason and a purpose.

What exactly is a *style*, anyway? One school of thought is that a style is everything an artist does *wrong*. Follow that? If the artist did it *right*, it would look like a photograph. So everything an artist does to adapt reality, in his or her way, onto the comic book page, becomes his or her style.

Another school of thought (so big it should be a university by now) is that a style is simply a collection of deliberate tasks and tricks and peccadilloes that artists introduce, usually deliberately, to make their work saleable in the marketplace. I think both schools are right.

Some artist have only one style. It's the *only* way they draw. They learned drawing along with certain preferences and techniques, and whether they draw comic books or other assignments or simply draw for pleasure, they have their own personal style. That's *not* to say they fail to change as the years go by. Every artist changes somewhat as he or she continues to learn and grow.

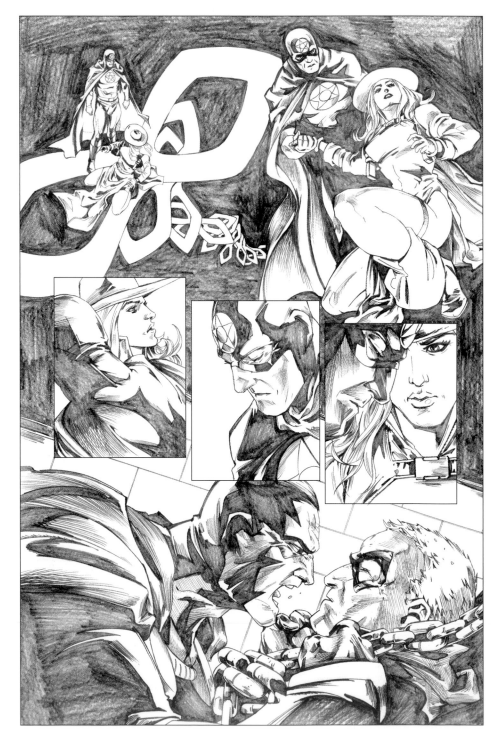

Jonathan Lau is a strong penciler whose work displays substantial detail.

(Artists who *stop* learning? I'm not sure I wanna know 'em!) I know of no artists who draw exactly the same at the latter phases of their careers as when they started. Jack Kirby's work changed in enormous ways over his fifty-year career. So did Gil Kane's, John Buscema's, John Romita's, Dick Ayers's, Don Heck's, Wally Wood's, and everyone else's I can think of.

Other artists are sensational "superadaptoids," equally adept at drawing in the styles of Disney or Pixar or Hanna-Barbera or superhero or dead-on realistic. Some artists have three or four or five styles, and their work in each style is spot-on and beautiful to behold. The advantage this holds is that if one job ends and the editor has a much different style of book available, these artists can grab that job as well!

THE HOUSE WINS!

Sometimes a publisher needs a *house style*. You already know what this is, even if you're not familiar with the actual term. Think of Mickey Mouse or Donald Duck. You know immediately how they're supposed to be drawn, don't you? They're illustrated in the Disney house style. Or how about Archie? You can picture in your mind's eye precisely what Archie Andrews, Betty Cooper, Veronica Lodge, Foresythe "Jughead" P. Jones, and Reginald Mantle all are supposed to look like because Archie's essential house style has been consistent for many years.

Similarly, if you're drawing something from Pixar's roster of characters (*The Incredibles*, *Up!*, and *Cars*) or anything from DreamWorks (*Shrek*, *Monsters vs. Aliens*, and *Kung Fu Panda*) you know their house style, as well. It's a necessary stylistic convenience for each company—creating immediately identifiable characters. Matching those house styles takes special skills, and artists who do it well are amply appreciated.

When I was head writer and editor-in-chief of Marvel, although we didn't have a house style, it *seemed* as though we did. Artists were suitably indoctrinated into a supreme storytelling sense—"Do it the way Jack Kirby does it!"—in terms of action and power and visual splendor. And John Buscema, Sal Buscema, John Romita, and Joe Sinnott were all such admirers of one another that elements of each individual's tricks snuck into all their work. It simply meant that we had comicdom's greatest artists, so I couldn't complain.

GENERAL PENCILING NOTES

- Most pencilers these days draw more tightly than they used to. That's partly because some publishers skip the inking stage altogether and go straight from pencils to color, saving both time and money. And it's partly because editors expect more. Gone are the days when a comic book artist had to draw three books a month to earn a living. A typical penciler finds a comfortable schedule to be about one book per month—roughly twenty-two pages and a cover, which comes out to right around one page per workday. Although there are speed demons capable of drawing two or three perfect pages per day, they're the exception, not the rule.
- If you are penciling with the intent to skip inks, choose a darker lead, and learn to clean and perfect your pencils in Photoshop. If you have impeccable digital files, you'll get the results you want.
- Understand that you are drawing for publication. As such, you draw pages larger than printed size so that they look better reduced. You can also paste up, erase, and change things, and it will still look perfect when printed, thanks to Photoshop and other techniques.
- With today's full-bleed books (that means the printing runs all the way to the edges of the paper), you have to be aware of proper sizes for your artwork. Fortunately, major publishers supply preruled paper with correct safe, trim, and bleed areas noted in non-repro blue. Several sources also exist to purchase comic book art board.
- If you're drawing most manga, the usual drawing size is often half the regular size of a comic book page. So you can cut a sheet of 11 x 17–inch comic book art board in half and work from there.

THE ELEMENTS OF STYLE

In the busy comic book biz, with several hundred new comics published each month, editors are always looking for great new talents that can tell a story well and dazzle the senses with detail and design. Let's look at a favored few prolific, contemporary artists, simply to see what's possible! I've chosen three artists well known in a variety of styles to cover the broadest bases. It's a lot of comic book styles coming out of just three terrific talents. You could be next!

WILSON TORTOSA

Now in his second decade as a professional comic book artist, Wilson credits "a lot of life drawing" for his adaptability.

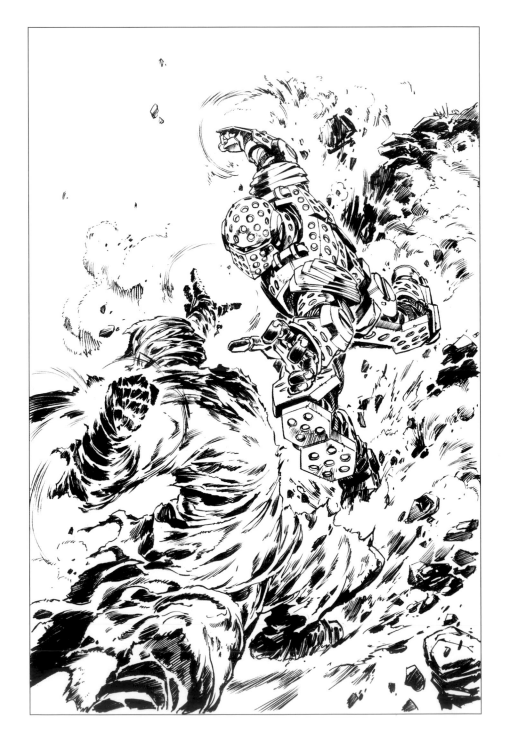

From an upcoming project, a high-energy style such as this complements the story line.

A Zorro cover is a straight-forward, dramatic adventure style suitable for most main-stream books.

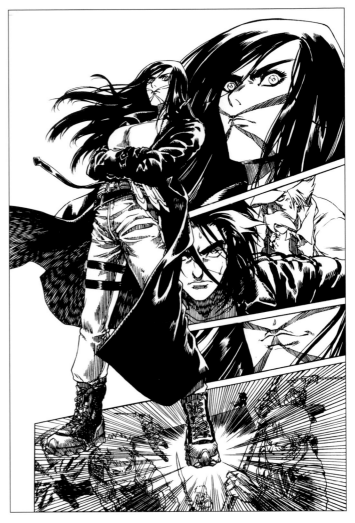

Here's Wolverine in a very specific, authentic manga style. The Wolverine manga books are even printed back-to-front and are read right-to-left.

MENTIONING MANGA

Keep in mind that *manga* doesn't actually refer to an art *style*; it means Japanese comics. So if somebody says, "I'm gonna draw this in a manga style," the first question needs to be, "*Which* manga style?" Not only are there dozens of valid manga styles, but plenty of *manhwa* styles also exist with some similarity to what many consider manga. These comics by way of Korea bring much more attention to color and costume design. With thousands of new pages of manga-style art produced in the USA each year (sometimes referred to as Americanized manga), it's a valid and vibrant addition to the American comic book industry.

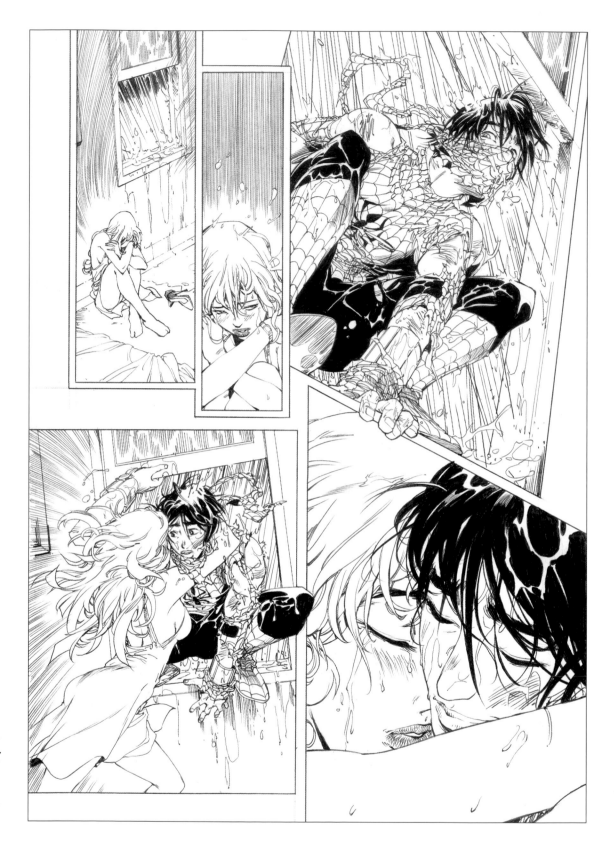

A fresh-styled, youthful page for a teen, romantic Spider-Man project. Variations of sizes of shots and shapes of panels make a simple scene interesting enough for a more youthful reader to follow.

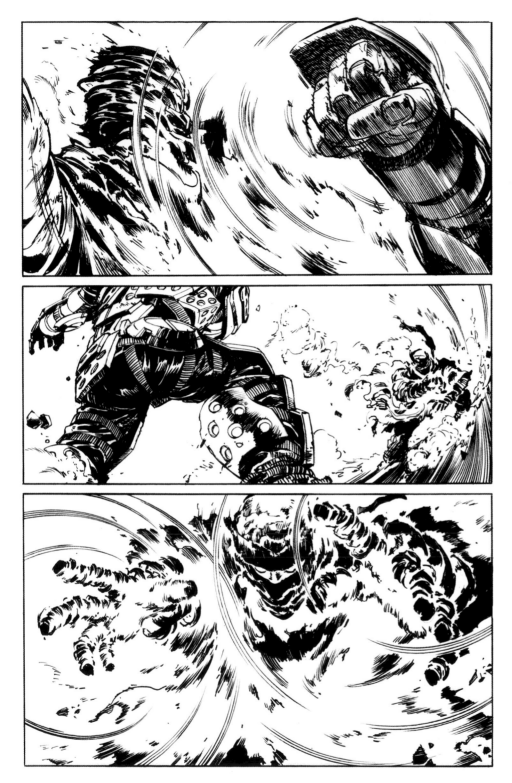

From Bring the Thunder, *the kinetic action between the hero and villain is displayed by the masterful linework.*

LEADERS & FOLLOWERS

Today's editors tell me there are two ways artists get noticed: either by being the talent that brings them something new, exciting, and fresh that establishes a new style or by being extremely good in one of the range of styles editors currently need.

Long-term, of course, it's best to be the trend-setter, the artist everyone else wants to follow. Ask Neal Adams or Jim Steranko or Jim Lee or Adam Hughes or Mike Deodato or Bryan Hitch about artists who have become their followers. Some of those followers are quite excellent and will adapt, in time, to become someone others will follow. Pre-Raphaelite-inspired artist Barry Windsor-Smith started out as an imitation of Jack Kirby! Bill Sienkiewicz began as a dynamite duplication of Neal Adams. Al Rio launched his career as a clone of J. Scott Campbell. They each developed into something quite different and unique.

AL RIO

In his third decade of comics, Al Rio has also become one of the most popular "girlie artists" in the world. He credits his early years in animation for his adaptability.

The sexy and dangerous Vampirella, as rendered by Al Rio, whose art style has made him famous the world over as a pinup artist.

This shows Al's adaptability as a more realistic artist.

This showcases Al's gray-tone pencil techniques.

This double-page spread offers Al's more cartoony, popular, adventure style.

ANTHONY TAN

Although he has been in the comic book business less then a decade, Anthony is well known in international children's-book circles, where he was asked to draw or paint kids' projects in every possible style, from fairy tale and caricature to scary and realistic.

Anthony created this sharp-edged, high-contrast style for a mixed-tone horror/humor series. Note that although Anthony's pages look like inks, they are actually tight pencils that have been scanned and adjusted in Photoshop.

This is Anthony's carefully rendered, manga-influenced style for an upcoming female fantasy series.

Anthony milked much comedy out of his humorous style thanks to the silly situations in this clever spoof on Robin Hood.

STARTLING SECRETS REVEALED: PUTTING IT ALL TOGETHER SO FAR

You know me . . . I'm always talking about comic books, and before you know it, I've revealed so many secrets from behind the scenes, you'd think nobody would ever tell me anything again! Well, you know how in previous chapters we talked about layouts and faces and reference and acting and action and all that good stuff? And yet some of you are still wondering how some tip-top artists, such is Mike Deodato, Jr., make their work seem so real, so raw, so powerful! Today's the day I tell you how. But I want you to promise it's just between you and me—that you won't tell another soul.

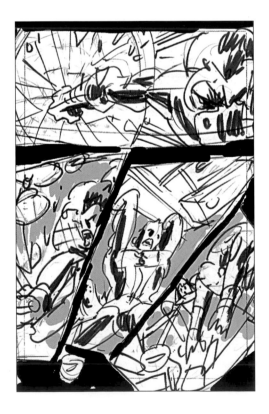

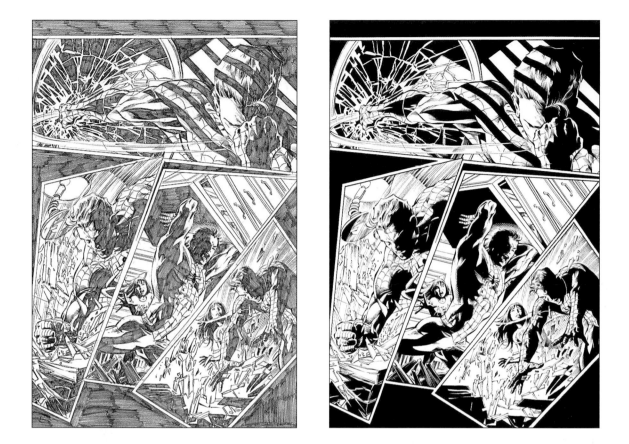

Step 1 (opposite, left): On page 91, you thrilled to this layout, as Peter Parker was given some bad news and got so angry he started trashing the place. Powerful, gut-wrenching, and emotional! Peter Parker just had to let it all out. Deodato did an amazing bit of storytelling.

Step 2 (opposite, right): But here's the part you didn't see. This is how a superstar like Deodato makes his pages look so real! His finished pages look photo-real because they are, indeed, photo-referenced—but you wouldn't suspect that he references himself!

 For virtually every panel Deodato draws, he has shot a reference of someone or something (usually several people and things). And he composes everything in Photoshop to match up to his layout. He has made multiple trips to New York City and shot thousands of photos. Where normal people take photos of themselves against landmarks, Deodato is snapping pictures of trash and toilet seats. His computer's hard drive is filled with thousands of photos. Nevertheless, he usually shoots new photos of himself in place of the superheroes that he draws! Notice how he pasted together photos in panel 1 to make his arm bigger for the proper level of foreshortening. See how he pastes a bigger shot of his head in panels 2 and 4 for the same reason. By the time he finishes, the photos match his layouts—not the other way around—and the final reference contains all the excitement and power the page requires.

Step 3 (above, left): Then it's a simple matter of printing out the finished reference at original art size, sliding it under his art board on his light table, and getting to work. Hours later, what you see below is the resulting beautiful penciled board.

Step 4 (above, right): And here are the finished inks! Usually Deodato either scans his work to print as tight pencils or he inks his own work, but on this series he jumped at the chance to be inked by Jovial Joe Pimentel, one of the finest inkers in all of current comicdom! Look at the beautiful line work that Pimentel puts over Deodato's already-amazing pencils! Intrigued by how such illustrious inking is achieved over such powerful pencils? Then it's time for the next chapter!

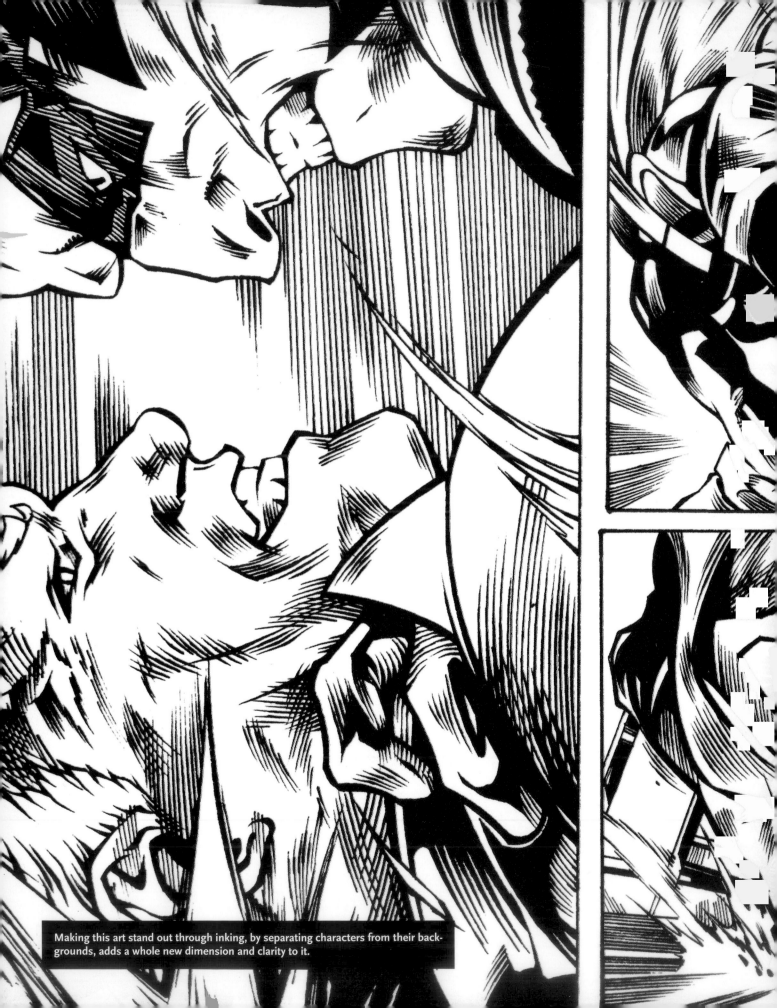

Making this art stand out through inking, by separating characters from their backgrounds, adds a whole new dimension and clarity to it.

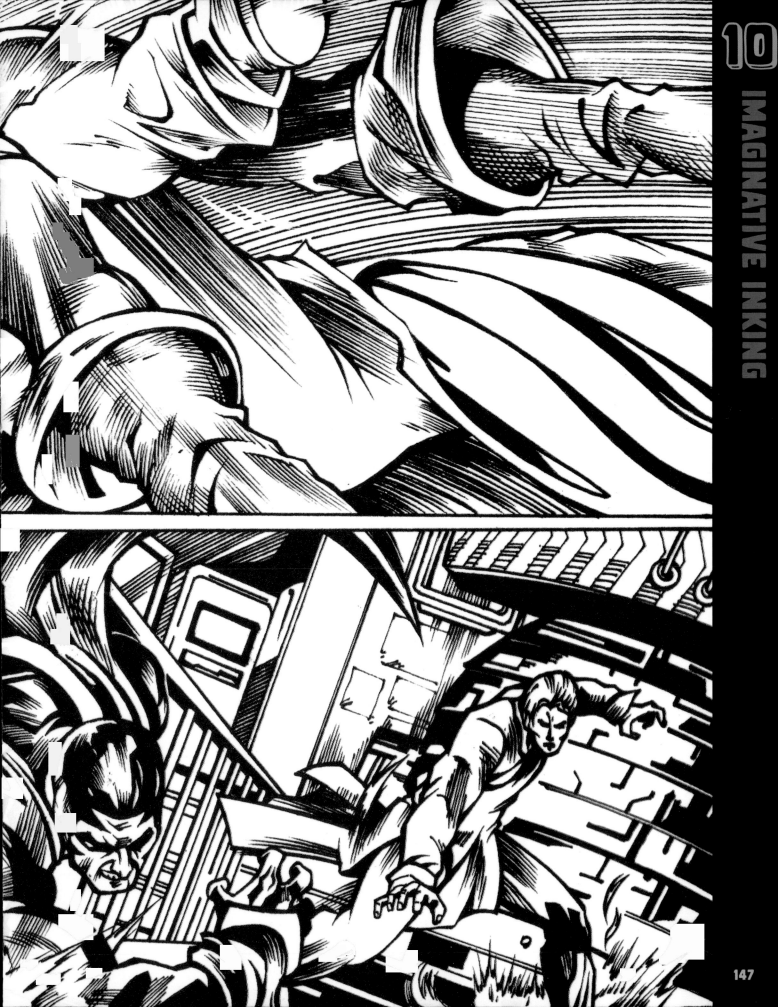

IT'S NOT TRACING!

I think my good friend Kevin Smith cast a shadow on the efforts of many fine inkers and finishers in the comic book industry when he riffed on the subject is his very funny film *Chasing Amy*. Poor, put-upon inker Banky Edwards, at a book signing, is repeatedly cajoled about being a "tracer" over his partner Holden's pencils. Let me state categorically that I agree with Banky's reply: "It's not tracing, all right?!"

Professional inkers are not tracers. Originally begun in the early days of comics to put down a solid black line over gray pencils for reproduction, inking developed into a way for a second artist to collaborate with the first. The best inkers take good pencils and make them better, catching and fixing mistakes, adding emphasis of textures and "thicks and thins" (lines of various weights) to add to the illusion of depth, and much more. That's why the best *inkers* in the business were also among the best *pencilers*. Often they chose inking because their dexterity with pen and brush meant they were faster, and more comfortable, working over someone else's storytelling.

This also led to the creation of *finishers*. These were top inkers who could work from a penciler's half-finished pencils (more detailed than layouts, drawn on the original art board, but not tightened and without black areas identified).

Improved digital techniques, tighter pencils, and better printing methods have also lessened the use of inking with some artists and publishers. Inking has sometimes taken the form of "digital inks"—a term that varies depending on who is defining it. It has also meant that many pencils are printed with only a bit of finessing in Photoshop, skipping the inking stage altogether.

Digital inking has come to mean two things: (1) digital cleanup and adjusting of line work to simulate ink lines using Contrast and Levels in Photoshop; and (2) actual inking of the artwork using a digital tablet. In this case, the inker uses all the same talents he or she would normally bring with pen and brush, except the same results are achieved using a pressure-sensitive pen and tablet—and there's no scanning involved afterward. Cleanup is done at the touch of a button.

"Traditional" inking, of course, holds a place near and dear to my heart. If you ever saw Jack Kirby's pencils finished by such varied inkers as Vince Colletta on *Thor*, Dick Ayers on *Sgt. Fury*, or Joe Sinnott on *Fantastic Four*, you'd see exactly what I mean. Each brought something special to the work.

Dick Ayers's inking over Jack Kirby's pencils for Sgt. Fury, #2, from 1963.

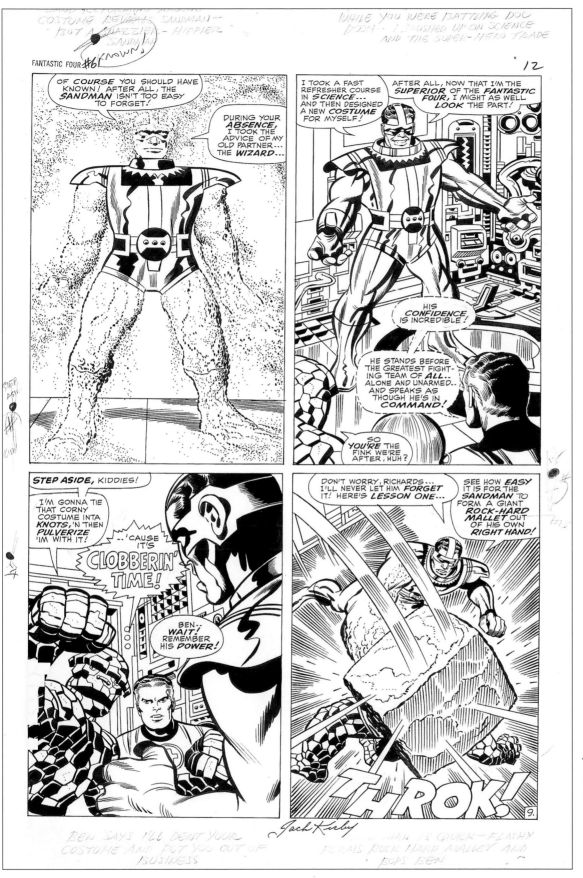

Joe Sinnott's inking over Jack Kirby's pencils for Fantastic Four #61, from 1967.

TOOLS FOR TOILING

Early on in the book, I identified the tools of the trade. Here are more specific recommendations for inking. The basic tools will get you started on inking your pages now, while the others to consider are for when you've mastered the basics and are ready to get down to business.

BASIC TOOLS
- brush
- crow quill
- technical pens
- pencil and eraser
- India ink
- acrylic white ink
- straightedge
- French curves

OTHERS TO CONSIDER
- A3 printer
- scanner
- Internet connection
- photo-editing software
- conditioner (for brushes)
- ink wells (for mixing ink)
- ultrasonic jewelry cleaner (for tech pen ink removal)
- light box

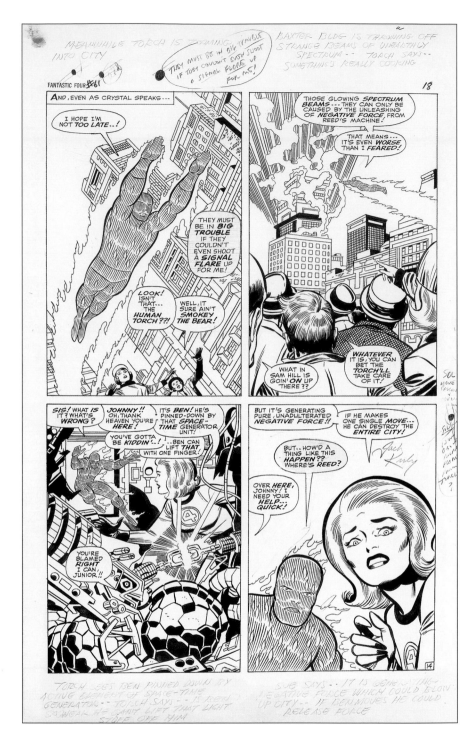

Joe Sinnott's inking over Jack Kirby's pencils for Fantastic Four #63, *from 1967.*

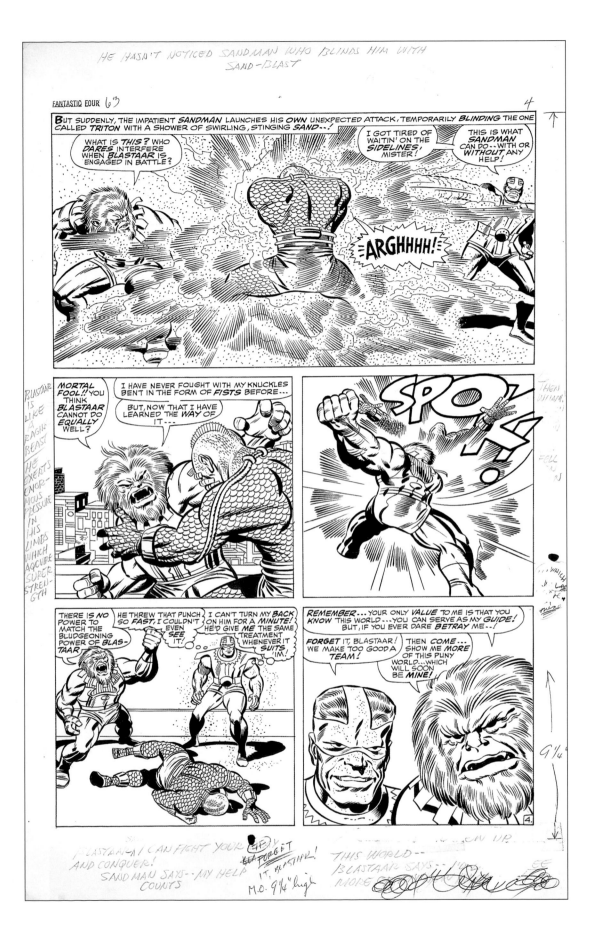

Another of Joe Sinnott's inking over Jack Kirby's pencils for Fantastic Four *#63, from 1967.*

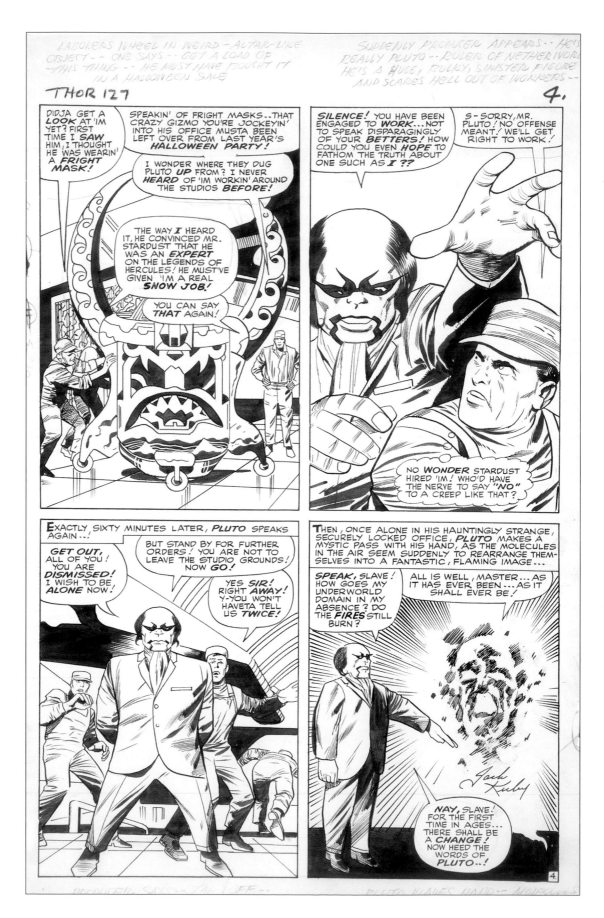

Vince Colletta's inking over Jack Kirby's pencils for Thor #127, from 1966.

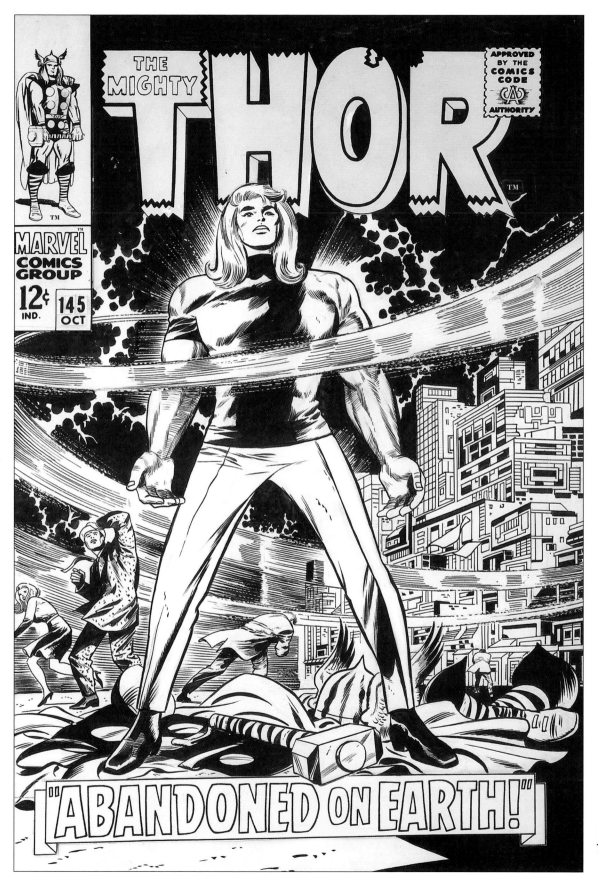

Vince Colletta's inking over Jack Kirby's pencils for the cover of Thor #145, from 1967.

THE PROCESS

Always have a copy of the actual page that you'll be inking for comparison and for reference purposes—it doesn't matter whether it's a printed page or the actual page itself. Always set your priorities when inking a page. Eventually, you'll have your own processes when inking. But here, I suggest an order you can consider when inking:

- Start inking the borders of the page (if applicable). Use a technical pen for borders.
- Concentrate on inking the thick lines throughout the page. Consider this as a way to warm your hands, as well. It's safer to work on the thick lines first until you're confident that you can finally work on portions of the page that require greater detail.
- Work on the finer details. While you're in good condition, you can now concentrate on the detailed portions of the page. Oftentimes, the female characters and faces require delicate handling. Sometimes, you lose a character's emotion by missing a line here and there.
- Leave the black areas for last, mainly for the reason that the comic book board on which you're inking will warp from being wet with the ink. You can certainly do the blacks ahead of time if you want to; however, it's easier to do hatching, cross-hatching, and feathering (see page 158) on flat paper or board.
- Don't work on the panels of a page in order. Think about where your hand might smear your inks. Work in a direction that minimizes smearing. Many inkers will work on several pages at a time, doing all the straight lines, then all the heads, then all the clothing, and so on. Figure out a way that works best for you.
- Don't tape down your pages. Your hands work best moving in certain directions, doing certain strokes. Maximize your talents. You may end up spinning your pages around quite a bit—and that's OK!

BEFORE YOU BEGIN . . .

- As you gain experience working with ink, you will learn what works best for you. You don't have to do what other inkers do. These steps are simply alternatives and may guide you as you discover your own process.
- Always warm up. Briefly work on your lines and strokes on a separate sheet to ensure that you have the proper command of your hands.
- Exercise. Exercising (push-ups, pull-ups, crunches, and so on) helps with your processes. Meeting deadlines can be stressful. Having a way to release that stress is critical to your longevity in the business.
- Practice, practice, practice! And if you think you've practiced enough, practice some more! Don't just be better at it—but be the best there is at what you do. And practice is the key to being the best.

ORIGINALS, PHOTOCOPIES, AND DIGITAL SCANS

As an inker, you'll be working not only with original penciled pages but also with photocopies or printed-out scans of the pencils—either by inking on a light box or by printing the image in a light-blue ink onto art board. Most pencils being inked today are sent to inkers via digital file and are printed on their own on an A3 printer. There are benefits in inking the printed copy rather than the original. Mainly, you keep your work. Inking over a blue line is also easier, since you don't have to erase the pencils. The blue lines are easily removed through a photo-editing software when art is scanned and converted to a black-and-white image. Here are some things to consider when inking:

- Ask yourself, "What happens to my lines if the art gets reduced to a comic book page?" Comic book boards are 11 x 17 inches and get reduced to the standard comic book format. Always consider that too thick of a line can overpower a panel/scene and too thin of a line can potentially disappear when reduced. Copy or scan your finished page and print it out at the size it will appear in the finished book to make sure it looks right.

- No need to reinvent the wheel. As a starting inker, you shouldn't try to be innovative with your inking style until you've mastered the basics: contrast, depth, and mood.

- You're the last line of defense. It's helpful to sometimes have the script, since you can compare the penciler's work with the actual script that the penciler used (what should have been a wire fence may end up being a stable fence, and so on). Again, it doesn't hurt to ask for clarification when you don't understand something on the page. You can move on to other details while waiting for a response to your query.

In this page showing Vince Colletta's inking over Jack Kirby's pencils for Thor #152, you can see that all the inking line work reads well. Nothing is too overpowering or too lightweight for the various subject matter.

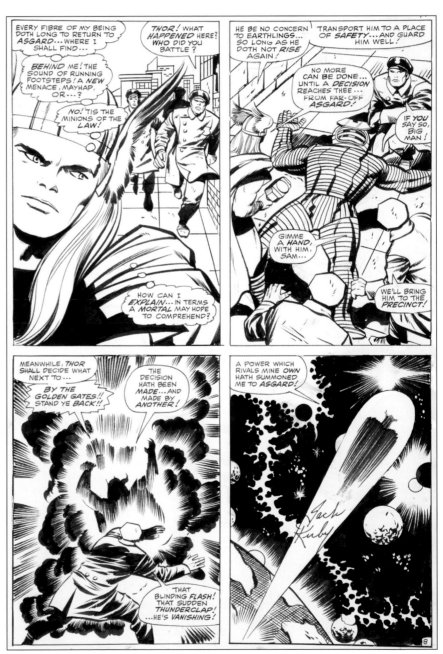

V IS FOR VERSATILITY

A good inker has to be versatile. Pencilers will always have preferences in how their pages are handled. These preferences are, at times, hard to accommodate but should be doable if you are versatile. But what does that mean? Some pencilers put down most of what you need but leave tiny details for you to complete: finish off hands, use a ruler where they free-handed a sword, and so on. Others pencil in just one line weight and expect the inker to add line weights. Still others prefer that you just ink their work as is rather than adding a lot more to it. And the rest are in between. Versatility is the key.

Some inkers are called on to do a *lot* more than ink. If editors know they can depend on your penciling skills, they can also entrust you with significant alterations when there's no time for the penciler to handle things. For example, I have to look no further than my own collaborations on *Spider-Man*. For a time, my long-term coplotter and artist, John Romita, was off drawing another book and the great Gil Kane was penciling Spidey for me. In the story, Peter Parker and Mary Jane and Aunt May all attend a funeral. As I started scripting dialogue from the pages Gil had penciled, I discovered a few things that needed adjusting. Fortunately, John Romita still found time to *ink* the book, and he could adjust things for me as he did. Compare the two versions to see what I mean.

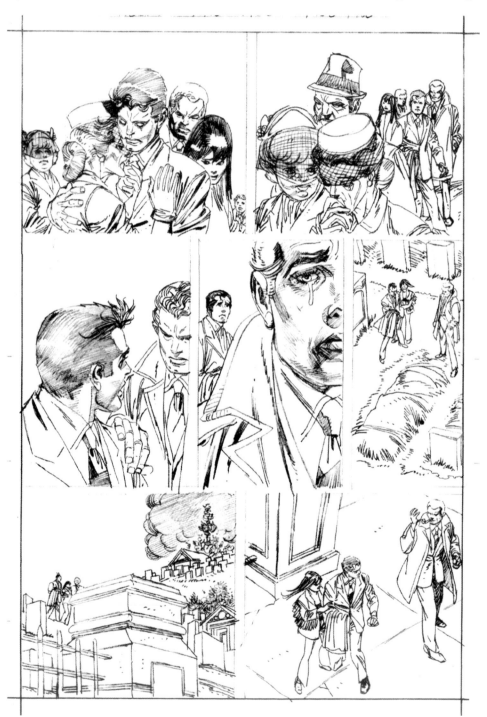

Panel 1: LOOK ON **ONE** OF THESE MOURNERS, PETER PARKER... WHO HIDES IN HIS SOUL THE SECRET OF **SPIDER-MAN:**

SHE WAS SO **YOUNG,** PETER. WHY DO OLD FOOLS LIKE ME LIVE **ON,** WHEN SOMEONE WITH HER WHOLE **LIFE** AHEAD OF HER...

PLEASE, AUNT MAY... DON'T SAY IT.

SOMETIMES THINGS JUST **HAPPEN.**

SOMETIMES THERE'S NOTHING WE CAN **DO.**

Panel 2: COME ALONG, MAY... GWEN'S GRANDPARENTS WANT TO **MEET** YOU.

YOU AND SHE WERE **CLOSE...**

...YOU SHOULD **SPEAK** TO THEM.

DOC OCK'S GUARD FOLLOWS HER **EVERY-WHERE...**

...EVEN **HERE.**

Panel 3: SAY, **PETE?**

LISTEN, PAL... I JUST WANTED TO TELL YOU, GWEN WAS THE **GREATEST.**

SHE ALWAYS LIKED YOU... THERE WAS NEVER ANYTHING **BETWEEN** THE TWO OF US ...**CAPEESH'?**

Panel 4: **SURE,** FLASH... I UNDER-STAND.

I HOPE YOU'LL **FORGIVE** ME--

BUT RIGHT NOW, I DON'T FEEL VERY MUCH LIKE **TALKING.**

Panel 5: SOON, ALL THE MOURNERS HAVE **LEFT...**

...AND ONLY **THREE** REMAIN.

Panel 6: PETE... JONAH SENDS HIS **CONDOLENCES,** BUT HE JUST COULDN'T **MAKE** IT THIS MORNING.

HE SAID SOME-THING ABOUT **"OTHER BUSINESS"...** AND HOPED YOU'D ACCEPT HIS **APOLOGIES.**

WHY **NOT?**

Panel 7: HE NEVER TREATED GWEN LIKE MUCH WHEN SHE WAS **ALIVE.**

WHY SHOULD HE PAY HIS RESPECTS **NOW?**

I KNOW YOU DON'T **MEAN** THAT, PETER.

JONAH CARES. HE'S JUST... SOMETIMES... **TACTLESS.**

SO WHAT **ELSE** IS NEW?

6

CAN THE AVENGER CALLED **HAWKEYE** TAKE ON THE DYNAMIC **DEFENDERS?**

In panel 1, "Robbie" Robertson and Aunt May's friend were removed because they weren't crucial to the scene. In panel 2, John removed the coat Peter had hanging over his arm, and Aunt May's gloves and hat were removed because they seemed a little too old-fashioned, even for May Parker. He even turned MJ away and adjusted Aunt May's hand somewhat. In panel 2, various background characters are placed in shadow so that we don't lose focus on Aunt May or Doc Ock's guard behind her. For panels 3 and 4, Robbie Robertson has been replaced with Flash Thompson! In panel 5, John added shrubbery because it seemed right for the scene. For panel 6, he removed the clouds, because they took the reader's eye away from the word balloons. For panel 7, MJ's swingin' clothing didn't seem right for a funeral, so John redrew 'em. He also redrew MJ and Peter's poses completely to make their body language more befitting a funeral. And John was "just" the inker. "Tracer," indeed!

TEXTURES

One of an inker's most important jobs is understanding textures. Simply put, you don't ink a rock the same way that you ink hair. Mashed potatoes shouldn't be inked the same way as mountains. Clothing isn't inked the same way as wood or metal. With that in mind, let's review some textures and techniques.

SPLATTER

Load a brush with ink. Then flick it against another object, such as a crow quill. Always keep your hands clean. Avoid using your fingers, since it could get messy. As an alternative, you can also use a toothbrush for this technique.

FEATHERING

It's easier to do feathering using a brush instead of a crow quill. Of course, if you're more comfortable with a crow quill, feel free. Start from light strokes to much heavier strokes or do the reverse.

DRY BRUSH

You can do this by loading up your brush just half-full with ink. By doing that, your brush will run out of ink faster than it normally would, and that will create the fading-ink effect.

CROSS-HATCHING

The first three examples of cross-hatching were done using a crow quill. Line weights can vary for this technique. You can create different shades of shadow just by adding crisscrossing lines until you reach the value that you desire. The last two were done with a brush; the lines are much thicker, and they go from thin to thick. This will create a darker value with fewer crisscrossing lines.

OTHER MARKS

These marks were done with a brush. The brush is much easier and faster to use for various textures. Just by changing the pressure, direction, or even using the side of the brush, you can create different marks and textures.

VARIOUS LINE THICKNESSES

Varying the pressure you apply to your brush or pen alters the thickness and weight of the resulting line and adds life to it.

ROCK

The shadow on the lower part of the rock is very strong. It's best to ink that part as is. By having a thinner outline on the top part, it gives contrast to the stronger and thicker bottom part of the rock. To give a little bit of texture, you could use a bit of ink spatter on it or a dry brush for effect.

BOTTLE

White ink is added to this image to get the effects seen. A streak of white ink gives the form a sense of three-dimensionality, since it pushes back the lines that should be at the back part of the bottle.

METAL PIPE

You can use a straightedge for the outline of the pipe to give the metal a hardened feel. If you feel like the shadow doesn't give the object the effect that it should have, as an inker you should change it; remember, part of your job as an inker is to be a visual editor, as well. With this pipe, the interior shadow was changed to create more depth and a 3-D look.

BRICK

Not much has been done to change this brick from its penciled version, but you can also use a bit of ink splatter or dry brush to achieve a rougher texture on it. Concentrate on inking while maintaining the penciler's style.

FRUIT

This fruit is pretty basic: The short hatching goes with the direction of the shape to give it a rounder effect, and there's slightly denser hatching at the bottom to give the image the 3-D look.

WINGS

By adding a lot of thick and thin lines, the image looks softer and more feathery in effect.

MIRROR

You can ink this as is. However, if you want to be more creative, you can put a streak of dry-brush effect instead of just placing lines across the surface to give it a sense of reflection.

CAPE

By using a thicker brush on this image, you can give the cape a more rugged, "furry" texture instead of a finer, more expensive, fur look.

ARMORED ARM

While time-consuming, rendering these details is pretty straightforward: Carefully ink each "scale" of the armor to give it a more jagged, rough-metal feel. You can also use white ink to separate the individual plates of the shiny part of the fingers.

TREE TRUNK

By leaving a bit of white streaks on the shadowy part of the tree, it won't look like just dead space. It's another way of adding texture on a blackened area.

INKING X 3

For comparison purposes, how about we look at a popular penciler and how three different inkers would approach his work? Jonathan Lau is a strong penciler and great storyteller whose work is often printed straight from the pencils. As you'll clearly see, even over a tight penciler with an identifiable style, each inker brings his own imagination, tools, and techniques to each page. Different editors would have different preferences, yet each version of this is a valid, professional inking style. What's your version?

ALEJANDRO SICAT

First I turned to USA-based inker Alejandro Sicat and asked him to wax poetic on this assignment. Here's what he had to say: "With this kind of detailed work, the only thing you can pretty much do as an inker is to make sure you do not lose any of the detail the penciler put on the paper. Losing the detail or the style of the penciler is basically the worst thing you can do as an inker."

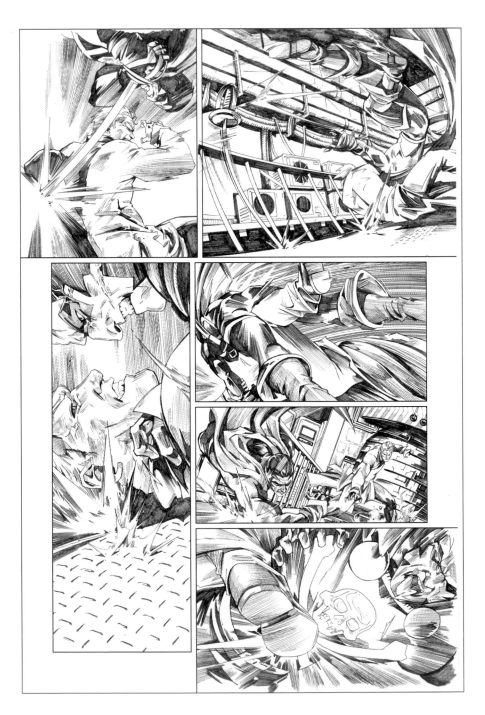

For the majority of this page, Alejandro used a brush to ink but could have easily used a crow quill. It's simply a matter of comfort. The tools used for this page were a Winsor & Newton Series 7 #3 brush, a crow quill (nib #102), and a Pigma Micron 005 felt-tip marker. A straight-edge, French curves, and oval templates were also utilized.

This page has a lot of speed lines, you can ink these lines either free-hand, if you have a steady hand, or use a French curve or straight-edge. Using French curves, templates, or a straightedge is not considered cheating. There is no such thing! Use whatever you can to do the job and do it well. Different tools were pur-posely utilized for this entire page just to show you that different tools can make similar marks and could look alike. But that doesn't mean that if you know how to use one tool you don't have to learn how to use the others. Remem-ber: Every tool has its limitations!

Here's the breakdown, panel by panel.
Panel 1: The figures were done with a brush, but the speed lines are noticeably all uniform in weights and evenly spaced out. This was done by using a French curve and a felt-tip marker. The outlines of the characters are thicker just to give some separation from the speed lines.

Panel 2: The figures again were done using a brush, but the backgrounds were mostly inked with a felt-tip marker and the rest were inked over with a brush. You can also use a halo effect around the character, but with all the speed lines, it could get a bit messy, so don't overdo it.

Panel 3: Aside from the speed lines between the two characters, everything else was done with a brush. The outlines were thicker than the speed lines and facial cross-hatching. As a result, the faces of both characters were effec-tively separated.

Panel 4: This panel is a mix of brush, quill, and felt-tip marker for the speed lines. Can you tell which parts were inked over by which tools?

Panel 5: The two characters were inked with a crow quill, and the background was done with a combination of brush and felt-tip marker. The character in the foreground has a thicker outline than the second character.

Panel 6: 100 percent brush.

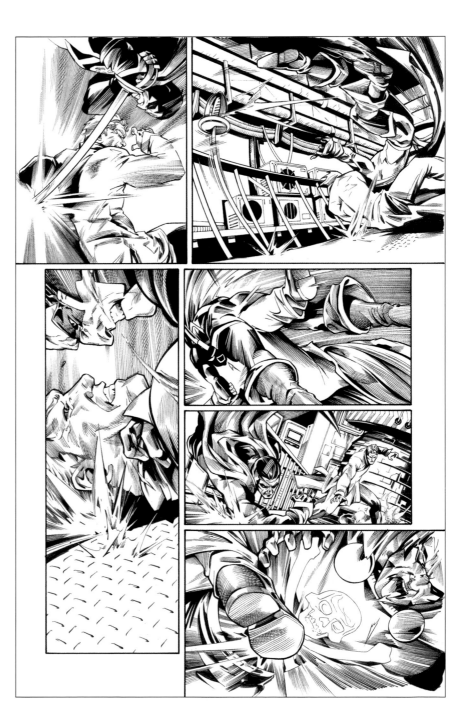

DAN BORGONOS

Here's the same page inked by another top-notch inker: Dan Borgonos, who has inked for a variety of publishers. He works entirely with pens.

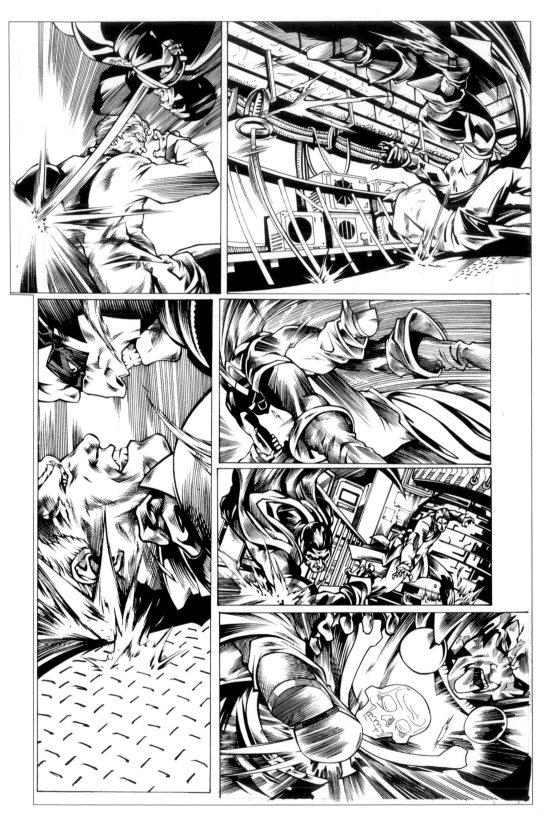

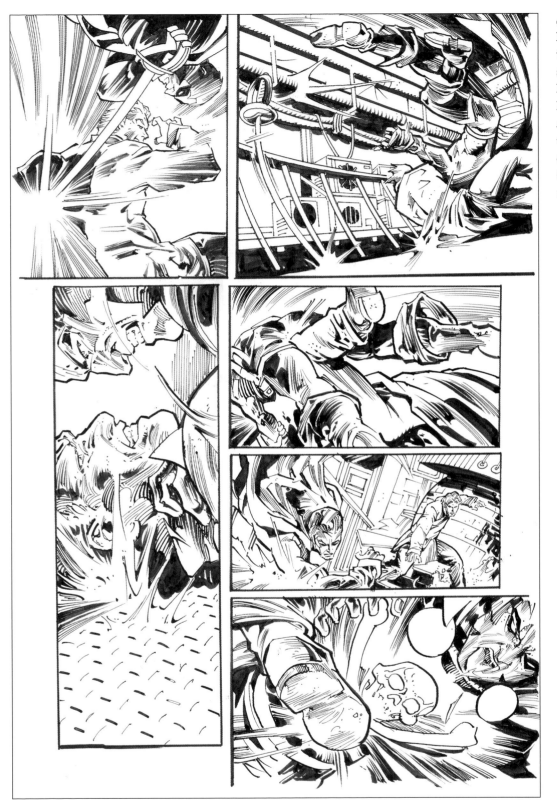

JUN LOFAMIA

Now here's a real treat! It's the same page inked in a classic Silver Age brush style by Jun Lofamia, one of the legendary Filipino artists who amazed the American comic book market with incredible brushwork at Marvel, DC, and Warren Comics. Jun was given permission to "do his own thing."

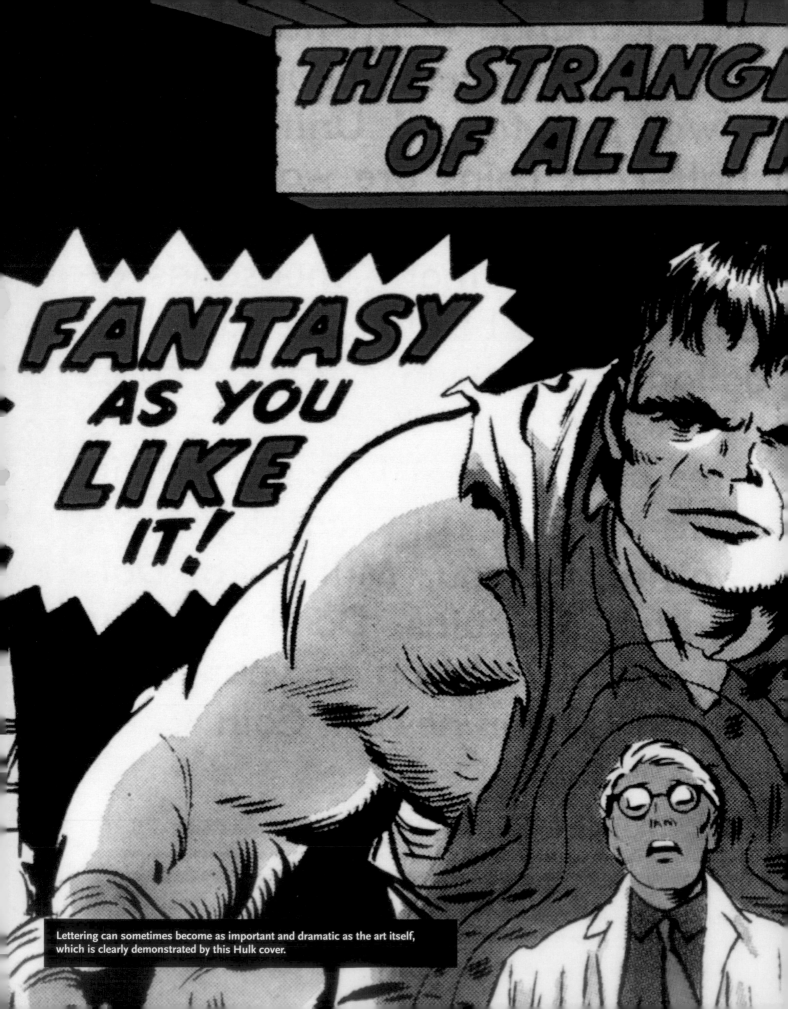

Lettering can sometimes become as important and dramatic as the art itself, which is clearly demonstrated by this Hulk cover.

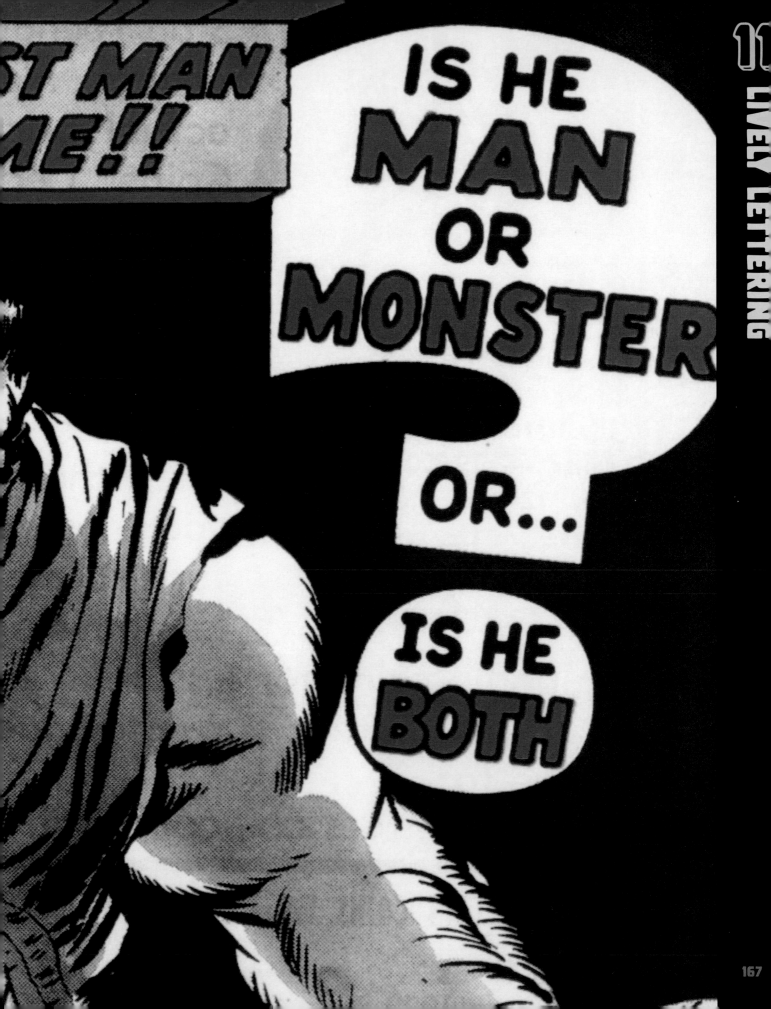

LETTERING: STORYTELLING AND VISUAL FLOW

Ah, those lovely, lively, loquacious letterers! They're the unsung heroes of the comic book world. Letterers receive the least amount of "star" attention amidst the creators of comics, yet it is their work that our eyes focus on most when we're *reading* a comic book. Paradoxically, the letterers who do the *best* jobs should get the *least* notice, because their work is all in service of the story (practically invisible, in a sense, rather than calling attention to itself).

Understand that the letterer's job is equal in importance to that of the writer, penciler, inker, and colorist in creating a successful comic book. Placement of a word balloon or caption can make or break the reader's experience. Even in the modern world of digital lettering, a knowledge of storytelling and visual flow separates the amateurs from the professionals.

So, before we can get our hands dirty with the actual chore of lettering, we first need to look at how a letterer helps keep the story flowing visually. The format of reading books from left to right, top to bottom has been ingrained in our minds from the moments we first learn to read. Comics are read in the same fashion. The comic book page is made of multiple panels that we read from left to right, top to bottom. (Unless we're reading or creating authentic manga; Japanese comics are read back to front, right to left.)

Our eyes have been trained to follow this pattern, and the artist uses this to guide the reader's eyes from scene to scene. Even without dialogue to help describe the action, we already have visual clues that lead our eyes. Without words to help us determine what to focus on, we will usually notice faces first, then dart around to anything that catches our eye, such as explosions, shiny objects, or lampposts. The reader will spend time guessing what information may be important and possibly lose the intended visual flow of the story. That's where the letterer helps.

Adding dialogue can either hinder or help the flow of the art. The letterer needs to be able to recognize the flow of the action and place the lettering in areas that will create focal points and move the reader's eyes smoothly from one focal point to the next. Keep in mind that, in some cases, the writer or the editor will place the word balloons for the letterer, numbering the balloons and indicating placement on photocopies; that was standard operating procedure for many years. More recently, with files transmitted electronically, that step is skipped. The letterer is expected to handle it and, with these tips, you can!

Death-Defying Devil as drawn by Edgar Salazar. Note that without direction, the eye will dart around looking for information. Well-placed dialogue gives the reader a smoother and more enjoyable visual path.

BALLOONS, CAPTIONS, SOUND EFFECTS . . . AND GASPAR SALADINO

Before we get into the nitty-gritty details of placing lively words into even livelier balloons, we need to look at some of the *best* lettering as a baseline and point of inspiration. Every art form has its legendary artists, and lettering is no exception. Beginning in the 1950s, a supremely talented and hard-working individual named Gaspar Saladino brought a much-needed uniqueness of style to comic book lettering. His logo designs were revolutionary. His lettering styles and techniques created a high-water mark to which future generations of calligraphers could aspire.

Unlike a novel, a comic book doesn't always have the ability—or need!—to use words to describe a character's vocal volume or the depth of emotion that the writer intended. Where a novelist might write, "The hero whispers in a weak, trembling voice, 'I will avenge you if it is the last thing I do,'" the comic book letterer will convey that whisper visually with a whispering word balloon (indicated by the dashed outline).

You can easily change the mood of the scene by changing the style of the lettering and by altering the word balloon. Here, what was a quiet, desperate, and private moment in the whispering word balloon is easily changed into a loud, angry, forceful one. That's the power present at the letterer's fingertips!

IN THE CLUTCHES OF DARKSEID!

THE DODO and the FROG

OKAY, HEROES!! YOU'VE MADE IT INTO DR. CYBER'S LAIR!...

DR. REGULUS

"The FILES and of DR. GEIST"!

DOCTOR LIGHT

--OR I'LL BE DESTROYED BY DOCTOR ALCHEMY!

DARKSEID

Gaspar had many dynamic attributes in his lettering, allowing words that were within a frame to become more enhanced.

The lettering in this ad for Sgt. Rock's Battle Stars *says it all about war.*

Top letterers use their artistic talents to help readers feel the emotions of the characters. Use of stylized word balloons and varying type sizes gives the dialogue a breath of life that was often missing.

Narrative caption boxes can also convey a certain theme, and Gaspar created some wonderful examples over the years. Where a simple rectangular box may be good for narration of a modern story taking place in New York City, a more intricate box—such as this one made to look like a scroll of parchment—can help to transport the reader to a medieval land filled with dragons and barbarians.

SPLASH!

SPLONK ZONK!

BLOOF!

Sound effects, often abbreviated as SFX, offer some much-needed fun. Here, the letterers can show their artistic side by creating imaginative and powerful effects that will enhance the story and make the writer proud of every SPAKK!, POW!, BLAM!, and BA-DA-DA-BOOM!

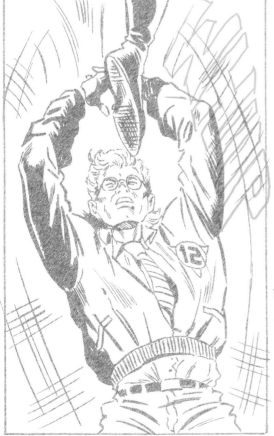

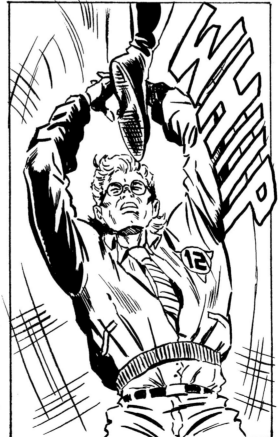

Given that most hand lettering is completed before the inkers work their magic, letterers will be drawing directly over pencilers' work. If letterers need to erase mistakes on the sound effect, they are going to be taking some of the pencilers' work off with it. Because of this, it may be best to pencil the SFX on a separate sheet of paper first, then use a light table to trace the finished design onto the artwork.

These two panels show the letterer's work in place prior to inking and then after inking.

HAND VS. DIGITAL LETTERING

Now that you've seen how lettering, like other comic book elements, is bound only by the length and breadth of your imagination, let's look into both lettering methods used today: hand and digital.

BA-THOOM! By the time the twenty-first century arrived, digital lettering exploded all through the comic book industry. Using computers and such programs as Adobe Photoshop and Adobe Illustrator, most letterers not only improved productivity but also could offer literally thousands of different lettering styles. Online "type stores" provide the letterer with an almost endless supply of unique fonts and premade sound effects—and can even sell you drag-and-drop word balloons. Digital lettering opened up many fresh options for today's letterers, but some still prefer the more natural, organic and—dare I say it?—artistic aesthetics of a hand-lettered page.

So, which is better, hand lettering or digital? It's simply a personal preference, but in fact, many of today's letterers provide a mix of both methods. In terms of productivity, digital lettering is frequently faster than writing everything out by hand, but nothing satisfies the artistic desire in a letterer as much as drawing out a cool KA-BLAMMM! sound effect against the backdrop of an explosion, the screeching SKRRRINCH! of smashing metal, or a gut-wrenching NOOOOO! as our harried hero screams out to the sky while cradling his dying sidekick. Letterers can draw out the sound effects on art board, scan them into their computer, and drop them into the page amongst the typed dialogue that is simply copied and pasted from the script, converting the words into the appropriate font.

Here's an observation worth noting: Just as the best inkers are also pencilers, the best letterers are also artists in their own right. Some have drawn their own strips. This means that letterers who use digital lettering, because they can't do it by hand, have to work a little bit harder. Here's why:

Digital lettering that *looks* like it was created on a computer is not successful lettering. Great font choices and even manipulating word balloons so that they look hand-drawn (rather than being perfect ellipses) help digital lettering to look more organic, and therefore natural, on the page.

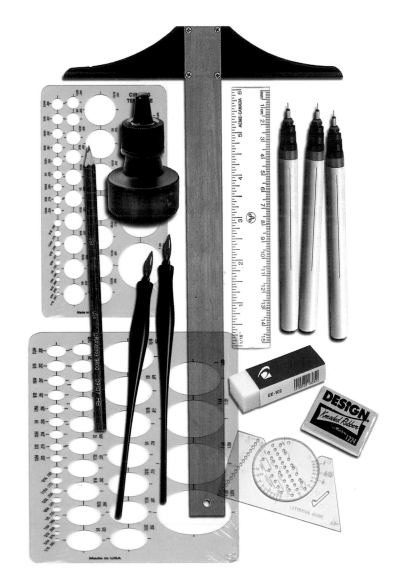

The tools are simple. A professional letterer will need a drawing table; a T square; a ruler; a little plastic device called an Ames lettering guide; an assortment of pens, pencils, erasers, and inks; assorted circle and oval templates; and opaque white (for correcting mistakes).

HAND LETTERING

I adore hand lettering. Swingin' Sammy Rosen and Adorable Artie Simek and Gregarious Gaspar Saladino (mentioned previously) were the best in the business when I was writing comics regularly. I'd pencil in the balloon shapes lightly right on the penciled original art, and they'd follow my cues, penning in my pithless prose and silly sound effects with equal aplomb. Then the art would be sent off to the inker.

In later years, as deadlines got tighter, hand lettering was done on vellum and painstakingly cut out and pasted up on the already-inked artwork. Some production people never even realized the "normal way" meant lettering onto the physical original artwork!

The best guys and gals make it look easy, but lettering by hand can be a time-consuming and arduous task. It sounds like an incredibly simple thing to do. In theory, all you need is a pen and the ability to copy the words from a script to the art board. But in practice, you need to develop patience, impeccable penmanship, and an eye for detail that will catch mistakes before they happen.

To get started, draw out some guidelines to make sure you're writing nice and straight, with even and uniform spacing between lines. First, determine the area you'll be writing in, and then draw out some rows of lines. (Check with your editor for any lettering size specifications.) On a full-size 11 x 17–inch comic book art board, the lettering should be approximately 1/8 of an inch high with 1/16 of an inch space between lines. Using your lettering guide, drawing these lines should be quick and accurate.

Then, before you start writing anything in ink, it's a good idea to quickly sketch the lettering out in pencil to be sure that everything will fit in the area you've selected.

Once you're sure there's enough space, start drawing out the text in ink. Many hand letterers work with a Speedball (or equivalent) B-6 pen point that they sand down slightly with a whetstone or fine sandpaper and the best India ink they can find. But the best advice is this: Experiment with different types of pens and inks to determine which will provide you with the best results and most comfort.

Captions, word balloons, and other balloon forms need the same thought and care before being drawn out in ink. Draw your balloons and boxes in pencil first, before finishing them in ink.

DIGITAL LETTERING

Is there anything that a computer can't do these days? Lettering can now be done in a fraction of the time with a simple computer trick known as "cut and paste." Aside from an image-editing or design program, such as Adobe Illustrator or the ubiquitous Adobe Photoshop, you'll need some good fonts. As I mentioned, there are "font stores" on the Internet that sell standard and unique lettering fonts. There are, literally, thousands of styles out there ready for your perusal, some of them created by the best hand letterers in the business. You can also find programs that will let you create your own digital fonts, which can give your work that edge of uniqueness that the story may require.

Sound effects can be just as easy by using either premade effects that you can just copy and paste onto the page or by typing out the effect and then applying different treatments available in your editing program. Got it?

A selection of digital comic book fonts.

FANBOY HARDCORE

ARMOR PIERCING

CASKET BREATH

LETTER-O-MATIC

MONKEYBOY

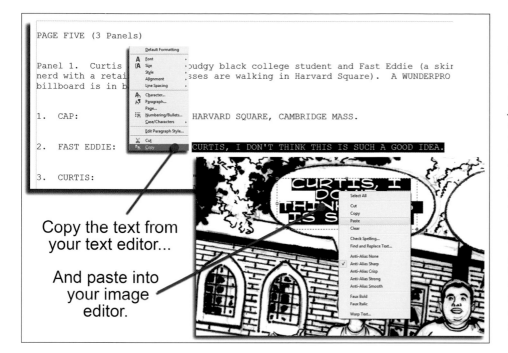

Copy the text from your text editor...

And paste into your image editor.

To start, you'll need the image-editing program of your choice, a stable of professional-quality comic book fonts (because one or two won't be enough!), a high-resolution digital scan of the artwork to be lettered, and the script. Just about every writer working today submits scripts in digital form, so your editor should be able to send you a copy of the script via e-mail so that you'll be saved from the tedious task of typing every word. You can simply cut and paste the dialogue from the script to the image-editing program.

Then open your artwork file in the image editor, and open the script with your text editor. Select and copy the first portion of text that you want to add to the artwork, and paste the text into the artwork file. You'll want to be sure that the text remains editable so that you can make changes later. Most image-editing programs will allow this.

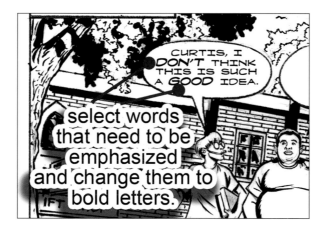

select words that need to be emphasized and change them to bold letters.

You can easily select individual words or sentences to change the style or color, make things bold, or even correct the occasional spelling error. This is really important: Proofread everything. Three times. If in doubt about a word, look it up! You are the last person in line to review this script, so it's your responsibility to make sure the final lettering is typo-free!

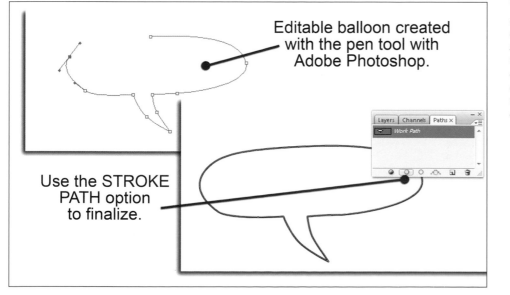

Editable balloon created with the pen tool with Adobe Photoshop.

Use the STROKE PATH option to finalize.

Word balloons and dialogue boxes are an easy task, as well. Most image-editing programs let you make simple shapes, such as ovals and boxes, and then manipulate them to create the classic balloon shapes that we all love and admire. Adapting them so that they appear more organically hand drawn will come with practice.

Color has evolved in comics over the years from simple four-color, as seen here, to ultra-rendered extravaganzas.

NOT YOUR FATHER'S COMIC BOOK COLOR!

If you're a seasoned comics reader, you remember that comic books for the longest time were printed on cheap newsprint with an extremely limited color palette. Officially, there were sixty-four color choices spun out of "screens" of 20 percent, 50 percent, and 100 percent shades of magenta (red), yellow, cyan (blue), and black—but the paper was so poor that about a third of those colors printed like mud and were therefore ignored.

Not anymore! The advent of computer color, not to mention much-improved printing and paper stocks, arms you with choices as wide as your imagination. Certainly, some colorists prefer other methods, particularly in Europe (where painting original art, or blueline or grayline stats of the art, remains popular). But we'll deal here primarily with computer color, which accounts for most of the coloring created for today's comic books and is mostly done using image-editing programs such as Adobe Photoshop or Corel Painter.

Being a colorist, of course, is much more than simply dropping in color like on a coloring book. The comics colorist is also a storyteller. His or her masterful use of color in artwork helps to convey mood, feeling, a sense of time, a sense of place, and a sense of perspective. Coloring, just like penciling and the other disciplines in this book, takes work, study, and practice to master. And yes, the incorrect use of color can ruin an otherwise well-told story.

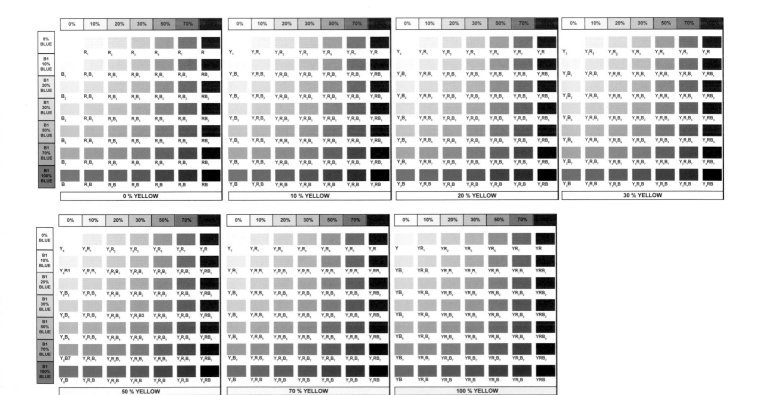

A 64-color grid gives you an idea of the range of colors out there!

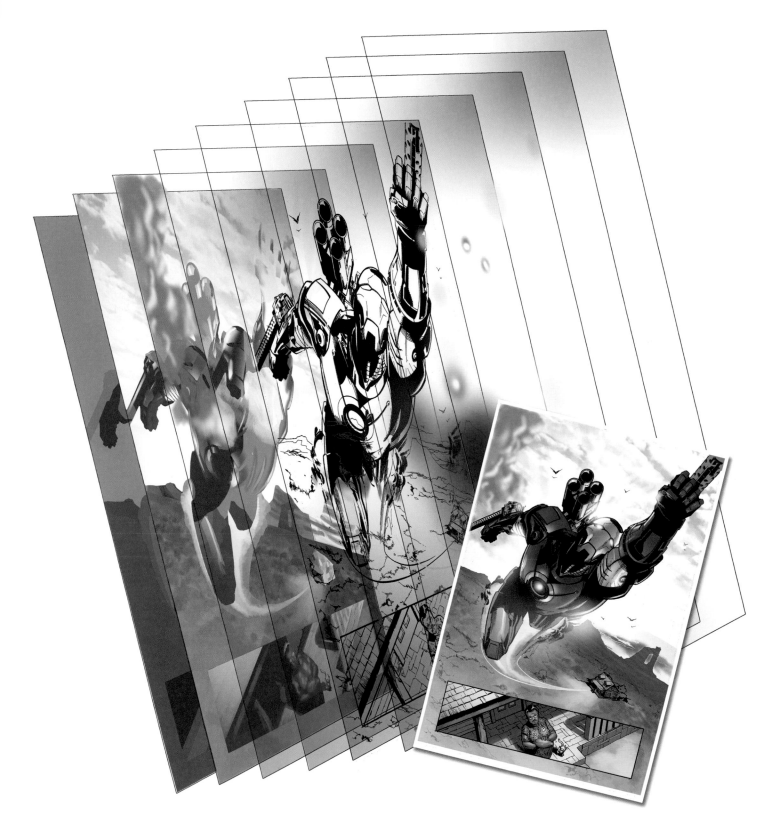

This is an exploded view of Photoshop layers making up a completed page. Different elements of the artwork (such as line, flat color, and special effects) are "stacked" one on top of the other to create the final image.

BASIC COLOR THEORY

To begin dealing with color, you should know the basics. Color theory seems like it would be a very simple concept, but in reality, we could spend hundreds of pages discussing it. To start, take a look at these three images.

100% **50%** **0%**

We have three black boxes. Each has a "black" circle in the center of it. The first box has a circle of 100 percent black. Obviously, you can't see the circle because it's the same color as the box. On the opposite end, we have a 0 percent black circle. There are two things to note about this circle: (1) 0 percent black is an absence of black, and (2) the resulting white circle offers the highest contrast to the black box. Contrast is the difference between colors that makes one appear to be more evident. In the first box, you can't distinguish the black circle from the box because there's no contrast. In the second box, the gray circle is noticeable, but the third box exhibits the most contrast.

Black and white are opposites. Opposites yield the greatest amount of contrast. Every color has an opposite. We can use a color wheel (right) to see the opposite of any given color. Colors that are opposite each other on the color wheel are called complementary colors. As you can see, the opposite, or complement, of red is green; the opposite of blue is orange; and the opposite of yellow is violet.

Every color wheel will also display the primary colors (red, yellow, and blue), so called because they cannot be mixed from any other colors. A basic, 6-color wheel such as the one seen here will also display the secondary colors (violet, orange, and green), which are produced by combining two primaries. Red and blue make violet, red and yellow make orange, and blue and yellow make green.

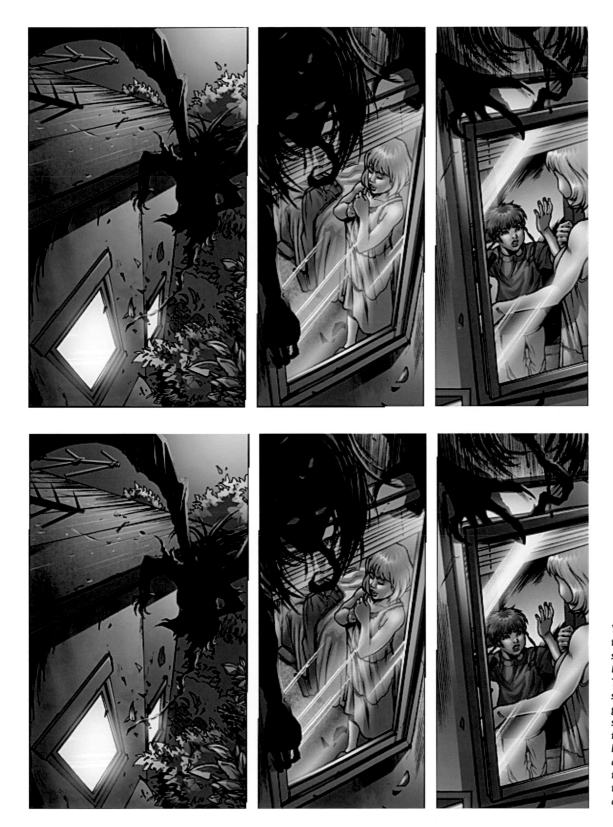

You can use complementary colors to make objects stand out in a picture. Look at these two images. The first one is colored in shades of blue. It looks good, but nothing really stands out. Now look at the next version. Much better! One of the characters stands out from the rest of the picture due to the use of orange, the complement of blue.

A 12-color wheel will include the tertiary colors, which are made by combining a primary with a secondary. The six tertiary colors are red-violet, red-orange, yellow-orange, yellow-green, blue-green, and blue-violet. In addition, you can use the color wheel to consider analogous colors, which are colors that are contiguous on the color wheel and have in common one primary. Typically, an analogous grouping consists of a third of the wheel, so that would be four colors on a 12-color wheel. Analogous colors can create a sense of harmony in a picture but still maintain a small amount of contrast. This is useful when you want to separate objects but not give emphasis to any one element.

Choosing colors that allow the reader to distinguish one object from another is one of the most important aspects of the colorist's job, and one of the most important aspects of color that allows this is called value. Value is simply how dark or light a color is. White is the highest-value color, while black is the lowest. An easy way to check the values of your colors is to convert your image to grayscale. By desaturating the spectrum, for example, you can see the value of each color; the lighter colors, such as yellow, have a much brighter value than the darker colors, such as blue. You want the values of your main objects to contrast against the background.

Finally, you need to be aware of a color's temperature. All colors are considered either warm or cool. Red and yellow are warm colors, while blue and green are cool colors. Of course, color temperature is relative to the surrounding colors. For instance, the yellow to the right looks warm compared to a blue background, but when the background changes to a vibrant orange, the yellow feels cooler than its surroundings.

SCANNING

Obviously, before you can color an image digitally, the illustration must be in digital form. In many cases, the black-and-white artwork will be delivered to the colorist (by e-mail or FTP site) in a digital format, usually a TIFF (.tif) or Photoshop PSD (.psd). Other times, the task of scanning the image will be the colorist's responsibility.

Scanning is easy and only requires that you have a scanner attached to your computer. Scanners come in many different sizes and styles to fit your budget. If you're going to be scanning full-size comic boards, it may be worth the few extra dollars to purchase a large-format scanner that can accommodate an 11 x 17–inch (or A3-size) art board. If your only option is a standard 9 x 12–inch (or smaller) scanner, don't worry; I'll show you how to make it work.

Before you scan your page, you'll need to input certain specifications for page size and pixel resolution. You'll need to see your scanner's documentation to figure out how to access the control panel. Scanning specifications will vary from publisher to publisher, but here are some basics to get you started:

- If given the option, set the physical size to 100 percent, meaning that the scanned image size will not be increased or decreased.
- PPI (pixels per inch) or resolution should be set to a minimum of 400 but preferably 600 or higher.
- The scan mode or type will be either Bitmap (sometimes listed as Black & White or Illustration mode) or Grayscale. The choice will depend on the type of illustration you're dealing with.
- Use Bitmap for standard black-and-white ink drawings and Grayscale for any images that contain washes, pencil shading, or any other effects that need to preserve a line that won't be 100 percent black.
- If you have a large-format scanner, you should be able to scan the image with one pass. If you're using a smaller machine, simply scan the image in multiple pieces; then, using an image-editing program such as Photoshop, you can splice the pieces together into one image.
- Once it's in the computer, it's time to "clean" your image digitally to remove any pencil lines, scratches, or other imperfections that the scan may have picked up. Simply use the tools available in your image editor to remove these imperfections before you begin coloring.

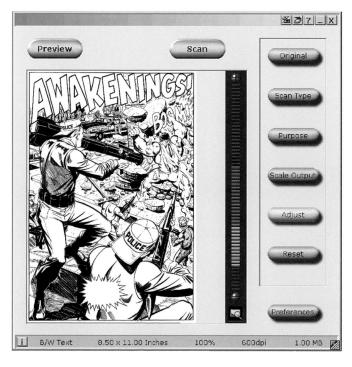

Here's the art board (far left) and how it looks once it's loaded into the standard scanner interface (left).

FLATTING

With few exceptions, most colorists start their page by separating all of the different elements of the page into easily selectable areas. This is called *flatting*. The examples here will assume that you're using Photoshop or a similar program.

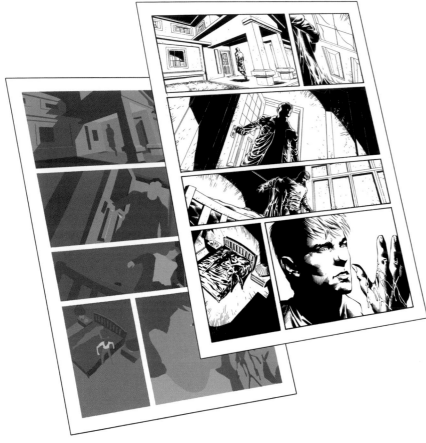

This is an example of how art is stacked virtually in Photoshop.

To start, open your file in your image-editing program. Change the Color mode to CMYK. Change the Layer mode to Multiply so that the white areas of the image will appear to be transparent when you start to add your colors. Create a new layer below the line art layer. This is the layer on which you'll be doing your work.

IMPORTANT! Before going any further, be sure that your tools are set correctly. All tools must have anti-alias turned off and any feathering or smoothing features must be set to zero. Then, using the Lasso tool, draw a line around any one object in your image. Use the Paint Bucket tool to fill in the selected area with the color of your choice. (Note: Your color choices aren't overly important at this stage. You will most likely be changing the colors when you begin adding shading to your image.)

Using the Lasso and Paint Bucket tools, continue selecting and filling in areas of the image until all elements of the page are separated. When you're finished, you'll have a layer of colors that will allow you to select small areas of the image that you can paint over without affecting other parts of the image. Now the real fun begins . . .

PLANNING THE PAGE: STORYTELLING WITH COLOR

Before you get to the actual coloring, you need to put some thought into your image. What is the mood? Are the scenes indoors or out? Is it day or night? Hot or cold? So many possibilities! Thankfully, you should have a script to help answer some of these questions, and when in doubt, you can ask the writer, penciler, and/or editor. They should be happy to help you out.

Page 13

Panel 1-
Eric is walking up to the front door of his house. The front porch light is on.

Eric (thinking)- WITH THE MONEY I'LL BE MAKING, I'LL FINALLY BE ABLE TO BUY A BIG HOUSE, A NICE CAR, AND GIVE JULIE ALL THE THINGS I HAVEN'T BEEN ABLE TO GIVE HER BEFORE NOW.

Panel 2-
Eric goes to unlock the door, but the door is open slightly.

Eric (thinking)- The DOOR IS ALREADY OPEN. I MUST NOT HAVE CLOSED THE DOOR ALL THE WAY WHEN I LEFT?

Panel 3-
View from inside the house. Eric opens the front door cautiously and looks in. It is dark in the house. Eric is illuminated by the porch light.

Eric (thinking)- YEAH, THAT'S RIGHT... I JUST DIDN'T CLOSE IT ALL THE WAY WHEN I LEFT.

Panel 4-
Inside Eric's bedroom. Eric is hanging up his coat. It is dark in the room. We can see Julie laying on the bed, as if she is sleeping. She is facing away from us.

Eric (thinking)- CHRIS IS FAST ASLEEP. TOO BAD, I WOULD REALLY LOVE TO TALK TO HER RIGHT NOW... LET HER KNOW THAT EVERYTHING IS ALRIGHT IN MY HEAD NOW.

Panel 5-
Eric sits on the bed. We can see that there is something wet dripping down the side of the bed. Eric's hand plops right into the thick liquid.

Eric (thinking)- OH WELL, I'LL JUST TALK TO HER IN THE MORN—UHGG...

Panel 6-
Eric lifts his hand to examine the thick red liquid dripping from it. blood!

Eric- WHAT THE HELL IS THIS ALL OVER THE BED?

Check the script for descriptions of locations and moods that will help with choosing colors.

The script and artwork will supply the colorist with most of the information they need to make color choices that will help the readers understanding and enjoyment of the story.

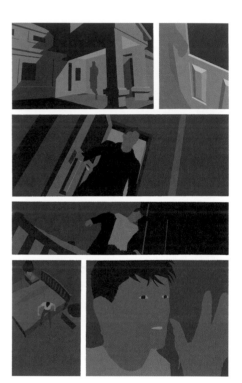

To start, take a look at your page and the script. What information will help you determine your colors? Well, you know it's night and the scene is outside at the top of the page and then transitions indoors in panel 3. The story is building suspense with a hint of danger, so you want the colors to reflect this mood.

So, what do you do with that information? Since it's nighttime, you should lean toward cool colors, so adjust your flat colors to reflect this choice.

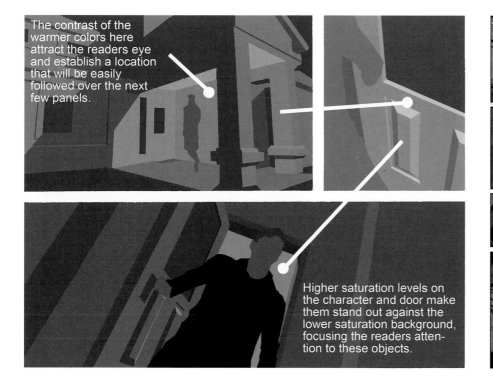

The contrast of the warmer colors here attract the readers eye and establish a location that will be easily followed over the next few panels.

Higher saturation levels on the character and door make them stand out against the lower saturation background, focusing the readers attention to these objects.

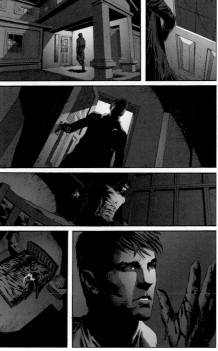

Next thing we know is that the character has transitioned from outdoors to indoors, so to convey that location change, you want a change in color. Notice that the yellow behind the character has created a smooth path of color for the reader to follow. This sense of place will help the reader follow the location changes. Once inside, the colors stay relatively cool, but slightly warmer colors are used as new elements are introduced onto the page, creating a slow build-up of warm colors leading up to the final panel. Higher saturation levels on the character and the door make them stand out against the lower saturation of the background.

Some other important color decisions to note: The addition of some warm color to the entrance of the building in panel 1 focuses the attention on that portion of the image, suggesting a focal point for the reader. In panels 4 and 6, the backgrounds are much less saturated than the character, helping to increase the contrast between the two elements. And in an important storytelling decision, the colorist refrained from using any red in the image until the final panel where the blood is revealed. This ensures that this important story element jumps out at the reader.

TONES AND TEXTURES

Sometimes, coloring goes way beyond color choices for setting, style, and mood. Certainly, some of the best coloring is done *without* all the tricks. If you've seen colored pages with too many gimmicks (i.e., lens flares, imported skies and moons, scanned patterns), you know what I mean. Less is more. If you can't make a great page without the tricks, a little more practice is the next step.

Yet sometimes an editor may ask you for a particular trick or texture to give the project a unique look. And also keep in mind that there's no one single way a page's color can be interpreted. Let's look at a cover from a new adaptation of Lewis Carroll's *Alice in Wonderland*. The artwork is by Erica Awano and the color is by PC Siqueira.

Here are four different versions of coloring for the exact same cover. The first version adds contrast to make Alice "pop" out from the background, while the second blends her more with the background and makes the floating cards the attention getter. The third and fourth versions both drop a moody texture over the first two versions, respectively. Which version would you choose?

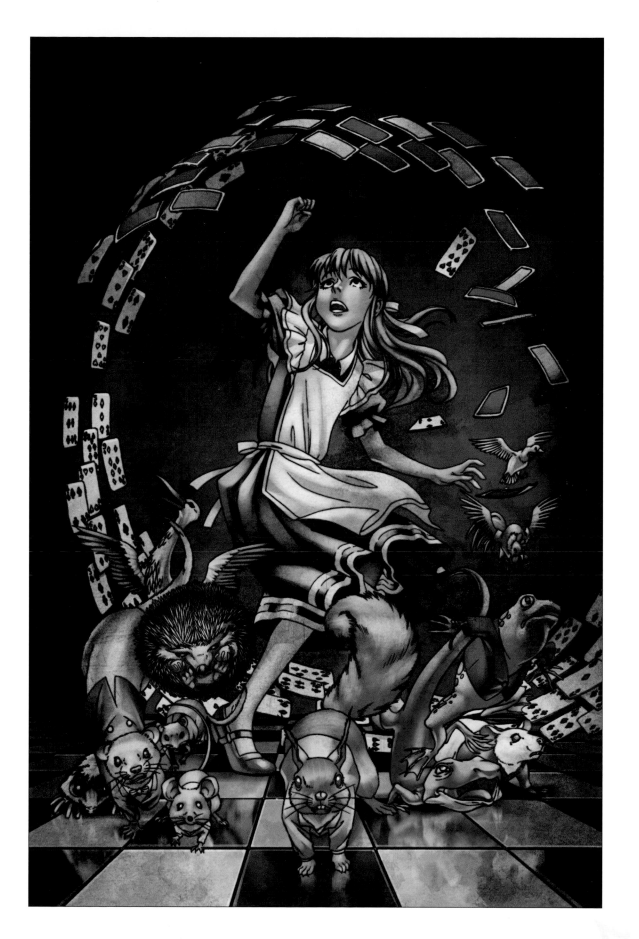

SEQUENTIAL COLOR

Sequential stories are a bit more complicated to color than just a stand-alone piece of art (such as a cover), because there can be many drawings to a single page. On these next four pages, let's consider some of the interior of Alice to continue the examination.

In the first versions of these two pages, PC Siqueira has given the art a lovely feeling, evoking watercolor illustrations in a children's book—gorgeous and perfect for the subject.

FINAL FILE PREP

So, you've completed your page! Now what? Well, all that's left is to save the file in the proper format and send it off to your editor. As mentioned earlier, most publishers will have a set of specifications that they'll want the file saved as, so always check with them first. Otherwise, you'll want to be sure to save your file in a standard format that will meet almost any publisher's minimum requirements for size and resolution.

You'll want to save a copy of your file as a single-layer TIFF, color mode set to CMYK, and a minimum resolution of 600 ppi. Some image-editing programs offer some type of image compression, such as LZW, that will greatly reduce the size of the TIFF without degrading the image quality. This is usually acceptable to, and in many cases preferred by, most publishers, but, as always, check with your editor first before delivering compressed files.

The editor had a moodier, more grown-up concept in mind, so he asked PC to drop a texture over his pages, dialing down the brightness and the watercolor tones. It seems to become a totally different style of book right before your eyes. Both versions are equally valid and display two different, professional visions. This is your power as a colorist!

Alex Ross, who painted this Buck Rogers piece, is the master of the modern comic book cover.

COVER TYPES

Covers that command the reader's attention are critical to the success of any comic book. Covers are the first thing you see on a store rack, and they compete for your attention with all the other comic book covers on the racks. A great cover interests you, intrigues you, and makes you want to pick up the book, buy it, and *read* it.

So, how do you create a cover that gets noticed in a sea of sameness from so many other publishers and talents? One trend today has been the rise of "pinup covers" that do nothing to define the characters, powers, or stories that are nestled beneath them. Essentially, characters just stand around looking heroic or sexy. They're great to hang on your wall or to be reused by publishers as promotional art—but they don't do much for selling the story.

A great cover artist focuses on three types of covers: a compelling-design cover, a compelling-event cover, or a compelling-concept cover. Each type has its own advantages. A compelling design has an immediate WOW! factor at the point of purchase. A story-based event cover catches attention now and is one the readers are likely to remember years later. And a concept cover sells the overall idea of a book— fantastic for a first issue of a new series or a relaunch of an old book.

COMPELLING-DESIGN COVER

Although a dynamic design can be part of a compelling-event cover, the artist's amazing acuity at visuals sets this apart from simply showing a scene from the story.

Cover art for both covers by John Cassaday.

COMPELLING-EVENT COVER

This gets my vote for the best type. As a story-based cover, it portrays an exciting, dramatic scene from the adventure inside the book. Whether it's the scene the way it happens or a scene that establishes the overall intention of the story doesn't matter.

Sometimes a cover needs no title at all when you have a cast of recognizable characters on it. Cover art by Michael Turner.

Cover art by Alex Ross.

Cover art by Jae Lee.

Think of this as a classic movie poster. It may not depict precisely a scene from the story, but in one dynamic image, it gets across the overall idea of the entire series.

Cover art by Frank Cho.

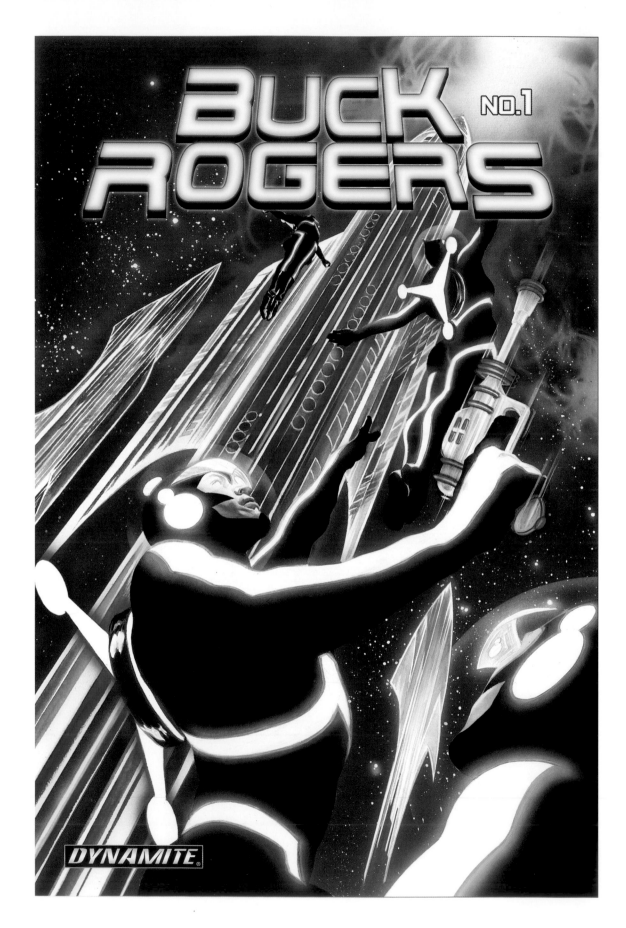

Cover art by Alex Ross.

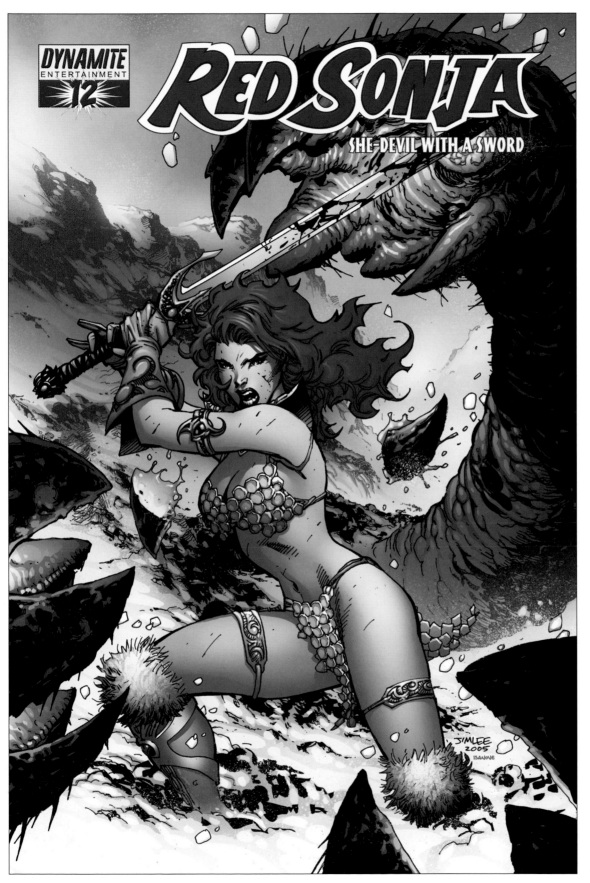

Cover art by Jim Lee.

CREATING A CONCEPT COVER

As with any interior page, a cover begins with a layout. Because covers are so important to the sales of a book, a savvy editor may ask you to submit several ideas based on a description of a story element—or, sometimes, no description at all.

Let's say we're creating a book about a new character. She's an angel, not like the winged X-Men character, not like Buffy's soulful paramour, but a lovely, leggy, winged, female angel. The editor wants to get across that she has powers—her wings really allow her to fly, she can take on even hell-spawned creatures, and she has come to Earth to do battle and protect a young teen. And yet the editor doesn't want her fighting with swords or shields or other mundane weapons. So you create three layouts for consideration, all of them, of course, professional level.

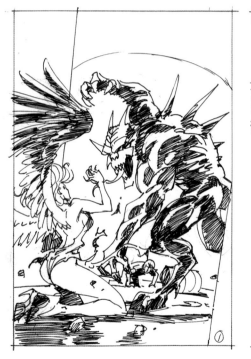 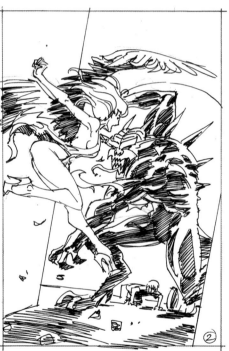

LAYOUT 1

A perfectly reasonable cover. Angel is in danger from the hell-spawned monster. It's an appealing pose: Her wings and shredded diaphanous gown establish her heavenly nature, and the cloven-hoofed creature is definitely demonic; however, this design doesn't show her flying, and she seems more of a victim than a savior.

LAYOUT 2

Much better for a first issue! She's in flight, she's doing battle, and the scene has power! Angel is flying a little bit high, though; her wings, which must be clearly established, could get covered by the book's logo.

LAYOUT 3

This one gets the vote! All the elements are in place, she's low enough on the cover not to get covered up by the logo, and she's in even closer to the creature than she was in Layout 2.

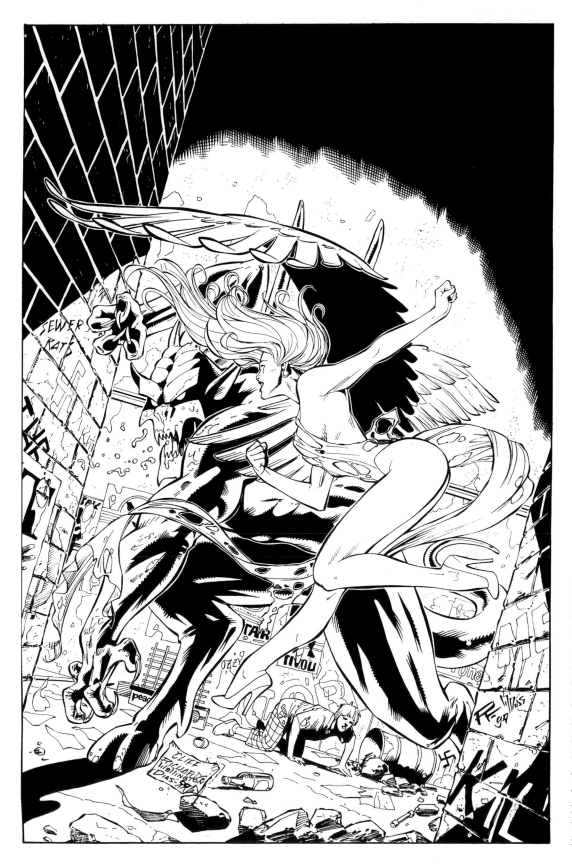

FINAL VERSION

Keep in mind that Layout 1 could certainly work for a later issue, and Layout 2 is great, only requiring Angel to be below the logo area. The editor just as easily could have said, "Go with number 2, but lower her figure." But he loves Layout 3, so . . . here's the finished cover, courtesy of Cliff Richards! It's dramatic, action-packed—and it includes all the elements of what this first issue is about!

CREATING AN EVENT COVER

Here's one where the writer is also the artist, and he knows exactly what he wants: Creator Frank Cho depicts the iconic Red Sonja in a life-and-death struggle with a powerful sorcerer! It's a scene pulled from the issue.

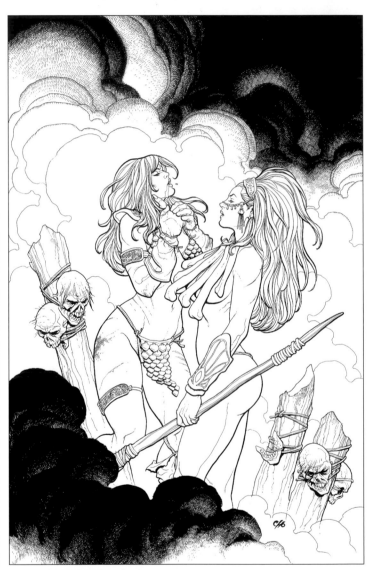

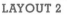

LAYOUT 1

Here's the initial sketch for the cover. It's a great start; however, all the elements need to be "tightened up" so that there is enough information to begin the inking process and leave less of a chance of making mistakes when laying down the ink.

LAYOUT 2

Now we're on to something! With the inking all finished, a piece of artwork like this is ready to move on to a color version. All the details are laid in, which comes in handy for the colorist to start making this a fully realized image ready for the comic racks.

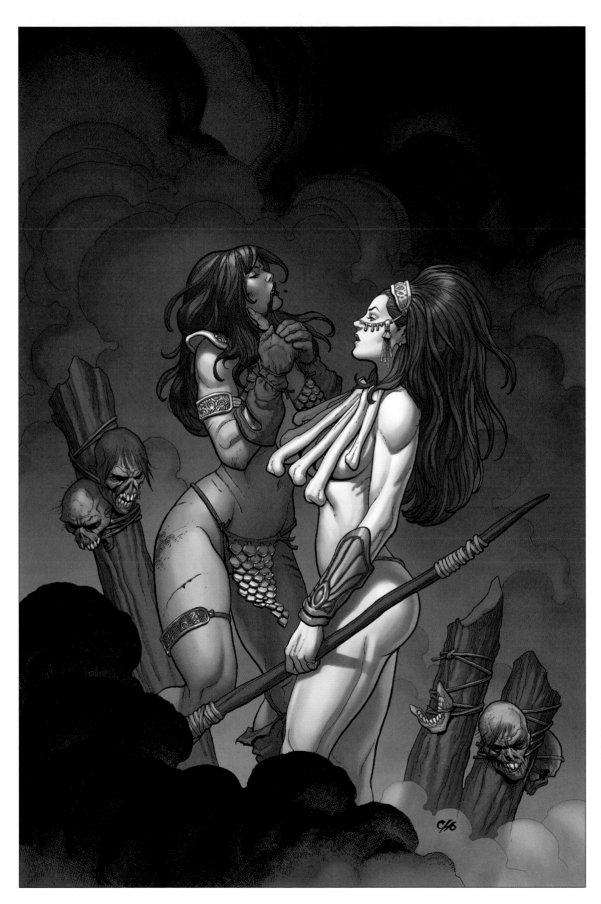

FINAL VERSION
Here's the completed
cover!

LAYING IN THE LOGO

Every comic book artist old and new has to consider such things as placement of the logo in every cover design he or she creates, just as every cover colorist has to consider such things as not coloring the top half of any two consecutive covers similarly so that the issues don't get confused on a spinner rack! Many times, the colorist will be responsible for final placement of the logo. Here's an example of the behind-the-scenes processes of just such an occasion.

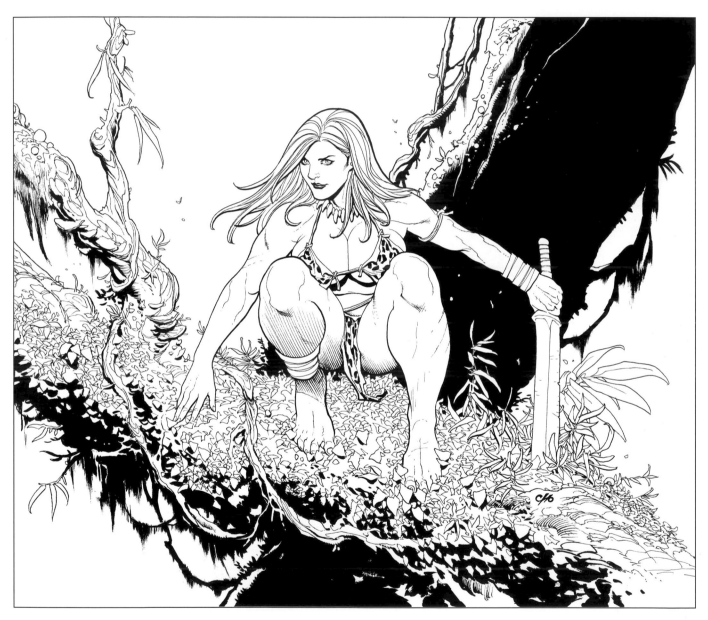

LINE ART
Here's the line art for Jungle Girl's premiere issue. The cover establishes the concept of the book: a sexy warrior in a savage world.

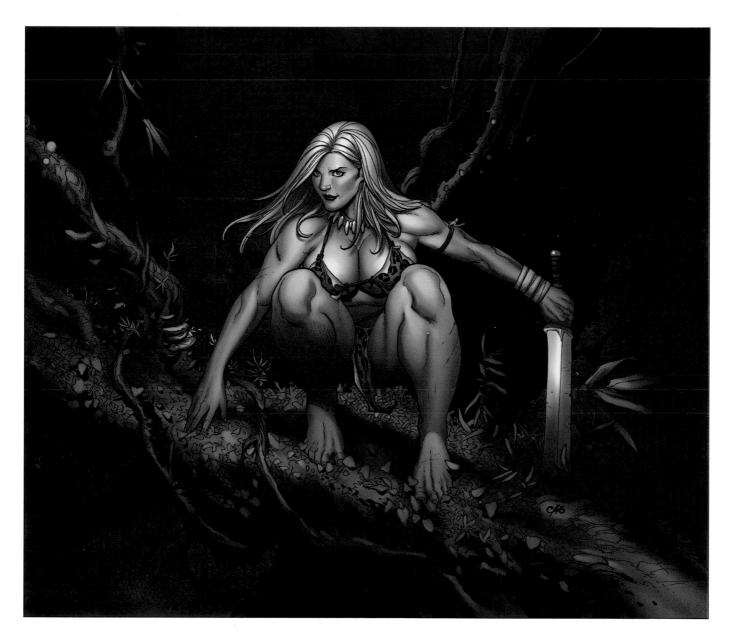

COLOR VERSION
The line art is turned
over to the colorist.

LOGO

Here's the logo for the book.

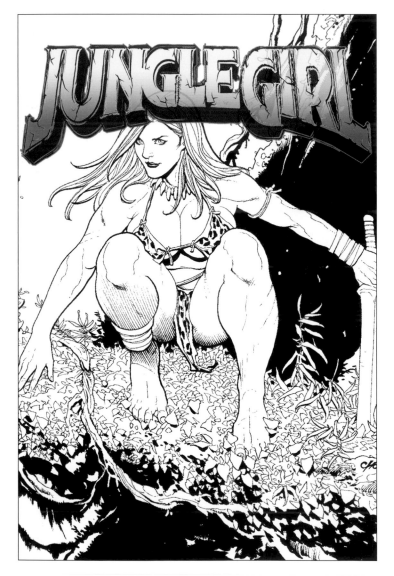

FIRST LOGO PLACEMENT ATTEMPT

As you can see, the cover has a teensy problem: If the logo is dropped in as is, it will cover the character's face! Unfortunately, there's not enough art at the top to move the logo up.

ADJUSTED ART

A design is created that will accommodate the logo and art.

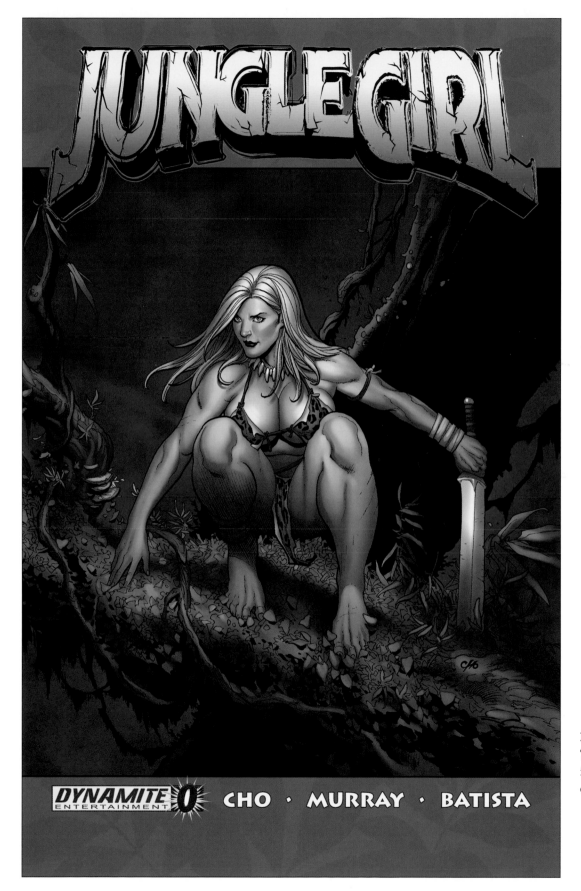

FINAL VERSION
The logo is added, the image is cropped, and the cover is complete!

Red Sonja hunts for prey; now it's your turn to hunt for work!

PREPARING YOUR PORTFOLIO

Now that you know how to do it all—or whatever parts of the process inspire you to want to live your dream as a comic book creator—it's time to try to get a job. It's a tougher application process than hitting up the local fast-food joint, but it's a lot more rewarding, as well. There are several ways to go about becoming a freelance artist, inker, letterer, or colorist, but they all follow the same basic path to comic book heaven.

Be certain that the work you submit is what you can truly deliver to the editor on a regular basis. That does *not* mean that you have to be able to draw a complete book of twenty-two pages a month plus a cover, or two books a month or three books a month or whatever you've heard it should be. It *does* mean that whatever schedule you can do, you inform the editor and you hold to it. If it takes you six weeks instead of four to deliver phenomenal artwork and an editor understands that, she can

still plan her schedules around it and assign you the projects you deserve. You're a talented person. So imagine yourself in the editor's shoes. What does she need to see to give this person a job? Whether you're submitting your work by mail, e-mail, or in person, try to understand what the editors need. They're doing the hiring.

Remember, it's *not* an editor's job to teach you how to draw or even how to draw comic books. If you're submitting a portfolio, you already need to know those things, just as a person

applying to be a heart surgeon at a hospital wouldn't expect the hospital to teach him surgery. (D'ya think that's not a balanced comparison? How many heart surgeons can draw great comic books? That'll show 'em!)

Just as you'd need to prepare and submit a resume when applying for any job, your portfolio is essentially the resume you prepare and submit to apply for a job drawing, inking, lettering, or coloring comic books. Let's look at the types of portfolios you may be preparing.

Remember to bring a portfolio that's easy to carry around. Most common types of portfolios come with the clear acetate sleeves essential for displaying artwork, whether it be pencils, inks, or final colored versions.

PENCILING PORTFOLIO

To show off your penciling skills, whether you create your own story or use a real script, your portfolio needs to show a little bit of everything in the course of a sequential story. It's easy enough to write to a comic book editor or agent and ask for some sample script to draw. Even if you don't have a script, you can create your own. Show off a variety of imaginative situations: personal and quiet, big and bombastic, moody or explosive. Don't just draw superheroes—because they're only a small part of drawing comics. Draw real people, including small children, in normal clothes. Draw cityscapes. Draw animals. Draw countrysides. The more things you prove you can draw well, the better off your submission will be.

That does *not* mean that you should bog down your portfolio with dozens of pages. Five great sequential pages is sufficient. Few will scream if you go as high as ten pages, showing parts of perhaps two or three different sequential stories with different characters, maybe even showcasing different styles. You might even want to include a couple of dynamite covers for variety's sake, one showing a compelling scene, the other showing an amazing sense of design. Leave your pinups at home on your wall to be admired.

INKING PORTFOLIO

If you don't pencil, you can still get your hands on professional pencils for inking in many different ways. Plenty of Web sites showcase penciled sequential artwork, and it's easy enough to download those to ink. Or you can browse original art sites for uninked pencils that pro artists are willing to sell cheaply. Or troll "Artists Alley" at conventions. You can

even beg and plead on comics message boards.

The best way, however, is still the simplest: Contact an editor, either by an e-mail asking for scans of pencils to ink or by sending the editor a large, self-addressed, stamped manila envelope requesting full-sized photocopies of several different pencilers to ink. Most editors are nice people and are pretty accommodating.

If you *do* pencil, however, it takes a bit of soul-searching for you to determine this: Are your own pencils at a professional level? Are you already getting work from them? If you use your own pencils and they're not good enough, or if you use another beginner's work, you may not be showing off your inking as the best it can be. Sure, some inkers can do wonders with weak pencils, but those folks are often great pencilers, as well.

It's best to show your inks over several different penciling styles, because not every inker is ideal for every penciler. And once your inks are ready to send, remember the most obvious part: When you send inks, send along *a copy of the pencils that you inked!* There's no way for an editor to know exactly how much you helped or hindered a penciled page if you don't send it along for comparison.

LETTERING PORTFOLIO

After you get your hands on some sequential art and get it lettered, proofread it. Then proofread it again. A third time wouldn't hurt, either. Editors appreciate accuracy. They also appreciate smart balloon placement and balloon shapes that seem to be organic (hand drawn) rather than computerized templates. As I've said, the best computer lettering doesn't look like computer lettering.

Once again, five to ten pages is plenty. You need to show a variety of wonderful things, so select pages that allow you to create titles, captions, word balloons, thought balloons, electronic balloons, weird special balloons, and lots of impressive sound effects. If you're great at designing logos, include a crisp helping of a half-dozen or so of those, as well.

Of course, if you're a really creative type and you've, well, created *type*—in other words, you've designed and are using your own comic book lettering fonts instead of purchasing them elsewhere—by all means, let the editors know! Suddenly you stand out from the pack, opening up a whole new area of opportunities, for the editor and for you!

COLORING PORTFOLIO

Some colorists prefer bringing their laptops to a portfolio review, and that's perfectly OK. Others supplement the laptop presentation with high-quality, accurate printouts of their work on photo paper, understanding that laptop batteries die and convention lighting sometimes isn't the best for squinting at a screen.

Some, of course, skip the laptop and bring those quality prints of their work, while also carrying CDs or DVDs of their work that they've burned as a "leave-behind" (a sample of their work to be left with an editor). A dozen coloring samples will often be plenty—enough to show coloring over different artists, depicting different coloring styles, and all the tremendous techniques at your disposal. Certainly you can pop more samples onto a disk, but an experienced editor will know from the first few whether a colorist is right for his or her needs.

SUBMITTING YOUR PORTFOLIO

Didja know that, aside from submitting to editors directly, comic book artists can work through an agent, just like the big-time Hollywood writers and actors and directors do? Yup, it's true. And although some of those comic book–savvy agents only represent tried-and-true talents, a select number even run talent training programs in various parts of our planet.

What do agents do? Everything except the actual art. They do all the "dirty work." They schmooze with editors, stand in line at cons (conventions) so that you don't have to, fly to meetings Hither and Yon (I've always wanted to visit Yon), beg for payments, publicize your career, haggle your contracts, sell your original art, and a whole lot more. It's a far shorter paragraph to describe what the agents *don't* do for you: draw. Because often, all these other chores take up so much time, the artist finds he has little time left actually to draw the assignments. Many artists, of course, don't need agents. They have the talent and the skills and the contacts and can do it all themselves and have it not interfere with their hours at the drawing board and computer.

Some editors love agents, because they know the artists are already trained and prepped and ready for prime time. But even the best agent cannot get you steady work unless you're a great, or potentially great, artist. And you need to create a mildly magnificent portfolio to prove it!

So what's the right way to get noticed by an editor or an agent? You've come to the right place to find out! Once you're sure you've become the best you can be, it's time to send out your portfolio, right? Not quite . . . you have one more step: a little research. Y'see, so many people wanna become comics superstars that some publishers have set up a few rules and regulations to keep the submission process manageable. Some won't even look at your submission unless they ask to see it. But how they can want to see your work until they've seen it? Confusing, right? All it takes is a little professional inquiry. Something along the lines of "Dear Editor, I wish to send to you .jpgs of five pages of my sequential pencils of your characters for consideration. Would you be willing to accept them for review?" They say "Yes!" and you're off to the races.

Other publishers have more specific Submission Guidelines, often published right on their Web sites, so a little research on their sites goes a long way. Some even take it one step further: They won't review your submission until you print out, sign, and send them an Idea Submission Form (on which you describe your submission briefly and agree to some conditions). Sound complicated? It's not, really—and it's pretty standard procedure these days.

TYPES OF PORTFOLIO SUBMISSIONS

Finally! You've done your research, studied submission guidelines, signed and submitted any necessary idea submission forms, and even received cheerful invitations to submit. So how do you submit your work to the peerless publishers with whom you hope to work? Glad you asked! I've been waiting for this all day!

E-MAILED PORTFOLIOS

This is the easiest and fastest way for both you and the editors:

- Write a cover note, identifying yourself with full contact information. Explain what you're submitting and why. You'd be amazed at how many editors receive fully inked, lettered, and colored submissions with no cover letter, and it turns out the person was only submitting lettering!
- Send reasonably sized .jpgs, big enough to get a good look at your art but not so big that they take a long time to upload or download. High-resolution .tif files aren't necessary at this point. And if you compress the files (as a .zip, .sit, or even .rar), that'll make them faster to send and to receive. Label your files correctly. Sample1.jpg or art. jpg won't fly, because if an editor downloads 'em and doesn't look at 'em until the next day, he won't know who sent them. Better to include your name in the file name, along with how many samples are in the sequence you're sending and what type of work you're submitting. ManeelyHULK1of4inks.jpg is a lot easier to locate and identify than 1.jpg, wouldn't you say?
- It wouldn't hurt to add your name, sample name, and your e-mail address at the top of each page of your sample, either.

MAILED PORTFOLIOS

Less immediate than an e-mail submission, mailed portfolios have the benefit of leaving a permanent printed impression of your work with the editor.

- As mentioned in the e-mail guidelines, write a cover letter. Typed is better than handwritten. Great personalized stationery is better than blank white paper. You wanna be remembered, don't you?
- Do not send your originals. Photocopies or printouts of scans only. Some editors prefer printed art submissions to be 11 x 17 inches so that they can study all the line work at original-art size; others prefer submissions on 8½ x 11–inch typing paper, because these fit easily into a file cabinet without folding. It never hurts to ask which size is preferred. When in doubt, go for the smaller size. Of course, lettering and coloring submissions need to match printed size.
- Write your name and full contact info—address, phone, and e-mail—on the front or back of every page of your submission, in case your cover letter gets separated from your art.
- If you expect to receive a response, include a self-addressed, stamped envelope so that the editor can write back to you. Yes, it's true that an editor might e-mail a response to the address on your cover letter, but

include the SASE anyway. Some editors, instead of writing a reply back to you, actually mark up your copies with their notes and send 'em back, so be sure you've included enough postage in case that happens.

CONVENTION PORTFOLIO REVIEWS

The bigger the convention, the longer the lines of heroes hoping to become the next comic book superstar. Consult con and publisher Web sites for rules and regulations. Scan the con program book for details. Some publishers post portfolio review times well in advance; some even have online sign-up schedules! A few even conduct panels at the cons that you must attend before showing your portfolio, and they have sign-ups right at their booths.

- Follow each publisher's rules.
- Be pleasant. Don't complain about the line or how long you've been waiting. You want the meeting to be a positive experience for both of you.
- Be professional in your appearance. While nobody expects you to be in a suit and tie, be clean and tidy, and dress appropriately casual for a business meeting. A T-shirt with a character or a rude saying on it isn't what a professional would wear to a job interview.
- Once again, six to ten pages plus a couple of covers are plenty.

Editors simply don't have time to look at a bunch of pages.

- Leave your excuses at home. ("That's an old piece." "I rushed that to have it done in time for the show.") The moment editors hear excuses—or, worse, arguments—regarding the work they're critiquing, the interview is over in their minds.
- Show your best, then listen and learn from the editor's advice. Nobody likes bad news. Everybody wants to hear "You're hired!" But you learn more by listening and applying the advice they give than by arguing about it.
- Prepare a "leave-behind" 8½ x 11–inch sample of your work with all your contact info. It's possible, even likely, that an editor will say, "Just mail that to me." You may think, "But you're right here!" You may not understand that convention submissions may end up being packed with the booth and convention swag and not be opened and sorted through for weeks. The editor may be saving your work from such a burial because he wants it on his desk to hire you!

OFFICE PORTFOLIO REVIEWS

If you're fortunate enough to get an appointment to meet with an editor at the publisher's office location, try not to give in to the temptation to ask for a tour; the editor is there to review your work, not be a tour guide. If the editor or someone else offers, that's fine, but getting too "fannish" isn't the best way to persuade an editor of your professionalism.

- All my suggestions for convention reviews hold here, as well, though it's even more important to be groomed and to dress professionally in this environment. If they dress in suits and ties and you show up in a dirty T-shirt with unkempt hair, you won't make the best first impression.
- Don't forget to leave the "leave-behind"!

AFTER THE PORTFOLIO REVIEW

In an ideal world, you'll come out from that office meeting with a script in your hands—your first assignment! More likely, they'll offer you a test script from which to draw or ink or letter or color a few pages by next week, to see how well you do under pressure.

But what if you follow all the rules, try to do everything right, and still don't get that job drawing the series you've always dreamed of? Draw some more! Real artists never stop drawing. They never stop learning. Just as a musician practices day in and day out, or a martial arts student continues to learn and rise and advance, so does an artist.

Look around you, Grasshopper. If you're on a bus, draw what you see: the people and the packages and the sights outside. If you're in a cab, whip out that little sketchbook from your pocket and sketch the inside of that cab; you never know when you might have to draw it someday. In a coffee shop? Draw the decor and even the waitress. If she's impressed, you might even end up with a phone number! Draw everybody, and everything, that you spy with your eyes—someday, you may need to draw it for a story.

Keep learning, keep trying to be the best. The more you draw, the more you understand what you draw, the better you will become. Because I want you to be the best. You know it, too, or we wouldn't be here!

Excelsior!

SUGGESTED READING, WEBSITES, SCHOOLS & SUPPLIERS

READING

GENERAL ART TECHNIQUE

Bridgman's Complete Guide to Drawing from Life by George B. Bridgman (Sterling, 2009)

Digital Prepress for Comics: The Definitive Desktop Production Guide, Revised Edition by Kevin Tinsley (Stickman Graphics, 2010)

Drawing Dynamic Hands by Burne Hogarth (Watson-Guptill, 1988)

Drawing the Human Head by Burne Hogarth (Watson-Guptill, 1989)

Dynamic Anatomy: Revised and Expanded Edition by Burne Hogarth (Watson-Guptill, 2003)

Dynamic Figure Drawing by Burne Hogarth (Watson-Guptill, 1996)

Dynamic Light and Shade by Burne Hogarth (Watson-Guptill, 1991)

Dynamic Wrinkles and Drapery by Burne Hogarth (Watson-Guptill, 1995)

Facial Expressions: A Visual Reference for Artists by Mark Simon (Watson-Guptill, 2005)

Form by Scott McCloud (Harper Paperbacks, 2000)

Human Anatomy for Artists: The Elements of Form by Eliot Goldfinger (Oxford University Press, 1991)

Perspective! for Comic Book Artists by David Chelsea (Watson-Guptill, 1997)

Re-Inventing Comics: How Imagination and Technology Are Revolutionizing an Art Form by Scott McCloud (Harper Paperbacks, 2000)

Understanding Comics: The Invisible Art by Scott McCloud, (Harper Paperbacks, 1994)

MORE ABOUT STAN LEE

Bring on the Bad Guys by Stan Lee (Simon & Schuster, 1978)

Excelsior! The Amazing Life of Stan Lee by Stan Lee and George Mair (Fireside, 2002)

How to Draw Comics the Marvel Way by Stan Lee and John Buscema (Fireside, 1978)

Origins of Marvel Comics by Stan Lee (Simon & Schuster, 1974)

Son of Origins of Marvel Comics by Stan Lee (Simon & Schuster, 1976)

Stan Lee and the Rise and Fall of the American Comic Book by Jordan Raphael and Tom Sturgeon (Chicago Review Press, 2004)

Stan Lee: Comic Book Genius by Steven Otfinoski (Children's Press, 2007)

Stan Lee: Conversations by Jeff McLaughlin (University Press of Mississippi, 2007)

Stan Lee's Amazing Marvel Universe by Roy Thomas and Stan Lee (Sterling, 2006)

Stan's Soapbox: The Collection by Stan Lee (The Hero Initiative, 2008)

The Superhero Women by Stan Lee (Simon & Schuster, 1977)

WEBSITES

www.comicbookresources.com
www.dccomics.com
www.dynamiteentertainment.com
www.marvel.com
www.newsarama.com